Jonathan Borofsky

2879437

Jonathan Borofsky

Mark Rosenthal Richard Marshall

Philadelphia Museum of Art in association with the

 Whitney Museum of American Art

This book was published on the occasion of the exhibition "Jonathan Borofsky," organized by the Philadelphia Museum of Art in association with the Whitney Museum of American Art and supported by grants from The Pew Memorial Trust and the National Endowment for the Arts, a Federal agency. The exhibition was presented at the Whitney Museum and at the Walker Art Center with additional support from the American Can Company Foundation.

Exhibition Schedule

Philadelphia Museum of Art

October 7–December 2, 1984

Whitney Museum of American Art, New York

December 20, 1984–March 10, 1985

University Art Museum, Berkeley

April 17–June 16, 1985

Walker Art Center, Minneapolis

September 13–November 3, 1985

The Corcoran Gallery of Art, Washington, D.C.

December 14, 1985–February 9, 1986

Cover: *Running Man,* painted on the Berlin Wall as part of "Zeitgeist" exhibition, 1982
Frontispiece: *I dreamed I found a red ruby at 2,879,437,* 1984, offset lithograph created by Jonathan Borofsky for this publication

Images of Man with a Briefcase interspersed throughout the book are from the artist's sketchbook, c. 1981
Texts accompanying plates are from interviews with the artist conducted by the authors
Works from the collection of the artist are reproduced courtesy of the Paula Cooper Gallery, New York

Contents

Lenders to the Exhibition

Allen Memorial Art Museum, Oberlin College
Jonathan Borofsky, Venice, California
The Edward R. Broida Trust, Los Angeles
Eddo and Maggie Bult, New York
Paula Cooper Gallery, New York
Copley Collection, Roxbury, Connecticut
James F. Duffy, Jr., Grosse Pointe
Dunkin' Donuts Incorporated, Randolph, Massachusetts
Jules and Barbara Farber, Amsterdam
Gemini G.E.L., Los Angeles
Harvey and Judy Gushner, Bryn Mawr
Wil J. Hergenrader, Memphis
Barry Lowen, Los Angeles
Lewis and Susan Manilow, Chicago
Museum Boymans–van Beuningen, Rotterdam
The Museum of Modern Art, New York
Oeffentliche Kunstsammlung Basel Museum für Gegenwartskunst
Philadelphia Museum of Art
Richard and Lois Plehn, New York
Private Collections (three)
David P. Robinson, New York
Doris and Charles Saatchi, London
Barbara and Eugene Schwartz, New York
Martin Sklar, New York
John L. Stewart, New York
George H. Waterman III, New York
Whitney Museum of American Art, New York

Preface

It is exciting to have the opportunity to present the work of Jonathan Borofsky in five cities across the United States. From the seemingly endless stream of images and visual ideas that constitute our environment over the past decade, his Running Man and Hammering Man emerge as powerful expressions at once personal and universal. We look to artists to reflect and transmute the feelings and preoccupations of an era, and few have done so in more compelling terms. The Philadelphia Museum of Art and the Whitney Museum of American Art are proud to join in this adventure, which accords equally well with the quite different visual and historical context of each institution. Mark Rosenthal and Richard Marshall have contributed their insights to this book, which records Borofsky's work to date, and in collaboration with the artist, to the content of the exhibition. It is a measure of their respect and enthusiasm for the artist that so many lenders have parted with objects in their collection for the length of time necessary to make this exhibition and its tour possible. We are most grateful for that generosity, and we are delighted that our colleagues—James Elliott at the University Art Museum, Berkeley; Martin Friedman and Marge Goldwater at the Walker Art Center, Minneapolis; and Michael Botwinick, Jane Livingston, and Edward Nygren at the Corcoran Gallery of Art, Washington, D.C.—have been wholehearted participants in the tour. Paula Cooper and the staff of her gallery have given invaluable assistance and encouragement to the exhibition curators during every phase of this project.

Without a grant from the National Endowment for the Arts, in its ongoing and crucial support of contemporary art in the United States, this exhibition, like so many others, would have had little chance of materializing. Generous support to the Philadelphia Museum of Art from The Pew Memorial Trust made it possible to carry the project to fruition. A grant from the American Can Company Foundation supports the exhibition at the Whitney Museum and the Walker Art Center.

To Jonathan Borofsky go our heartfelt thanks for his thoughtful collaboration with the organizers of the exhibition from its inception over four years ago to its presentation in five museums, the galleries of which each offer a different set of challenges for the installation with which he is profoundly concerned.

Anne d'Harnoncourt
The George D. Widener Director
Philadelphia Museum of Art

Tom Armstrong
Director
Whitney Museum of American Art

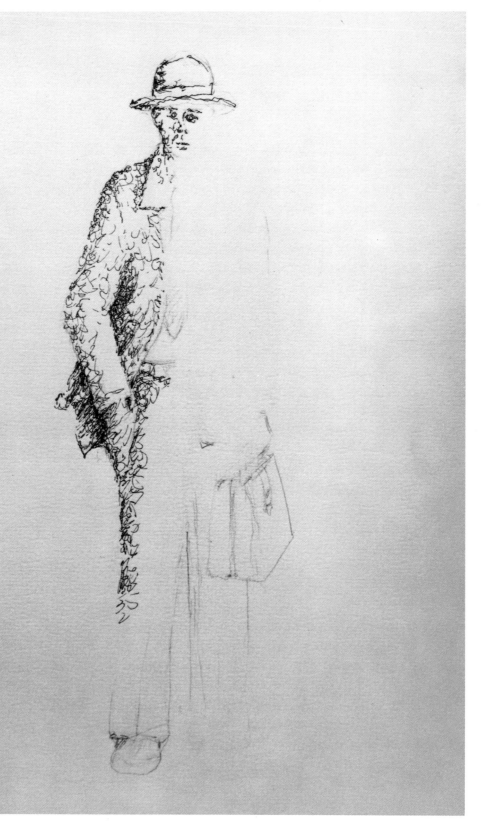

Acknowledgments

When I initially encountered the work of Jonathan Borofsky at his first solo
exhibition in 1975, I was overwhelmed by the powerfully direct, unique character
of his art. I felt that I was in the presence of a remarkable artist who had the
potential to make a profound mark on the art of this era. The working associa-
tion and friendship that ensued enabled me to follow closely the development of
his art. This enormously rewarding and satisfying experience has culminated in
the present publication and accompanying exhibition. I am grateful to Jonathan
Borofsky for the trust he has placed in me throughout the course of this work.

I collaborated with Richard Marshall on virtually every important aspect of
the exhibition and book. His contributions have enhanced this project enormously.

Organization for this project began while I was on the staff of the University
Art Museum, Berkeley, with the support of James Elliott, Director. I am especially
grateful to Anne d'Harnoncourt, Director of the Philadelphia Museum of Art,
who enthusiastically endorsed the exhibition upon my arrival in Philadelphia and
encouraged its evolution. Mrs. H. Gates Lloyd, Chairperson, and members of the
Twentieth-Century Committee of the Philadelphia Museum of Art have also been
extremely supportive.

Paula Cooper and her staff, particularly Bertha Sarmina, were extremely help-
ful in tracking down crucial information. Working with them has been one of the
pleasures of this undertaking.

On the staff of the Philadelphia Museum of Art, Carol C. Wolfe worked
tirelessly and good-humoredly on the many details of the project. Others at the
Museum executed their responsibilities with admirable skill: Judith Brodie in the
Registrar's office; George H. Marcus, Laurence Channing, Judith Ebbert Boust,
Mark La Riviere, Victoria Ellison, and Bernice Connolly in Publications; T. S. Farley
in Packing and Shipping; Margaret Kline, of the Twentieth-Century Art depart-
ment; Anne Schuster, in the Director's office; Tara Robinson and her staff in Mu-
seum Installations; and Suzanne F. Wells, of Special Exhibitions.

M.R.

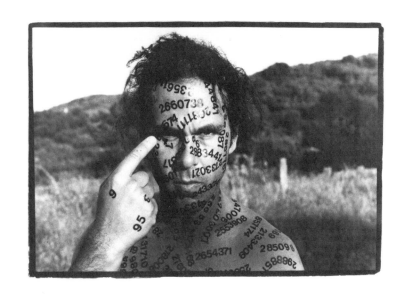

Self-Portrait, 1980
Photograph, 29³/₄ x 41″
(75.6 x 104.1 cm)
Edition of 6
Collection of the artist

Jonathan Borofsky's Modes of Working Mark Rosenthal

If anything is predictable about Jonathan Borofsky's art, it is its unexpectedness. He is best known for installations consisting of a panoply of images, environments that may differ dramatically in character. In some, there is heroic scale and spare, elemental imagery; in others, apparent chaos prevails. Within an installation, the objects themselves have surprisingly varied aspects. Undeveloped or finished, sculpted, painted, or drawn, Borofsky's art ranges beyond the boundaries of an autograph style. Nevertheless, certain consistent modes of working firmly underlie his art.

At the heart of Borofsky's art is the activity of drawing. From his pen come hundreds of works on paper each year. Drawing occupies him either completely or as a kind of unconscious reflex while he is otherwise engaged. In 1971–72, after years as a painter and sculptor, and at a time when he had dispensed with art making altogether in favor of the meditative activity of counting, it was drawing that brought him back to art. Out of a certain tedium, he began to doodle on his sheets of counting (fig. 2). Drawing for Borofsky is a demonstration of his thoughts, as he explained, "My thought process is an object" (see fig. 3).[1] Thus, the concrete manifestation of the thought is an artwork, usually a drawing, for it is the sheet of paper that is conveniently present to receive the first intimations of thought as it emanates from Borofsky's conscious and unconscious mind. Typically, he allows the initial drawing to flow freely from his hand in an almost unconscious or trancelike manner, so as to preserve the formative impulse.

After a thought makes its appearance in a drawing, Borofsky contemplates new "generations" (his word) for that initial impulse. The thought has become image—art—and can then undergo artistic manipulation. It may be redone as a large drawing or transferred to a transparent sheet of plastic. Once transferred, the image can be projected onto a wall for tracing as a wall drawing, or onto a canvas for a painting; even a sculpture may ensue. One need only explore the many manifestations of his Man with a Briefcase, for example (figs. 4, 5 and pls. 59, 188, 191, 192, 201), to see these transformations.

Not only does drawing make thought visible in Borofsky's art, it reflects his preoccupation with the subject of time. In 1969 he wrote in his Thought Book: "As an artist, my goal is to present . . . illustrations of my thoughts regarding the meaning of time."[2] If his art is concerned, in part, with the subject of time, it should be recognized that a drawing visibly demonstrates an activity occurring in time. Moreover, the bounty of drawings shown at an exhibition represents the activity of a specific time period (see fig. 6 and pl. 101). He often refers to the unceasing "chatter" in his mind; the flow of echoing drawings reproduces the passage of time in which the chatter occurs. When Borofsky combines drawn images from various points in his past at an installation, he creates a retrospective, which is an exercise in compressing time.

1. Jonathan Borofsky, Thought Book (1967–70), p. M154.
2. Ibid, p. M118.

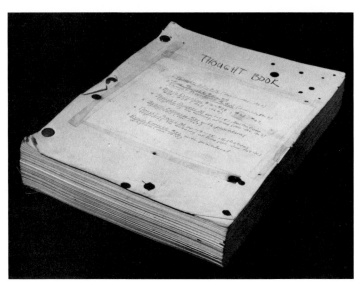

Fig. 1 *Untitled at 2,429,053*
Ink and conté crayon on paper,
7⁷/₈ x 12″ (20 x 30.5 cm)
Collection of Harvey and Judy
Gushner, Philadelphia

Fig. 2 Sheet from *Counting from
1 to Infinity* (pl. 2), 1978
Ink and pencil on paper, 8¹/₂ x
5¹/₂″ (21.6 x 14 cm)
Collection of the artist

Fig. 3 *Thought Book*, 1967–70
Ink on paper, 11 x 8¹/₂ x 3″ (27.9 x
21.6 x 7.6 cm)
Collection of the artist

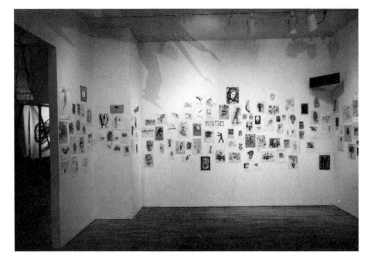

Fig. 4 *Man with a Briefcase at
2,756,805*, 1980
Ink on photocopy 11⁵/₈ x 8¹/₂″
(29.5 x 21.6 cm)
Collection of the artist

Fig. 5 *Man with a Briefcase*, 1979
Aluminum, 89¹/₄ x 35¹/₂ x ¹/₄″
(226.7 x 90.2 x .6 cm)
Edition of 15
Gemini G.E.L., Los Angeles

Fig. 6 Installation at The Museum
of Modern Art, New York, 1982

According to Borofsky, "To understand the universe, man thinks in systems."[3] In the welter of thoughts-cum-drawings is a system founded on Borofsky's own psyche (see figs. 7–9). A second, more rational structure, the counting, accompanies the first; both reinforce Borofsky's emphasis on systems in general, and, perhaps, suggest the ways of the universe. The activity of drawing, however, initiates this exploration of the universe.

Borofsky's drawings almost always have subjects, for he wants to make a statement, to take "a political stand."[4] In place of what he calls "cool art,"[5] he seeks connectedness to society. A child of the 1960s, he recognizes about that period a "shared emotional upsurge" in which people were solicitous of one another.[6] To participate in the world, Borofsky hopes to depict subject matter of universal consequence. Toward that end, he has developed a pattern of recurring, generalized themes that are often highlighted by archetypes and archetypal situations. It should be understood that often a theme or an archetype may have multiple, sometimes even opposing, meanings, much as an experience in life may have varying connotations.[7]

The major subject of Borofsky's work is the artist himself, an ego in the world, thinking and feeling. His life, with his fears, ambitions, and anecdotal events, is constantly on display (see pls. 5, 8). Through his art he hopes "to understand my own pains and happinesses."[8] To the extent that these works force us to share in the depths of his emotions, they may become archetypal of human experience in general. Thus the Man with a Briefcase, initially a portrait of Borofsky himself carrying his drawings from one installation to the next,[9] becomes symbolic of the modern man in society. This anonymous, unemotional figure is tied to his work, symbolized by the briefcase.

Borofsky acknowledges that virtually every one of his works is a self-portrait.[10] The head is a frequent form of expression in this regard; there are literally hundreds, which are frankly self-portraits or, at the very least, suggestive of such (pls. 33, 35, 36, 133). Some have animal ears, recalling his "dog or animals or hearing or, if nothing else, two points heading up toward the heavens to receive energy. Antenna receiving and sending energy" (pl. 54).[11] He says of these spiritualized beings who are in touch with forces beyond human sensation: "It's me, but . . . me as an animal" (see fig. 10).[12] A major variation is the individual with a book or light atop its skull (pls. 48, 147, 148). Symbolic of knowledge, according to the artist,[13] the book or light may also suggest consciously acquired human enlightenment in contrast to animal instincts. Therefore, by inserting an image of the Polish activist Lech Walesa within his own forehead (fig. 11), he suggests an enhanced political consciousness acquired through events external to his original state. Some heads imply interior dilemmas and psychological traumas (pls. 47, 53); for example, one figure removes its head (fig. 12), a head is completely split in two, and a head is located within or behind another (fig. 13). At times the

3. Ibid, p. M116.
4. Quoted in interview by Kathy Halbreich, in Cambridge, Hayden Gallery, Massachusetts Institute of Technology, *2699475—Jonathan Borofsky: An Installation,* December 1–24, 1980.
5. Quoted in Lucy Lippard, "Jonathan Borofsky at 2,096,974," *Artforum,* vol. 13, no. 3 (November 1974), p. 63.
6. Quoted in Joan Simon, "An Interview with Jonathan Borofsky," *Art in America,* vol. 69, no. 9 (November 1981), p. 165. For further discussion of 1960s context, see Mark Rosenthal, "The Ascendance of Subject Matter and a 1960s Sensibility," *Arts Magazine,* vol. 56, no. 10 (June 1982), p. 94.
7. See Jennifer Allen, "From Obscurity to the Whitney," *The Daily News* (New York), February 20, 1981, p. M9.
8. Quoted in Lippard, "Jonathan Borofsky at 2,096,974," p. 63.
9. See Joan Simon's essay, "Borofsky/Dreams," in Kunsthalle Basel and London, Institute of Contemporary Arts, *Jonathan Borofsky: Dreams, 1973–81,* 1981.
10. Halbreich, in Cambridge, Hayden Gallery.
11. Ibid.
12. Quoted in Simon, "An Interview with Jonathan Borofsky," p. 164.
13. Ibid.

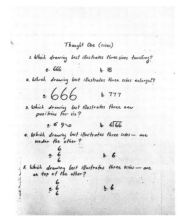 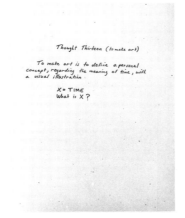

Fig. 7 Thought One (Sixes), from *Thought Book,* 1967–70
Ink on paper, 11 x 8¹/₂″ (27.9 x 21.6 cm)
Collection of the artist

Fig. 8 Thought Thirteen (To Make Art), from *Thought Book,* 1967–70
Ink on paper, 11 x 8¹/₂″ (27.9 x 21.6 cm)
Collection of the artist

Fig. 9 Thought Sixteen (Fourteen Steps of Clarification), from *Thought Book,* 1967–70
Ink on paper, 11 x 8¹/₂″ (27.9 x 21.6 cm)
Collection of the artist

Fig. 12 *I dreamed I found a red ruby at 2,783,500,* 1982
Two-color lithograph, 76 x 39¹/₂″ (193 x 100.3 cm)
Edition of 27
Gemini G.E.L., Los Angeles

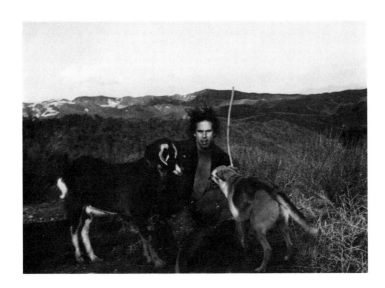 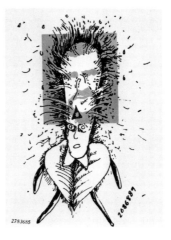 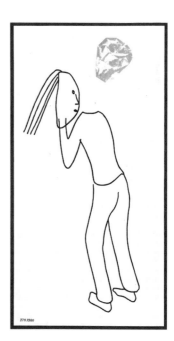

Fig. 10 The artist with animals, 1980

Fig. 11 *Self-Portrait at 2,783,685 and 2,686,889,* 1981–82
Three-color lithograph, 40 x 30″ (101.6 x 76.2 cm)
Edition of 23
Gemini G.E.L., Los Angeles

head seems on the verge of bursting from interior activity, notwithstanding its being a vehicle by which the soul of an individual is characterized.

In one panel of *Continuous Painting* (pl. 4), Borofsky places plus and minus signs on his forehead. This arrangement epitomizes the many dichotomies with which he is fascinated. He depicts the male and female sides of himself (pls. 32, 38, 63) on many occasions, or in relating his counting to his dream images, "the left and right side of the brain, like positive and negative charges, or like yin and yang. According to Eastern thinking, the goal is apparently to get beyond dualities to a new kind of energy . . . which propels things."[14] Unlike the heads discussed previously, this one reveals wholeness and the complete integration of conflicting forces.

Borofsky is fond of employing objects that symbolize important aspects of his life and of humanity in general. Flowers may represent mother, and the boat, father; a variation is one tree as mother and two as parents. An aureole of light signifies "home" (pl. 35).[15] The combination of a heart and a star often appears (fig. 14), referring in part to the Jewish star, with which the artist feels a close identity.[16] (This shape also includes the heart, signifying feeling, the triangle, his aggressive nature.) The ubiquitous Ruby, which he "began to think of . . . as my heart,"[17] used as a paperweight for the stack of counting, symbolizes his emotional side combined with his intellectual-rational aspect (see pls. 108, 118). But crucial to Borofsky's method is the idea that these symbols and totemlike objects possess more than one meaning. For example, when he writes "I dreamed I found a red ruby," he is not referring to his heart as much as to a keystone of beauty and spirituality, much as William Carlos Williams, and after him Charles Demuth, exclaimed "I Saw the Figure Five in Gold." Rubies accompanied a Flying Figure in Borofsky's exhibition in Basel (pl. 209), as if representative of celestial orbs that establish a heavenly host for the Flying Figure and guarantee its safe journey.

The state of spiritual well-being and wholeness is a major theme in Borofsky's art, and toward this end, he spent a great amount of time, before his return to the making of art in 1972, contemplating the nature of the universe.[18] One of his first efforts subsequent to this was *I dreamed my model for the universe was much better . . .* (pl. 9), in which cylinders are used as a symbol of the universe. Later, other symbols appeared to replace the cylinders, including planetary rings, apparently endless lines, and ribbonlike forms (see figs. 15, 16). These were subsequently conjoined with figures, often encircling heads, to suggest synchronization with otherworldly forces (pls. 43, 117, 149). Other examples of this harmony include the head in *Continuous Painting*, discussed previously, the combination of the heart and star, Brancusi-like sleeping heads bathed in the well-being of a womblike space (pl. 32), and *Venice Boardwalk* (pl. 39). In the last, Borofsky follows Picasso's example of depicting a blind musician, an icon for the artist who possesses interior sight.

14. Quoted in Halbreich, in Cambridge, Hayden Gallery.
15. Lippard, "Jonathan Borofsky at 2,096,974," p. 63.
16. See essays by Christian Geelhaar and Dieter Koepplin and ill. p. 44, in Kunstmuseum Basel, *Jonathan Borofsky: Zeichnungen 1960–1983*, [1983].
17. Simon, "An Interview with Jonathan Borofsky," p. 162.
18. Halbreich, in Cambridge, Hayden Gallery.

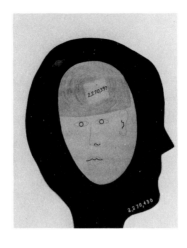

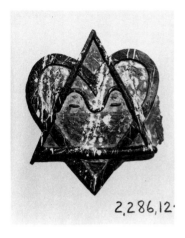

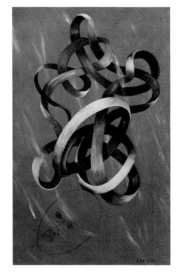

Fig. 15 *Head in Space at 2,541,071*, 1978
Acrylic on paper, 80½ x 53½″
(204.5 x 135.9 cm)
Location unknown, photograph
courtesy of Paula Cooper Gallery

Fig. 13 *Two Heads at 2,270,244; 2,270,397; and 2,270,430*, 1974
Acrylic, ink, pencil, enamel, and
paper on paper, 24½ x 20⅝″
(62.2 x 52.4 cm)
Private collection

Fig. 14 *Untitled at 2,286,124 and 2,283,174*, 1973
Acrylic on plaster, 15½ x 12½″
(39.4 x 31.8 cm)
Collection of the artist

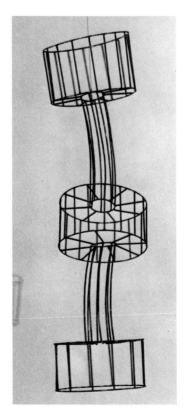

Fig. 16 *I dreamed my model for the universe was much better after I removed three cylinders from the top at 2,695,210*, 1978
Welded steel, 41 x 11 x 11″ (104.1
x 28 x 28 cm)
Collection of the artist

Fig. 17 *Man with Sword at 2,345,722*, 1976
Ink on wall, 60 x 36″ (152.4 x 30.5
cm) (approximate)
(Paula Cooper Gallery, New York,
1976)

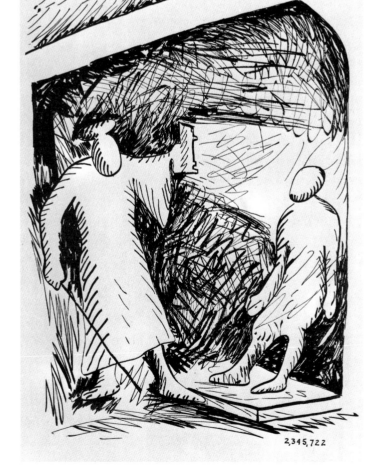

Another sublime or spiritual manifestation in Borofsky's art is his counting (pl. 2). About this rarefied, intellectually pure activity he says: "It's my anchor. This numerical counting is the purest statement I can make. It's like Brancusi's *Bird in Flight*. . . . It's just that pure line for itself."[19] The stack of sheets is comparable to Brancusi's *Endless Column*, too, for both imply infinity.

Manifestations of light are, also, evocative of spirituality. He sees the lamp in *Age Piece* (pl. 3), for example, as "a flame—spiritual—reaching for the light."[20] Elsewhere, light accompanies moments of revelation (fig. 17). In his 1981 London installation, which was in part concerned with the political conflict in Northern Ireland, an oval of hot magenta light offered solace and relief (pl. 185), and in his Paula Cooper Gallery show in 1983, the lone Chatterer not absorbed by a painting had a fluorescent halo on his head and stared up at a pattern of light near the ceiling (pl. 220).

Spirituality is the natural province of two types of beings in Borofsky's iconography: animals and Asians. When he represents himself with animal ears, takes a horse on his lap, or joins his image with that of a bird, he assumes part of the attuned essence of the creature for himself. *Two Men with Fish* (pl. 29) suggests a similar meaning, as if by the act of fishing a talisman of the spirit is caught. The fish appears often again, including once when its eye is a Ruby in the installation at Purchase, New York (pl. 135). Borofsky admires Asian cultures for their integration of spiritual values in daily life. He shows knowledge being handed down in Eastern culture (pl. 16), as well as holy men, such as the Shinto priest (pl. 74), with whom he identifies personally.[21] In Borofsky's art, Asians are generally stoic mystics, filled with a kind of inner peace.

"Art is for the Spirit" is emblazoned on a banner that has reappeared in several of Borofsky's installations (pl. 158). He says of this message, "Art helps to make life happen."[22] Not only is the banner a declaration or manifesto, it also characterizes the world into which the spectator has entered as being spiritual. The motto also occurs in a painting, but juxtaposed with a self-portrait (pl. 1). Instead of being rabbit-eared here, the artist is in tune with his immediate world wherein art is created.

A contrast to spirituality is work, which evokes the immediate, imminent world and a fundamental activity of it. There are several different manifestations of this, including Borofsky's signature archetype, the Hammering Man. It began as a drawing, based on a photograph in the *Book of Knowledge,* of a Tunisian shoemaker hammering (pl. 17). The subject reappeared in various forms (figs. 18–20), including a silhouette within a head juxtaposed with a number. In the context of this duality, work is an intuitive, imaginative, or irrational activity compared to the counting. As a twelve- to twenty-six-foot-high sculpture with its arm continuously in motion (pl. 178), the figure assumes further associations of subjugation and violence. Yet it is forever at work, endeavoring and creating, a very active and dynamic being.

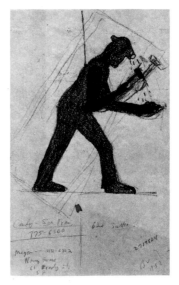

Fig. 18 *Hammering Man at 2,719,824,* 1981
Charcoal on paper, 12¹/₂ x 9¹/₈"
(31.8 x 23.2 cm)
Kunstmuseum Basel

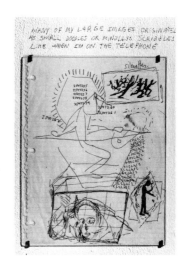

Fig. 19 *Silhouettes*
Ink on paper, 11 x 8¹/₂" (28 x 21.6 cm)
Collection of the artist

19. Quoted in Simon, "An Interview with Jonathan Borofsky," p. 167.
20. Quoted in Lippard, "Jonathan Borofsky at 2,096,974," p. 62.
21. David Bourdon, "Discerning the Shaman from the Showman," *The Village Voice,* July 4, 1977, p. 83.

While discussing the Hammering Man, Borofsky cryptically noted that the word *strike* "had two opposite meanings . . . to work and not to work."[23] In this context, he wrote the Polish word for strike—STRAJK—across a drawn version of the Hammering Man for *Artforum* magazine. With this reference, Borofsky not only suggested a pun between the figure's arm in motion and the possible cessation of that action, but also provided a contemporary meaning to the figure. He called attention to the importance of the work–no work dilemma in a modern country. Without work, that nation begins to move toward a state of chaos.

Borofsky has made various other images concerned with the theme of work, including *Woman at Wheel* (pl. 27), *Pushcart Man* (see pl. 79), and *Not Made to Rule, but to Subserve.* In these, work is of a primitive and basic variety, and the worker is a faceless everyman or everywoman. But the Hammering Man is seemingly a member of a different species inhabiting Borofsky's world, a race of giants that tower over the surroundings and stride across the landscape, seeming supermen on earth (see pl. 193). Thus a huge Hammering Man was juxtaposed in 1981 in the Basel Kunsthalle with a visual quotation from Michelangelo, God's hand bringing about the creation of Adam. Borofsky conceives of man on earth as an exalted being, capable of a sublime level of endeavor. The activity of work symbolizes that state of exaltation.

Borofsky's preoccupation with political situations has led him to give great emphasis to a cluster of themes concerned in general with violence, oppression, and anxiety. These are the more pessimistic implications of life in this world as opposed to the glorified worker. He constantly calls attention to the arms race between the United States and the Soviet Union, sometimes writing about it on a wall or utilizing a Ping-Pong table as a symbol of this competition (see fig. 21). As long as the arms race continues, anxiety for the safety of humanity will be a primary concern for him.[24]

The chief totem of political violence for Borofsky is Nazism. References to Hitler, the Nazis, and ovens (fig. 22) are so prevalent that one need hardly ponder the meaning of a barbecue placed near an image of a suffering Cambodian woman (pl. 152). In *I dreamed that some Hitler-type person was not allowing everyone to roller skate in public places . . .* (pl. 41), the oppressed figure holds a symbol of the universe, showing that spirituality is endangered along with life itself. The male (and his penis) is a perpetrator of violence and aggression on all fronts in this world, and nuclear war is forever an undercurrent of it (pls. 57, 58).

Victims of various kinds of oppression are seen frequently in Borofsky's art, including imprisoned figures, birds, Cambodians, seals, and the artist himself covered with numbers that recall Nazi tattoos. Elsewhere, heads split apart or are under duress caused by tremendous weights pressing down on them, and men disintegrate in space (pls. 49, 50). Other weapons, too, swords, clubs, and guns (pls. 5, 23, 198), are shown as the tools of dangerous villains.

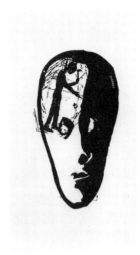

Fig. 20 *Split Head with Hammering Man at 2,669,857 and 2,688,101*, 1979–80
Lithograph, 30 x 22¼" (76.2 x 56.5 cm)
Edition of 18
Collection of the artist

Fig. 21 *Ping-Pong Table (Feel Free to Play)*, 1981
Painted Ping-Pong table, paddles, ball, net, with sign and lamp (not shown)
(Installation at Kunsthalle Basel, 1981)

22. Halbreich, in Cambridge, Hayden Gallery.
23. Simon, in Kunsthalle Basel.
24. Interview with Jonathan Borofsky conducted by Mark Rosenthal, May 1983.

Certain figures in Borofsky's art seem, indirectly, as if they are the ones who cause oppression on earth. Notwithstanding his personal identification with the Man with a Briefcase or its evoking the idea of work, when seen looming over a gallery this figure has a highly ominous presence (see pls. 191, 192, 201). He seems an emblem of conventional life, which by its very acquiescence to repressive events may condone and even encourage them. Perhaps also indicative of compliance is the race of Molecule Men (pls. 56, 222), which are devoid of body substance. Their fragile, punctured state seems to signify the weakened position of humanity on earth.

Escape is one way to counter suffering, and Borofsky shows various forms of it in his art. Skating (see pl. 41) and walking a tightrope (fig. 23), for example, may be understood as ways of remaining barely in touch with everyday traumas. Apart from its symbolizing his father on occasion, the sailboat offers "the possibility of escape, and a voyage and a path."[25] In *Berlin Dream* (pl. 61), the extinguished lives of the birds symbolize for Borofsky the lives of the East Germans, who were themselves unable to flee. Borofsky himself often achieves flight in the form of his Flying Figure (figs. 24, 62, 65 and pl. 209). He is a full-bodied superman—unlike the Molecule Man—attaining a seemingly effortless escape from daily occurrences.[26] In the air, he has a clearer, more enlightened perspective, which enhances his spiritual quest.

The most dramatic archetype of escape in Borofsky's art is the Runner. Its first appearance, perhaps, occurred during the time he was frequently drawing dreams from his subconscious. He simply stated in 1973, "I want to run away" (fig. 25), as if to escape from psychological anxiety. The Runner returned several years later. It "came when I was jogging daily while doing a show in Holland. . . . It's me I guess, but it's also humanity. He's looking back with a certain anxiety. It relates to my moving at a fast pace. Looking over my shoulder to see who's chasing me—person, my past, Hitler, whatever."[27]

Certainly, today, running is ubiquitous. The Runner is virtually "humanity" given the degree to which this activity now links many people. It may be said that as the *Shinto Priest* symbolizes the striving for spiritual well-being in Eastern cultures, the Runner symbolizes the desire for physical well-being in the Western world (figs. 26–28, 31 and pls. 110, 119, 126, 145). However, fear is in the eyes of Borofsky's Runner; as he says, he feels the need to escape his past and his culture. Furthermore, he sees each of his installations as "a performance, an athletic event."[28] Thus he fuels the content of the figure with his personal ambitions at an artistic "meet." In the Berlin "Zeitgeist" installation (pl. 200), the Runner was at once Borofsky himself in the company of the most notable artists in the world, and the Berliner caught in the web of an international conflict, frightened for his future.

Fig. 22 *Oven at 2,566,499,* 1979
Enamel on plywood, with glass, light bulb, and frying pan, 34½ x 30 x 24½" (87.6 x 76.2 x 62.2 cm)
Collection of the artist

25. Lippard, "Jonathan Borofsky at 2,096,974," p. 63.
26. A number of Borofsky's themes, such as the Runner, Tightrope Walker, and Flying Figure, are similar to those in the work of Paul Klee. Both artists are concerned with maintaining connectedness with, yet distance from, the everyday world.
27. Quoted in Simon, "An Interview with Jonathan Borofsky," p. 164.
28. Halbreich, in Cambridge, Hayden Gallery.
29. See Michael R. Klein, "Jon Borofsky's Doubt," *Arts Magazine*, vol. 54, no. 3 (November 1979), p. 123.

The most basic theme of all in Borofsky's art, underlying each of the above, and combinations of these, is sheer ambivalence and conflict. While this is Borofsky's own prototypical state of mind, it may also be seen as affecting much of humanity in general as we confront or ignore the state of society. Personal ego versus compassion for others, physical well-being versus spiritual well-being, good versus evil, exterior versus interior concern, life here versus the beyond—the themes run constantly through Borofsky's art. Is the Man with a Briefcase a perpetrator of evil or merely a victim? The Ping-Pong table denotes play but symbolizes conflict as well. Always this ambivalence prevails.

Borofsky's counting and numbers can also be understood as symbolic of ambivalence and ambivalent meaning. He initially used numbers to balance the lunacy he found in himself and society. Counting was meditation and peace. But numbers were used to brand Jews, which ultimately confounds any notion of them as benign. In the Nazis' hands, numbers became a weapon. Certainly mathematics is, itself, utterly human, and there, perhaps, is the inescapable conflict. To be human is to be flawed, finally, in Borofsky's world. To counter such baleful thoughts, Borofsky grasps at a spiritual mode of life, repeating the motto for it, sometimes in English and sometimes in Persian: "All is One."

When Borofsky's individual objects are scrutinized, one discovers many indications that he is "uncertain"[29] about the precious sanctity of art and its making. Indeed, his work rests precariously upon a quicksand of ambiguity. This is reflected in the great range of styles and mediums, from realism to abstraction to expressionism to photography, and in the groups of pieces he chooses to show together. He seems to revel in the juxtaposition of artistic attitudes created by such an arrangement, meanwhile holding the concept of "style" in low repute. Style for Borofsky is not a hard-won achievement conveying the essence of the artist and his personality, but simply a manner of working. Borofsky feels free, then, to apply a style without regard whatsoever for the underlying artistic philosophy, but only with an interest in the visual impact of the juxtaposition and the subjects expressed.

Borofsky is also unwilling to decide between masterly or rough execution. One discovers remarkable virtuosity and found objects existing side by side. On nearing completion of a magnificently painted head and shoulders of a figure, he stopped and scrawled above the canvas: "This painting is unfinished" (pl. 34). Fine execution, attention to detail, and concern with finish are often anathemas. Instead, the process of making art and the consciously overt manipulation of an image preoccupy the artist. He delights in stressing the mechanical means by which an image is created or the concrete essence of the object holding that image. Thus canvases are found on the floor; empty stretchers are exhibited; and paintings spin or are shown tilted, upside down, or on the ceiling (see figs. 29, 30 and pls. 123–25). Images are rendered on canvas sections that are physically

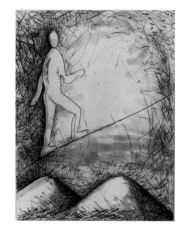

Fig. 23 *Man on a Tightrope at 2,354,128 and 2,531,117,* 1978 Oil and ink on canvas, 95 x 79" (241.3 x 200.6 cm) Museum Boymans–van Beuningen, Rotterdam

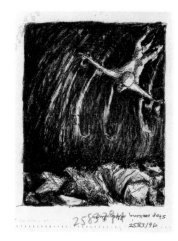

Fig. 24 *Stop Seeking Alternatives at 2,583,196; 2,583,394; and 2,583,960,* c. 1978 Ink on paper, with tape, 10 x 8" (25.4 x 20.3 cm) Kunstmuseum Basel

separated (pls. 47, 208, 217), or when painted directly on a wall may be interrupted by a doorway (pls. 104, 105). A mechanical "chattering" figure blocks our view of a work and makes comical the activity of looking at art (pl. 218). We walk through the door into a Borofsky exhibition, only to find ourselves facing the back of a canvas (see pl. 220). On the one hand, Borofsky shows a remarkable ability to manipulate the art object and the image; on the other hand, he exhibits considerable discomfort with images he has rendered, often undercutting the expressive force and archetype he himself has created.

Borofsky's uncertainty is consistently expressed by the placement of a number on each of his works. Instead of leaving a highly personal image unadorned and confrontational, he places it in an abstract, conceptual context through the inclusion of a number. It is as if he needs this rational support to balance the unabashed instinctuality of the image. Borofsky's uncertainty with regard to the value of an image may be joined with the context of much twentieth-century art and its frequent avoidance of accessible subject matter.

Borofsky belongs to the period that not only exhibits a discontent with the art object, but also at times shows disgust with the investment potential of art. *Acrylic on Unprimed Canvas with Bubble Wrap and Duct Tape* (pl. 31) is an especially graphic example in this regard. Leaning against a wall in bubble wrap, the painting—and its evocative power—has been largely emasculated. It has, instead, become an object of trade. Money spent on art was ironically juxtaposed with money spent on armaments in Borofsky's 1979 installation at the Paula Cooper Gallery, New York (pl. 123). The artist seemed to offer a selection of differently shaped canvases for amusement and purchase, this in conjunction with a declaration of how the Soviet Union and America spend much of their funds. Money invested on both activities was linked and these expenditures held up for ridicule. And yet the exhibition occurred in a gallery wherein Borofsky's own art was offered for sale. Thus in this exhibition, he suggests his personal situation and his discomfort regarding his options. Borofsky's tendency is to make such uncertainty the subject, in large measure, of his art, continuously jibing but never canceling the component extremes of his thinking. A dialectical mode of operation, Borofsky's uncertainty questions everything in its path and leaves a clear outlook absent.

Borofsky's first solo exhibition, at the Paula Cooper Gallery in 1975 (pls. 64–66), announced the overriding mode of his career, within which everything else is integrated. He created an installation that was dense with dream images, childhood memories, symbolic objects, and personal statements, as if to allow much of the contents of his mind to be experienced by the viewer. Although his work was shown in the conventional context of an art gallery, Borofsky would not make this flow of thoughts esthetically palatable. Instead, they were rendered

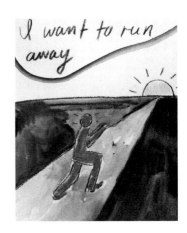

Fig. 25 *I Want to Run Away at 2,152,386,* 1973
Oil on canvas board, 20 x 16"
(50.8 x 40.6 cm)
Collection of the artist

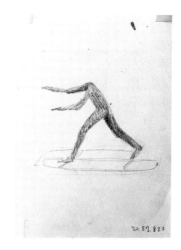

Fig. 26 *Untitled at 2,287,823,* 1975
Pencil on paper, with tape,
12 x 9" (30.5 x 22.9 cm)
Collection of the artist

with a directness founded primarily on the need to be honest, and with a variety of styles, materials, and techniques indicative of a compulsion toward free expression. Borofsky had, in so doing, realized a major and fundamental tenet of Surrealism: to make his subconscious life the material of art without allowing esthetic concerns to modify the initial stimuli. The Surrealists themselves had prescribed this path, but always in the end they veered off in deference to the art object. By contrast, Borofsky's overheated installation mirrored the energetic flux of the mind. A lifelike, somewhat chaotic atmosphere was more important than single artworks. As he would later say, he treated the gallery space as "my studio"[30] and anything at all might be included in it (pls. 70–78).

The atmosphere of the 1975 exhibition was repeated in more or less the same fashion in other installations until 1979, with one exception. Borofsky had discovered that certain of his images, now often rendered as wall drawings, had the force of archetypes, and hence he gave them greater prominence. In the 1976 installations at the Paula Cooper Gallery (pls. 82–84) and the Wadsworth Atheneum (pls. 79–81), there was more of a spare, stark impact and comparatively few images. With riveting power, these images seemed to represent extremely significant, moving, and notable events, the meaningfulness of which had the potential to extend beyond the artist's psyche and haunt many viewers.

About 1979, Borofsky began to synthesize the approaches he had taken to installation. In a series that has continued to the present, he has subtly orchestrated the content within an apparently chaotic, emotionally charged, personal atmosphere. Most often, there is a key thematic juxtaposition that compares human potential with reality or destruction. Borofsky is preoccupied with this dichotomy, holding the view that life is founded on a dynamic opposition verging on contradiction; he wants his art to reflect that situation by constantly showing "little fights going on."[31] The 1979 Portland installation included a crucial contrast between a happy-go-lucky, 1950s-style figure in an automobile and an emotionally devastated Vietnamese boat person. Borofsky renders many variations of this juxtaposition; for example, a Flying Figure, usually evocative of freedom and escape, together with the quotation of the Michelangelo Creation was opposed in Basel by references to the arms race, running/rioting figures in silhouette, and Borofsky's ubiquitous Hammering Man. In several pages drawn for *Artforum* magazine in 1981, he contrasted a delicate, highly sensitized head with long ears to a seemingly oblivious Man with a Briefcase. Also opposed on these pages were the Michelangelesque hands and a figure lying stabbed, as well as the words *God* and *gold.* Within extremely dense installations, many such meaningful parallels and rhythms exist.

Certain of Borofsky's archetypes are used repeatedly in his installations, as if they were simply props manipulated by the artist. By distributing his favorite

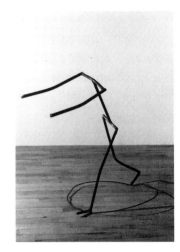

Fig. 27 *Headless Running Man at 2,287,823,* 1973–74
Welded steel, 26 x 18⅝ x 38"
(66 x 47.3 x 96.5 cm)
Collection of the artist

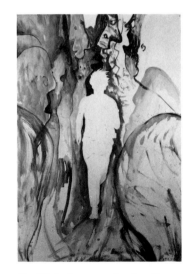

Fig. 28 *As I was awakening, it seemed I was being chased by the spirits at 2,783,194,* 1982
Acrylic on canvas, 108 x 72"
(274.3 x 182.9 cm)
Collection of the artist

30. Halbreich, in Cambridge, Hayden Gallery.
31. Ibid.

archetypes throughout an installation, he can provoke meaningful comparisons and new intuitions and interpretations about those archetypes. The Runner, for example, is usually an anxiety-ridden escapist, but when contrasted with more desperate figures, as it was in Portland, it becomes a symbol of self-absorbed, bourgeois culture (pls. 136–41). Its location can further modify its meaning; thus the Runner becomes Bigfoot in Portland but an escapee from East Germany wher placed on the Berlin Wall (pl. 200).

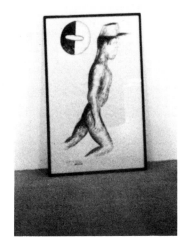

Fig. 29 Installation at Galerie Rudolf Zwirner, Cologne, 1981

Borofsky conceives of these installations in a manner similar to painting, particularly Abstract-Expressionist canvases. He was inspired at an early age by the allover qualities of Jackson Pollock's art,[32] and sought to extend that esthetic. He said: "My studio is wherever I am. For me, to be in a space for three weeks and deal with that space is like making a painting. My work is concerned with the three-dimensional interior structure, and I try to make people aware of the space they're in, in a holistic way."[33] He explains that he might start an installation with a large image and then begin reacting to it formally in other areas in the space.[34] The process is a visual one, of composing, balancing, heightening, and activating various areas. By the use of elements such as string and wire extending from ceiling to floor, wall drawings that continue around corners or extend across doorways, and flyers littering the floor,[35] Borofsky activates all parts of a room, making his installations totally encompassing experiences. Even aural and olfactory sensations may be offered to further envelop the viewer.

Although Borofsky's installations are most often site-specific only in the sense of addressing the physical character or plan of a room, on occasion he integrates his feelings about the locale in which he finds himself. The "Zeitgeist" installation in Berlin is replete with associations pertaining specifically to the city and its history (pls. 200–206). He created a room inhabited by a painted bird and filled with Rubies to provide a spiritual haven within this city of Nazi and politically turbulent associations. (Another painted cardboard Ruby was placed on a nearby hillside, visible from the room, on the former site of a Gestapo torture chamber, but that Ruby disappeared shortly after the opening of the exhibition.) From the window of the room, a Flying Figure appeared to jump toward East Berlin. He should be understood, according to Borofsky, as a human emanation of the bird, leaving its nest to carry the beauty found there into the Communist sector of the city; this man-bird was an attempt to heal the political rift of Germany. To demonstrate the ramifications of that rift, Borofsky placed perhaps his most frightened Runner directly on the Berlin Wall.[36]

Another example of site specificity occurred in Borofsky's installation at the Institute of Contemporary Arts in London (pls. 184–87). There, by means of a microphone placed at a window and speakers within the installation, he deliberately brought to his work the sounds of the exterior environment. A motorized, crashing, trash-can lid drew attention to a means of protest employed in Northern Ireland. Borofsky cannot help reacting in this way if he feels the situation

32. Ibid.
33. Quoted in Constance W. Glenn, "Artist's Dialogue: A Conversation with Jonathan Borofsky," *Architectural Digest* (June 1983), p. 44.
34. Halbreich, in Cambridge, Hayden Gallery.
35. Ibid.
36. Jonathan Borofsky provided this explanation of the "Zeitgeist" installation during an interview conducted by Mark Rosenthal, January 1984.

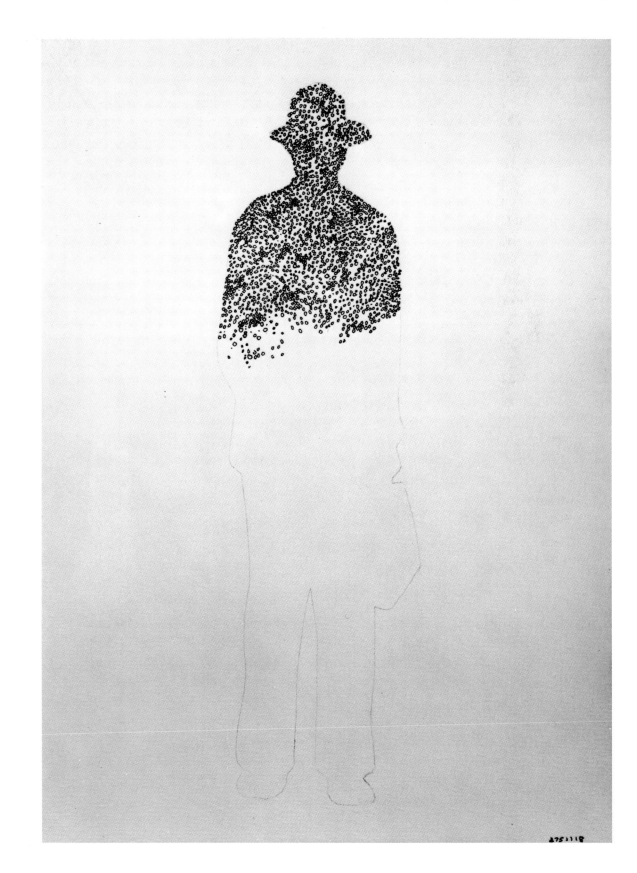

requires such an empathetic response. He explained his use of the *Shinto Priest* in the men's shelter in New York (pl. 87) by saying, "People are sick and hurting in this place, so a spiritual image seemed appropriate."[37]

Borofsky's urge toward installations is so great that he has begun to create smaller versions when the opportunity arises. At the 1983 Whitney Museum "Biennial Exhibition" (pl. 207) he treated two works previously shown individually as props forming a single, unified installation, and in the process suggested new meaning for these works. This latest development in Borofsky's installations shows his continuing desire to undercut the impregnable indivisibleness of artworks and, at the same time, envelop a viewer more completely than is possible with an individual object. Installation is his means of attaining these ends.

Following the example of the 1983 Whitney Museum installation, Borofsky, in his exhibition at the Paula Cooper Gallery in the fall of the same year (see figs. 32, 33), organized objects made in his studio, rather than wall drawings done on site. While sacrificing some degree of spontaneity, Borofsky did in fact set out to make a group of objects that would relate to each other. Indeed, the exhibition was a virtuoso demonstration of his installation mode, representing a new level of complexity for him. The installation offered multiple centers of interest, propelling the visitor from one to the next by the incredible density of the objects and images, by the often unfinished or processlike nature of the pieces, by the pockets of sound emanating from many of the works, which created islands within the whole, and by the conflicting styles and characters of the works jostling for attention. Dizzying but also unifying were the rhythms created among the many images.

The Chattering Figures, like the five Hammering Men before them, both broke up and unified the entire space. The rhythm of observing initiated by the Chatterers was reinforced by the military men in *The Maidenform Woman. You Never Know Where She'll Turn Up* (pl. 60) and the watchful males in *Chattering Man with Photograph* and *Untitled (Man on the Beach)*. An exception was the white Chatterer with a light bulb overhead; his enlightenment eliminated the need to observe the visible world. The moving foot of the *Dancing Clown* (pl. 63) was echoed in the nearby *Duck Dream with Chattering Man,* in which a foot causes the death of some birds and in *Footprint with Two Chattering Men.* The death of the birds was repeated in *Berlin Dream* and paralleled in the photograph of a fish being cleaned, shown in the back room of the gallery. The wrestlers, whose hands are locked in combat, can be compared to the peaceful, ceremonial handshake depicted in *Green Tilted El Salvador Painting with Chattering Man.* The pursed lips of the clown contrasted also to the continuously chattering mouths of the figures throughout the installation. Juxtaposed with the chattering and music was a pattern of visual voids, including the unpainted sections of the *Berlin Dream, Sing* (pl. 55), *Split Wire Dream with Chattering Man,* and the

Fig. 30 *Upside-Down Flowers #1,* 1976
Oil on canvas, 48 x 36" (122 x 91.4 cm)
Collection of the Reiner Children, Bethesda

Fig. 31 *Running Man with Head of an Animal at 2,415,921,* 1977
Ink on paper, 57 x 35¼" (144.8 x 89.5 cm)
Museum Boymans–van Beuningen, Rotterdam

Chattering Men with Two Stretcher Frames. The *Green Space Painting with Chattering Man* (pl. 62) and the fluorescent light piece reinforced the emphasis on pure, untainted space within the installation; indeed the position of the fluorescent lights gave a celestial connotation to these voids.

Paralleling the visual cacophony was the aural component of this installation. Melodic music emanated from *Sing* and the *Dancing Clown,* groans and a recitation of facts about the universe came from the *Universal Groan Painting,* aggressive conversation was "mouthed" by the two wrestlers, and "chatter" was endlessly repeated by the standing figures. One experienced these sounds separately or in overlapping patterns, much as one perceived the images. Indeed, the experiences of sound and sight are simultaneous in this, Borofsky's most ambitious aural installation to date.

The overriding theme in the installation was the contrast between interior and exterior states and manifestations of that dichotomy. For example, the Maidenform painting combines uniformed, faceless men and a strongly characterized, half-undressed woman. The men exhibit an exterior, superficial, clothed existence; the woman emphasizes interior values. The birds live and are safe within a refrigerator, but die when they move outside that haven. The street worker is beneath the surface of the city, and the split wires emerge from underground. Elsewhere, Borofsky is within the subconscious of his mind in *Painting with Hand Shadow.* Inner exploration is also symbolized by *Sing* and *Green Space Painting;* opposing are the exterior, political concerns shown in *Male Aggression Now Playing Everywhere* (see pls. 57, 58) and *Green Tilted El Salvador Painting with Chattering Man.*

Most literally demonstrative of the exterior-interior opposition was the very path of the visitor to the Paula Cooper Gallery. Stepping from the New York street outside, into the gallery, was a move from an exterior world into a kind of antechamber of the interior realm. One began to have a strong sense of what was to come when confronted immediately with the back of a canvas stretcher. The effect recalls the Surrealist device of the mirror as an entryway to a world of transformation, dream, and metamorphosis. Inside the gallery, one entered a Fellini-like field of associations. One was engulfed by the sounds of chatter, like a chorus within one's subconscious, which competed for attention with the exterior visual stimuli that the eye was receiving.

Borofsky organized the many parts of the installation in relation to a major axis marked by the clown. This Picasso-like symbol of the artist is, as should be expected, part male and part female. Singing the anthem of a driven individual, "I Did It My Way," this ringmaster orchestrated the surrounding events. But the figure is maudlin and seems to live a life in the everyday world. On a diagonal from the clown following the axis of the gallery itself from the front door toward the deepest interior portion of the building was *Sing.* In this painting is depicted

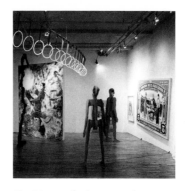
Fig. 32 Installation at Paula Cooper Gallery, New York, 1983

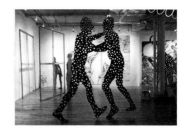
Fig. 33 Installation at Paula Cooper Gallery, New York, 1983

37. Bourdon, "Discerning the Shaman from the Showman."

the contrasting inner or spiritual world, for a robed Borofsky, apparently holding a biblical tablet, has received instruction from on high. As if in accordance with these instructions, he has attached to the painting a tape recorder, which plays songs sung by him. Between the clown and *Sing,* on axis, were the wrestling figures, in this installation symbolizing the two sides of Borofsky's warring soul. The Chatterer with the halo, beneath the fluorescent light pattern signifying the universe and enlightenment, is perhaps the artist himself in the guise of an apparition who has stepped from the body of the clown, previous to his apotheosis in *Sing.* With the slightest presence, the vase of flowers, a prop in *Universal Groan Painting, Sailboat Painting,*[38] and the tree in *Chattering Man with Double Crescent Moon Painting* created a second, crossing axis of family and nature, thus a backdrop to Borofsky's spiritual quest.

For Borofsky, an installation is most of all involved with "space." But that word must be understood in very broad terms. It concerns space of the room and of the geographical locale, the space of the mind, and, finally, space in the cosmos. Borofsky attempts to account for it all in an installation, and there give a statement of his concept of the universe.

The late 1960s–early 1970s period, from which Borofsky emerged, was dominated by Minimalism and Conceptualism. In that period, the artwork per se was often diminished in some way, while its subject matter became the object itself, the politics of art, or the very notion of Art. It was asserted that painting was dead, this because the activity tended toward representation, a completely retrograde ambition at the time. Without ever rejecting these ideas altogether, Borofsky was, nonetheless, willing to embrace understandable subject matter and content. At the time of his 1975 exhibition, this was a somewhat isolated position in New York, although there was not an absence of representational art at the time.[39] But Borofsky's frank, unadorned works approximated a Minimal esthetic and thereby seemed to coincide with advanced ideas about art. That his work was shown in a gallery known for its adventurous spirit signified a breakthrough. His art was on one hand a hybrid between avant-garde ideology and traditional values, and on the other hand a look into the future, wherein was found an art variously known as Primary Image, New Image, and Neo-Expressionism.

In the subsequent rush toward expression, there has been an emphasis on the subject depicted, but often as a motif used with little thought for its content. Borofsky, by contrast, is vitally involved with meaning and the implications of the depicted theme. His position is that of a sort of poet-politician, as in the 1960s,[40] commenting darkly, ironically, or mysteriously about events. And while Neo-Expressionism has usually been seen as a repudiation of the preceding conceptualist mode, Borofsky's embrace of subject matter included, moreover synthesized, the earlier developments.[41] "I feel like an idea person, an idea painter.

38. The sailboat was placed in the back room of the installation a few days after the exhibition opened.
39. For example, Neil Jenney and Susan Rothenberg.
40. Rosenthal, "The Ascendance of Subject Matter and a 1960s Sensibility."
41. Mark Rosenthal, "From Primary Structures to Primary Imagery," *Arts Magazine,* vol. 53, no. 2 (October 1978), p. 107.

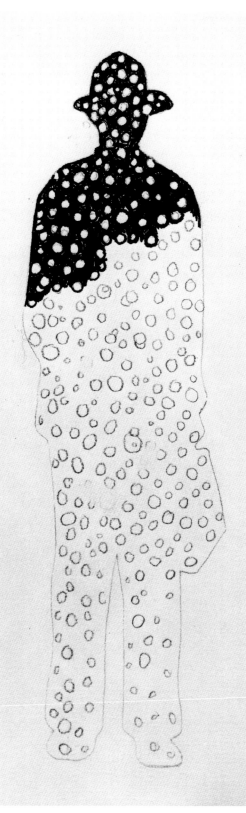

2748404

. . . it [the artwork] always has to be the idea *with* the painting."[42] For him, the "idea" should be understood as either the meaning of the subject shown, or the manner by which art is created. That is, Borofsky continued to emphasize his process, the literal character of the object, and the physical space in which he was working as well as its politics.

The experience of an installation by Borofsky is virtually unique in contemporary visual art. He expands our conception of what we might expect to find in an art context. Certainly wonderment and a sense of intense vitality are intrinsic to the experience, for he commands a deep response by the viewer. Borofsky's achievement has also to do, in part, with the returning of art to a position in which it expresses moral and emotional values, even as it sustains conventional analysis vis-à-vis contemporaneous art developments. Finally, in the kaleidoscopic installation he creates, Borofsky reaches toward that nineteenth-century, romantic conception: the *Gesamtkunstwerk*, the total artwork. He combines media, senses, and styles so as to envelop and affect his audience completely—physically, emotionally, and intellectually. As a result the viewer's life is heightened.

42. Quoted in Dieter Koepplin, "Viele Zeichnungen Borofskys und eine durchgehende Linie," n. 58, in Kunstmuseum Basel, *Jonathan Borofsky: Zeichnungen 1960–1983* [1983].

Works

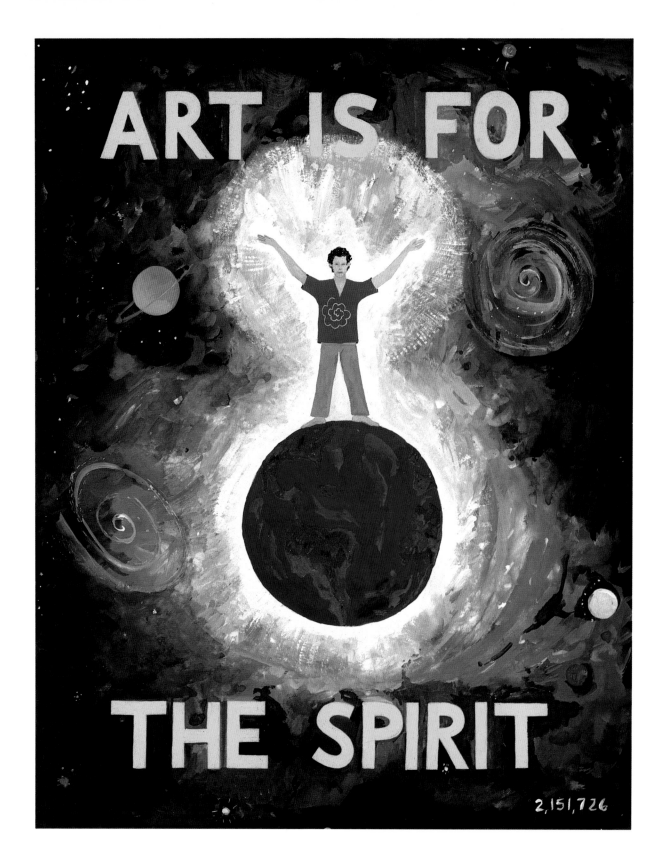

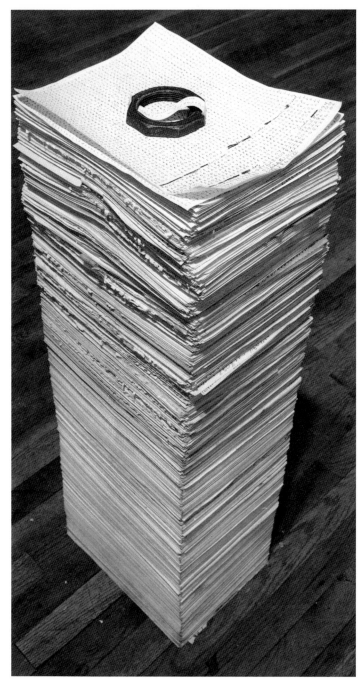

1. *Art Is for the Spirit at 2,151,726*, 1973
Tempera on illustration board,
19½ x 15⅜" (49.5 x 39.1 cm)
Private collection

2. *Counting from 1 to Infinity*, from 1969
Stacked sheets of paper, 32 x 8½ x 11" (81.3 x 21.6 x 27.9 cm)
Private collection

This piece is a stack of 8½-by-11-inch sheets of paper, which is approximately 4 feet high. It is called Counting from 1 to Infinity, *and pages are added to the top as I continue to count. There is a connection to Brancusi's* Endless Column *in the continuous stacking of pages. I began playing with numbers in 1968, but 1969 is the beginning date of this particular piece. The numbers were written on graph paper with a digit in each square for the first few thousand pages. Afterward I began to break off into other kinds of paper, because sometimes I had a notebook or some other kind of paper with me. The counting became less rigid even though it remained a linear activity. I have used ball-point pens, crayons, or pencils, but for the first couple of years I stuck to graph paper and BIC pens. I counted either on one side of a piece of paper or on both sides. I also wanted to take my counting in both directions, so I started writing −1, −2, −3, and so on. I only got up to about −10,000 and stopped, and then went back to the original forward counting.*

The counting piece was the culmination of a period of what was labeled conceptual work—just pen, pencil, and paper, and using the mind, more or less, as a device to exercise daily. It was the clearest, cleanest, most direct exercise that I could do that still had a mind-to-hand-to-pencil-to-paper event occurring. It was very linear and very conceptual. There was no intuition involved and everything was planned out ahead of time. All I had to do was get up the next day, pick up my pencil, see what number I was on, and continue counting from there. In 1971, after counting for a couple of years (and doing nothing else), I had the occasional need to scribble on the same sheet of paper as the counting. It was like taking a break. The counting had become a break from my thought process, and the scribbling now became a break from the counting. I would start moving the pencil around and making forms. Then I started making stick figures, and then stick figures doing different things. There were heads, and heads tied to trees.

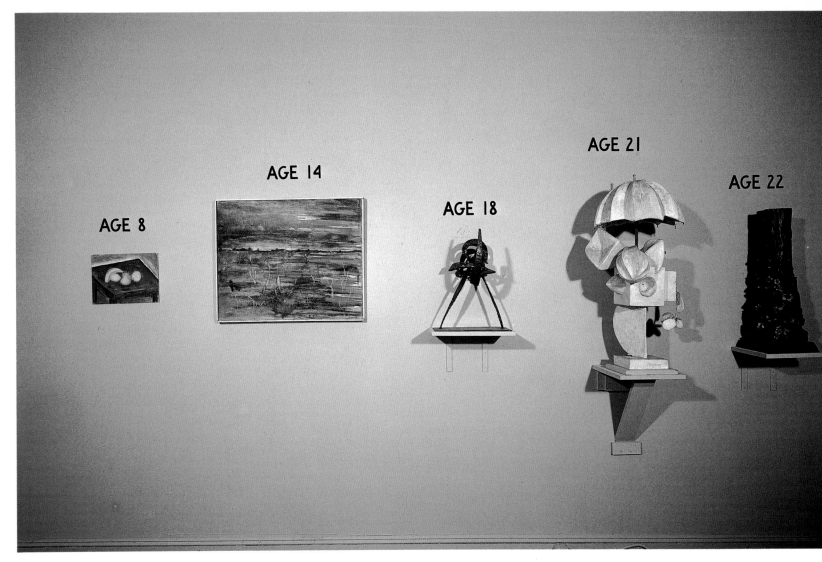

AGE 8

AGE 14

AGE 18

AGE 21

AGE 22

3. *Age Piece*, from 1972
Mixed media, 12 objects, length
approximately 40′ (12.2 m)
Private collection

At the age of thirty, I was thinking over my evolution as an artist, and realized how many specific, concentrated groups of work there were that represented different periods of my art life. I thought that it would be important to make a piece to show this evolution, not unlike a retrospective. It also seemed important to see this evolution as continuous: one life with changes in it. As a youngster I had always been impressed by Picasso's different periods—the Blue period, the Rose period, the Saltimbanque period, the Cubist period—and that an artist could do different things, and could work in many styles.

I wanted to make a piece that would show my changes, so I made a sketch in which I slowly isolated the different periods, deciding what the key work that still existed from each period was. I wanted to fit these into a sequence that would be placed along a wall with the ages at which they were com-pleted written over them. The sketch itself is included in the work at Age 30, but it includes blanks for Ages 34 and 40, which balance the yearly increments at the beginning of the piece, and create a perfect symmetry, with Age 24 in the center. I think for Age 34 I will add a wall drawing, maybe a dream that is highly representative of that period. I'm forty now, and I'm still working, so I will have to wait to see what work would be right for this period.

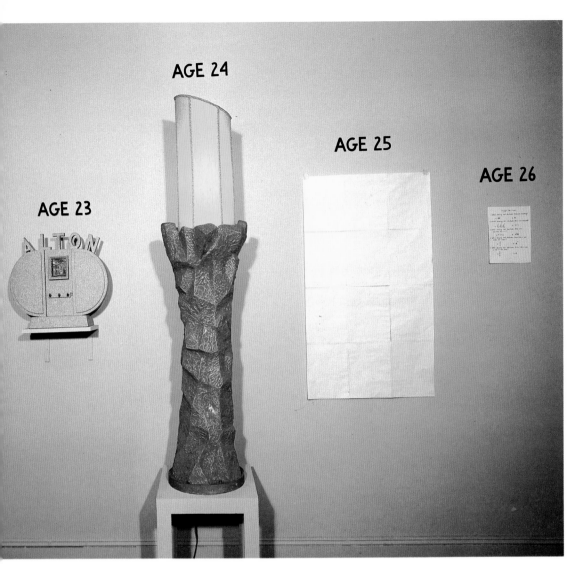

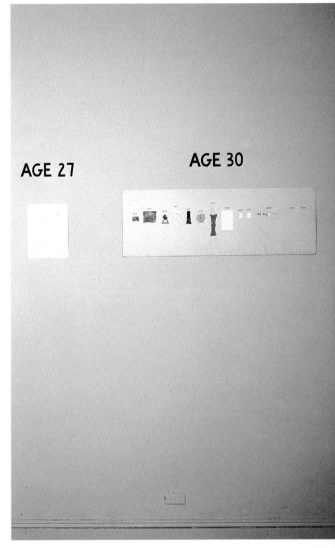

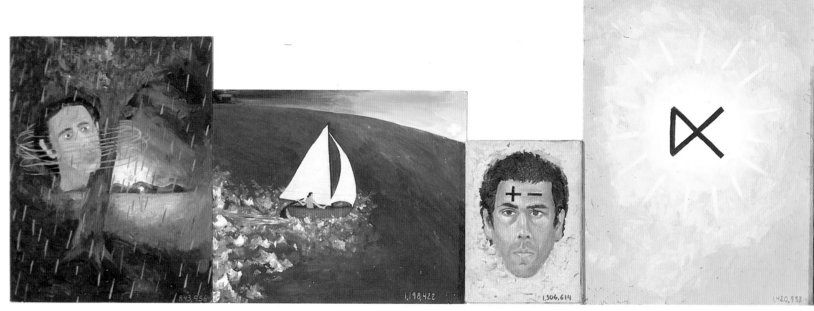

4. *Continuous Painting,* 1972–73
Oil on canvas and canvas board,
13 panels, 24 x 200¾"
(61 x 509.9 cm) overall
Kunstmuseum Basel

I was going back over some of the counting pages one day, looking at some of the scribbled images on the side, and thought it would be nice to paint one of them—the one of a head tied to a tree. I bought a canvas board and a set of paints like I used when I was a child. I began to paint again, having blocked it out of my system since I had come to New York in 1966. It was like coming back to something. I began with simple canvas board—nothing pretentious, something that is easy to stack away or make

mistakes with. It took me a day to paint the first of the images that I had drawn in the counting.

I leaned the painting against the wall in my apartment and remember going down and adding a number to it in the corner—it was 843,956. That was the number I was on in the counting. At that moment something special had happened. I had taken the counting and linked it to the image. By putting the number in the corner where I would normally sign my

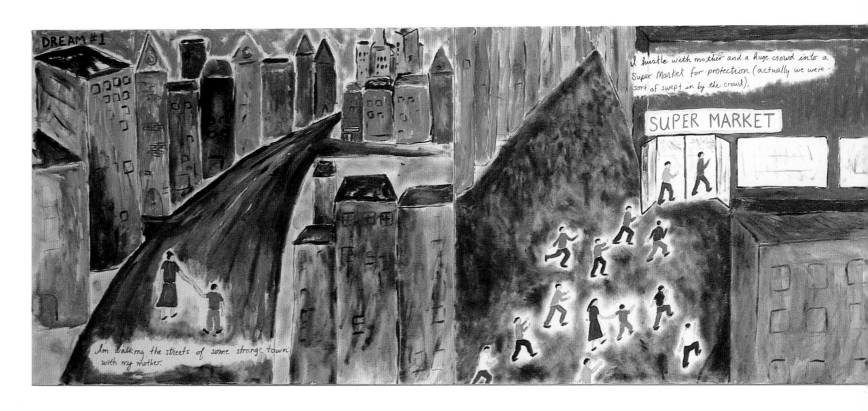

Within the image: DREAM #1

I'm walking the streets of some strange town with my mother.

I hustle with mother and a huge crowd into a Super Market for protection (actually we were sort of swept in by the crowd).

SUPER MARKET

5. *Dream #1 (I'm walking the streets of some strange town with my mother. I hustle with mother and a huge crowd into a supermarket for protection . . .) at 1,944,821,* 1972–73
Oil on canvas, 6 panels, each 48 x 60" (121.9 x 152.4 cm)
Collection of the artist

1905.299

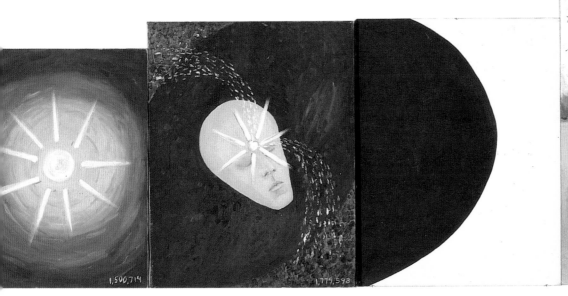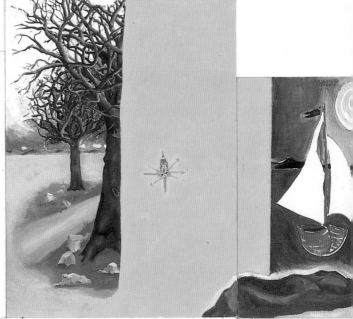

name, it implied that the next time I made a painting, I could take the number I was then on and put it in the same corner. It would be a different number, but it would still be like a signature and would be recognizably mine.

A few months later I had the urge to make another painting—a sailboat with me in it, heading toward a positive sign on the horizon and away from a negative sign on the horizon. I numbered it. Then I did my self-portrait very realistically with a positive and a negative sign on the forehead and numbered that in the corner. At this point, I had the paintings leaned up against one another (side by side) on the floor and liked the way one led to the next. So I decided to continue. Like the counting I now had a continuous shift in images, styles, as well as a record of my own changing psychological states of mind.

But I know that two of the kids with guns are already in there (I saw them go in earlier). So I tell mother that we must get out of here through the back entrance.

Suddenly, there are gun noises and rushes of different people. Little 14 year old "minority" (Black and Puerto Rican) gangsters are shooting at each other but also anyone else they feel like.

In the back alley we start running—run into several gangsters—they menace us with their guns. I plead for mercy as we slowly pull back from them. A thought crosses my mind — if they are going to shoot one of us, who would I rather it be? — my mother! I saw one of the gangsters faces clearly — he was the one I was pleading with and was about 12 years old, very clean whiteish baby face, possibly of some Spanish extraction — (maybe he's me).

We get back into the Super Market for safety—almost everyone is gone. Buddy Rifkin is having a neck wound (bleeding) attended to (note: Buddy Rifkin was such a "good" boy—maybe even better than me — especially in High School — he won the election.) I realize that the bullets might be only B.B. guns. Very little more before I woke up.

1,944,821

41

WHAT IS DRAGGING ME?

I am unhappy because I am not perfect. I want to be better than everyone else. I want to be unique and I do not know that I am unique! I want to be unique by being "better" — this is a false premise. These feeling keeps me in a state of tension which I seem to enjoy. As long as I enjoy this tension I cannot be creative. Use the tension instead of enjoying it. Go through the pain rather than sitting on it for truly creative productivity.

I have to make a greater effort to take better care of myself beginning with my body and my eating habits.

* I don't like where I'm at now (that I'm not perfect) and instead I want to be there (god state) now. I don't want to work for this because I know deep down inside that I never can be god-like, so, though I don't give up, I never work really for what I can do — namely MY BEST. And this way I get into the comparing state which is Death because as soon as I start to compare myself I loose my uniqueness I can only do mine and what is in me and the more I know myself, this self will then come out in my work.

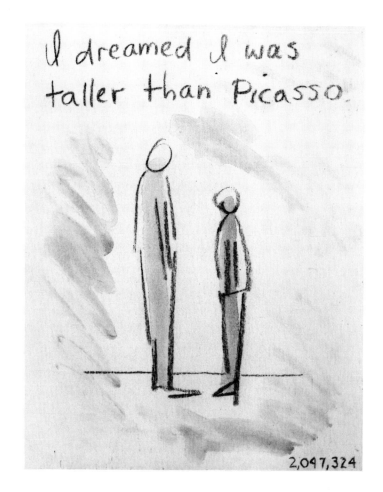

I dreamed I was taller than Picasso.

2,047,324

6. *What Is Dragging Me?* at
2,022,173, 1973
Ink on canvas board, 24 x 18"
(61 x 45.7 cm)
Collection of the artist

7. *I dreamed I was taller than
Picasso* at *2,047,324*, 1973
Oil on canvas board, 19⅞ x 15⅞"
(50.5 x 40.3 cm)
Collection of Martin Sklar,
New York

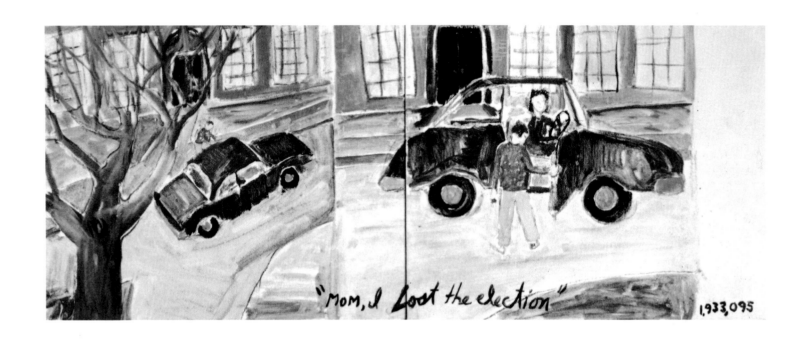

8. *"Mom, I Lost the Election"* at
1,933,095, 1972
Oil on canvas board, 2 panels,
each 16 x 20" (40.6 x 50.8 cm)
Private collection

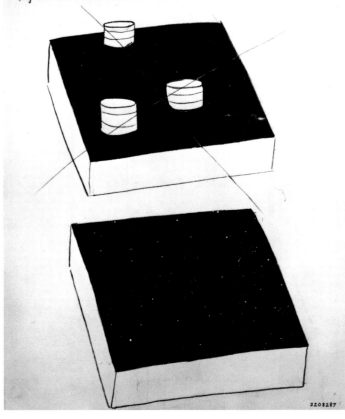

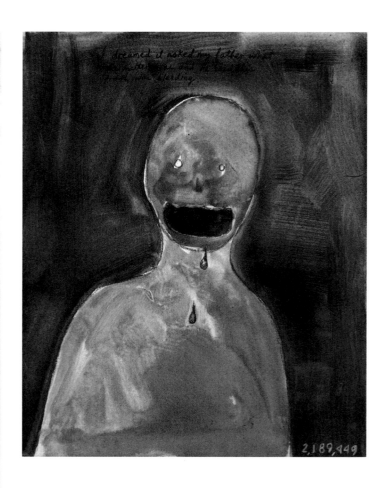

9. *I dreamed my model for the
universe was much better . . . at
2,208,287,* 1973
Charcoal and acrylic on canvas,
66 x 50″ (167.6 x 127 cm)
Private collection

10. *I dreamed I asked my father
what the matter was and he said
his tooth was bleeding at
2,189,449,* 1974
Oil on canvas, 24 x 20″
(61 x 50.8 cm)
Collection of the artist

11. *2,264,477*, 1974
Acrylic on paper, 12⅝ x 25⅞"
(32.1 x 65.7 cm)
Private collection

12. *Blue Boy at 2,238,123,* c. 1974
Ink on paper, 60½ x 57"
(153.7 x 144.8 cm)
Collection of the artist

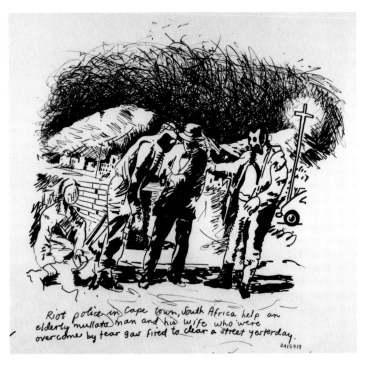

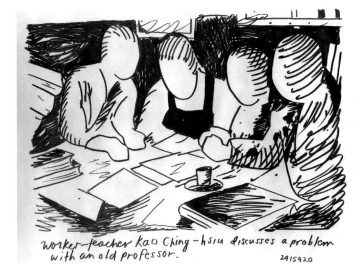

13. *Riot Police in Capetown,*
South Africa . . . at 2,415.919,
1977
Ink on vellum, 44¼ x 45¾"
(112.3 x 116.2 cm)
Collection of the artist

14. *Untitled at 2,487,107,* 1978
Ink on newsprint, 8 x 7¼"
(20.3 x 18.4 cm)
Collection of the artist

15. *Parapsychologist Dream at*
2,515,358 and 2,566,493, 1979
Ink and latex on wall, with string
and plastic disc, 72 x 60"
(182.9 x 152.4 cm) (approximate)
(Paula Cooper Gallery, New York,
1979)

16. *Worker-teacher Kao Ching-*
hsiu discusses a problem with an
old professor at 2,415,920, 1977
Ink on paper, 40½ x 54½"
(102.9 x 138.4 cm)
Museum Boymans—van
Beuningen, Rotterdam

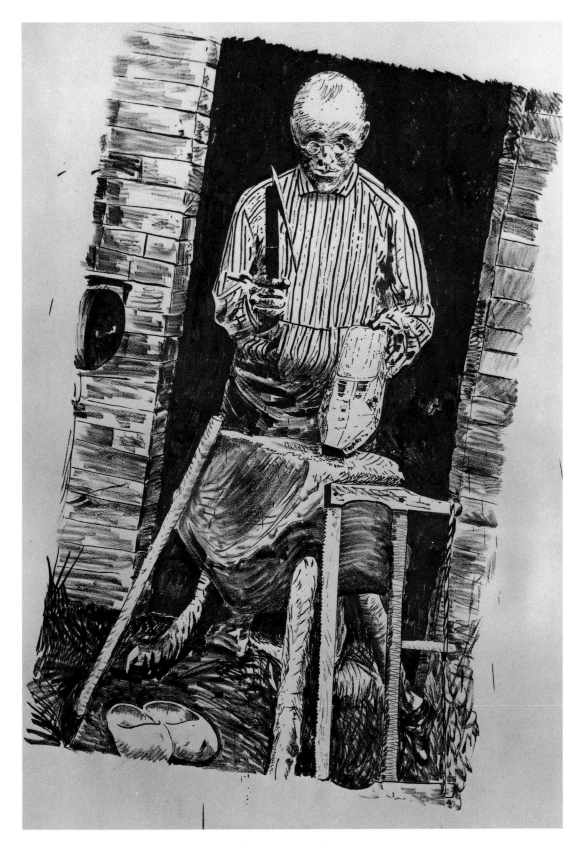

17. *Untitled (Shoemaker),* 1976
Ink on wall, 150 x 66"
(381 x 167.6 cm) (approximate)
(Paula Cooper Gallery, New York,
1976)

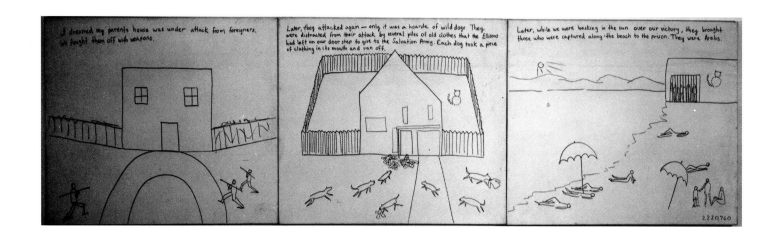

YOU ARE ALONE

SLOW DOWN

THERE IS NO ONE TO PLEASE BUT YOUR

18. *You Are Alone,* 1975–76
Acrylic on canvas, 54¼ x 144¼"
(137.8 x 366.4 cm)
Collection of the artist

19. *I dreamed my parents' house
was under attack from foreigners
. . . at 2,220,760,* 1973–74
Ink on canvas, 3 panels, each
44 x 52" (111.8 x 132.1 cm)
Collection of the artist

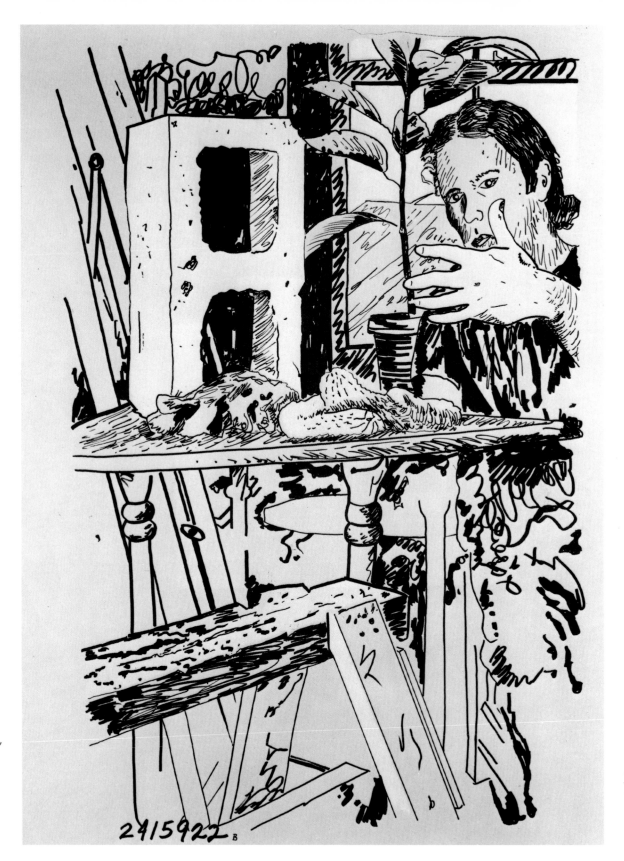

20. *Still Life at 2,415,922B,* 1977
Ink and acrylic on paper, 58⅞ x 41½"
(149.5 x 105.4 cm)
Collection of Jules and Barbara
Farber, American Graffiti Gallery,
Amsterdam

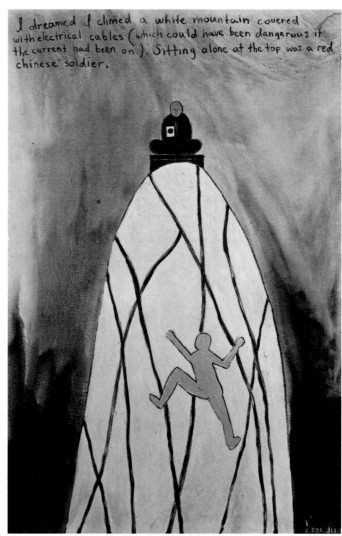

I dreamed I climbed a white mountain covered with electrical cables (which could have been dangerous if the current had been on). Sitting alone at the top was a red chinese soldier.

21. *I dreamed I climbed a white mountain . . . at 2,211,406,* 1974
Wax, steel, chicken wire, and plywood, 32⅞ x 13 x 7⅝″
(83.5 x 33 x 19.4 cm)
Collection of James F. Duffy, Jr., Detroit

22. *I dreamed I climbed a white mountain . . . at 2,206,311,* 1975
Oil on canvas, 54 x 36″
(137.2 x 91.4 cm)
Museum Boymans–van Beuningen, Rotterdam

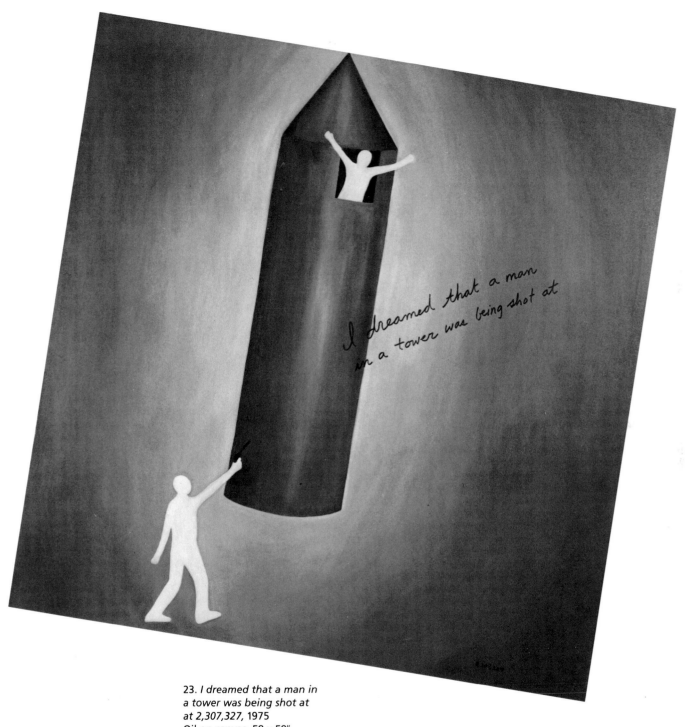

I dreamed that a man in a tower was being shot at

23. *I dreamed that a man in a tower was being shot at at 2,307,327,* 1975
Oil on canvas, 58 x 58"
(147.3 x 147.3 cm)
Collection of the artist

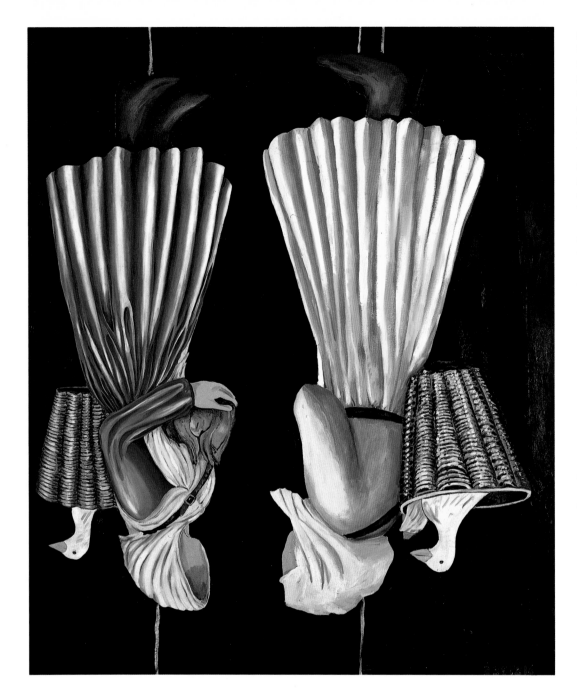

Doing upside-down paintings was a way of throwing more irrationality into my image making. I was continuing the counting and I was also making images, but the images were not irrational enough for me. I started to draw and then paint images upside down. I painted a little sailboat, the women with geese, as well as upside-down vases with flowers.

The geese painting is adapted from a photograph of some Rumanian women. I excluded most of the details because the forms themselves were the most interesting to me—the baskets, the dresses, the cloths around their heads, and the geese. The original photograph was one of those images that I had been carrying around with me. I made a small drawing from the photograph, a tracing that I did on a light box. By tracing the image, a certain amount of editing took place. I then projected that drawing upside down and painted it upside down. I put the white lines in the painting to tie the figures into the space.

24. *Upside-Down Women with Geese at 2,397,216*, 1976
Oil on canvas, 52 x 44"
(132.1 x 111.8 cm)
Private collection

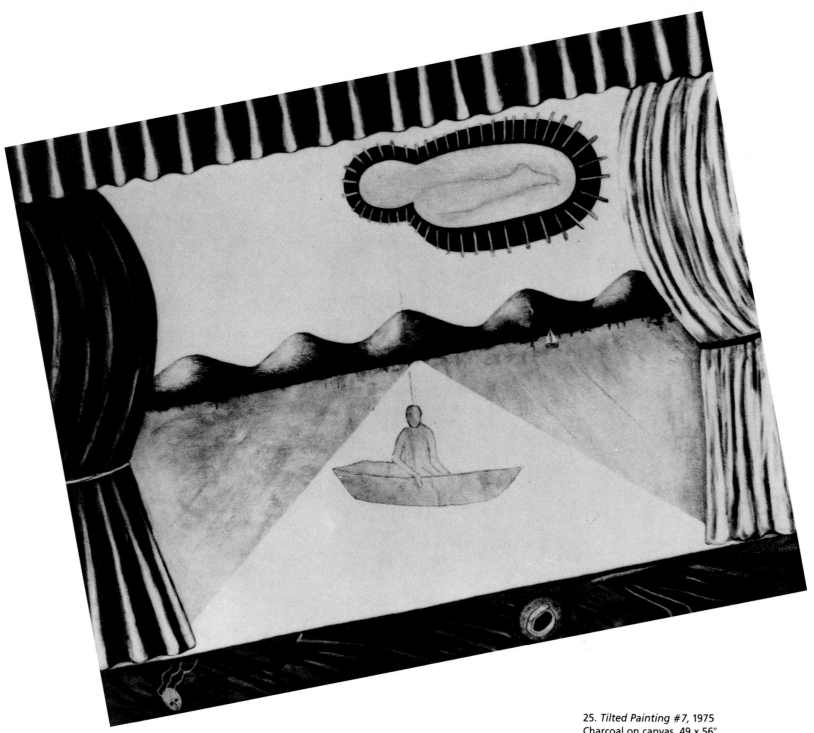

25. *Tilted Painting #7*, 1975
Charcoal on canvas, 49 x 56″
(124.5 x 142.2 cm)
Collection of Doris and Charles
Saatchi, London

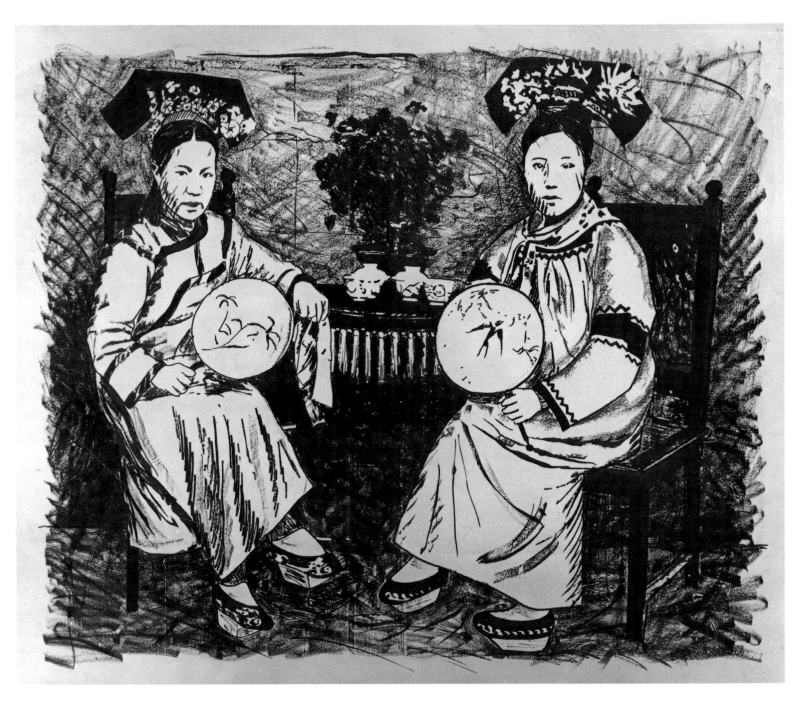

26. *Two Chinese Women,* 1976
Ink on wall, 36 x 48"
(91.4 x 121.9 cm) (approximate)
(Paula Cooper Gallery, New York,
1976)

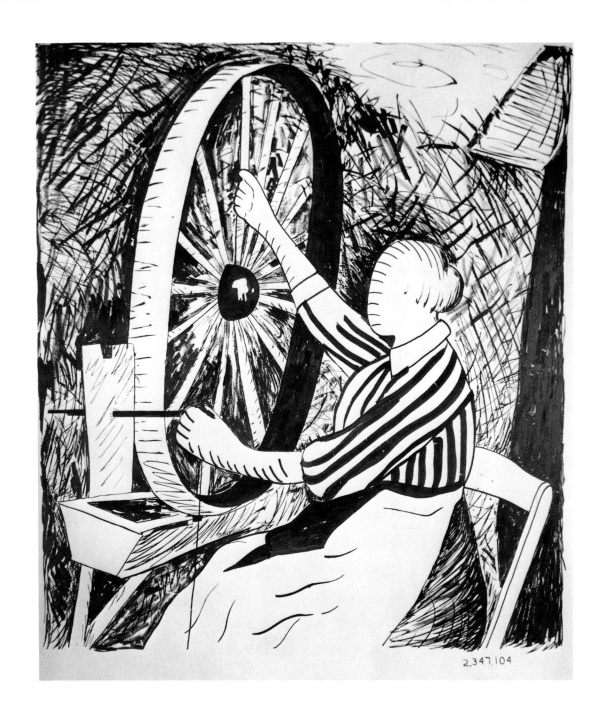

27. *Woman at Wheel at*
2,347,104, 1976
Ink on wall, 72 x 60″
(182.9 x 152.4 cm) (approximate)
(Paula Cooper Gallery, New York,
1976)

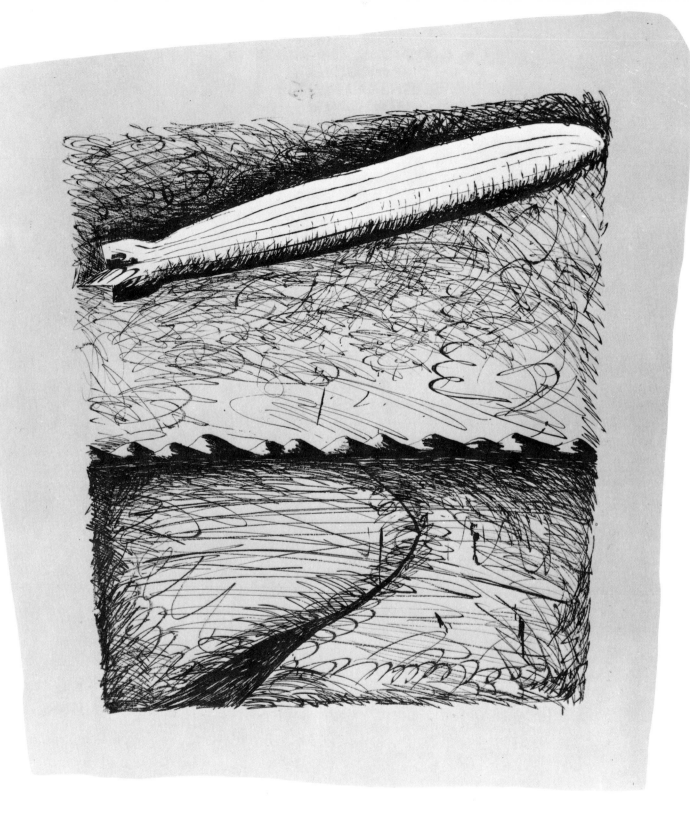

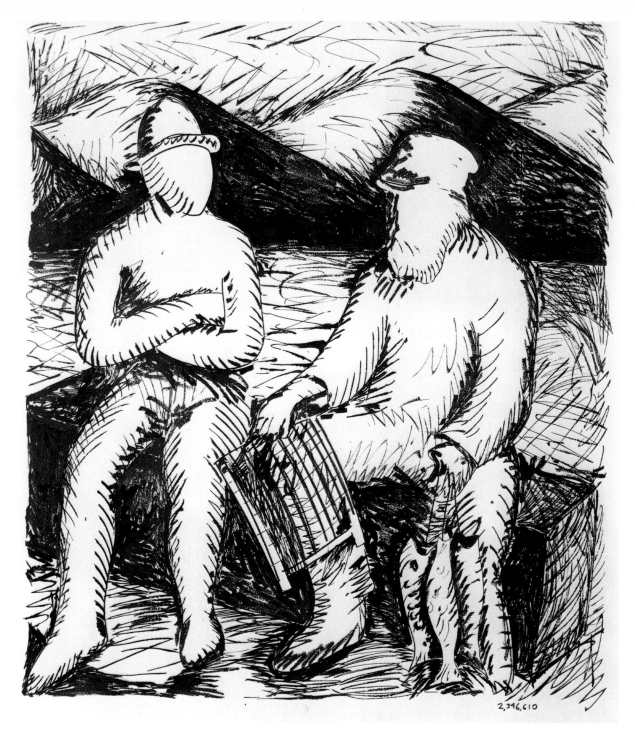

28. *Blimp*, 1975–76
Ink on wall, 96 x 84"
(243.8 x 213.4 cm) (approximate)
(Paula Cooper Gallery, New York,
1976)

29. *Two Men with Fish at
2,346,610*, 1975
Ink on wall, 72 x 60"
(182.9 x 152.4 cm) (approximate)
(Wadsworth Atheneum,
Hartford, 1976)

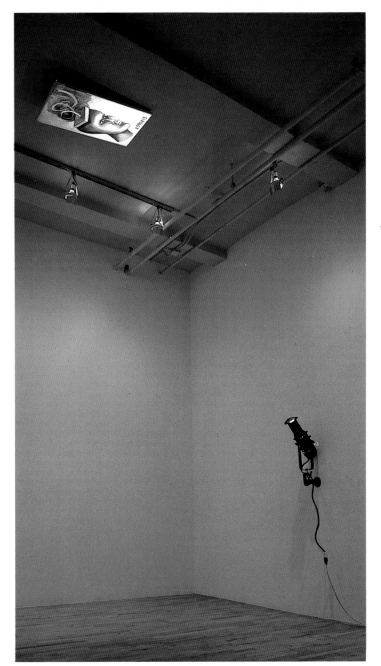

30. *Light Where the Painting Is,
Painting Where the Light Is at
2,590,213,* 1978–80
Oil on canvas, with stage light;
canvas 36 x 20″ (91.4 x 50.8 cm)
Collection of George H. Waterman III,
New York

31. *Acrylic on Unprimed Canvas
with Bubble Wrap and Duct Tape
at 2,680,377,* 1978–80
Acrylic on canvas, bubble wrap,
duct tape, 113½ x 92″
(288.3 x 233.7 cm)
Paula Cooper Gallery, New York

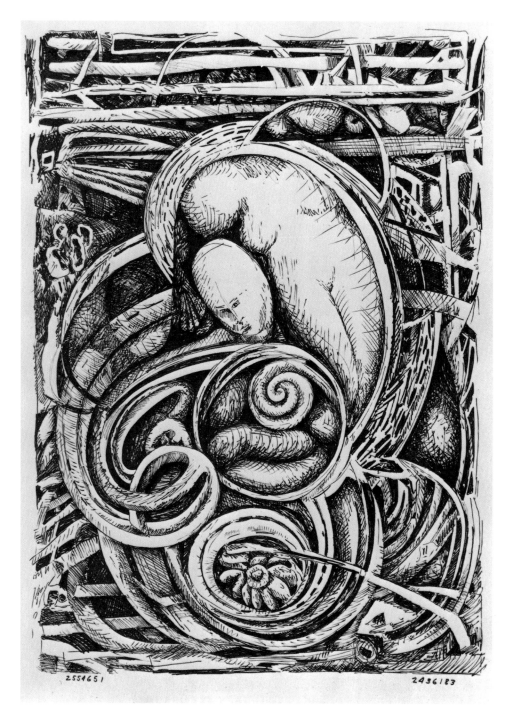

32. *Self-Portrait with Female Image at 2,436,183 and 2,554,651,* 1979
Ink on paper, 77¾ x 60″
(197.5 x 152.4 cm)
Location unknown, photograph courtesy of Paula Cooper Gallery

33. *Untitled at 2,600,611 and 2,600,612,* 1979
Acrylic on 2 stones, 9½ x 4 x 4¼″
(24.1 x 10.2 x 10.8 cm) and
6 x 2½ x 2¼″ (15.2 x 6.4 x 5.7 cm)
Collection of Madeleine and Jay Bennett, New York

This painting is unfinished 2560492

34. *Unfinished Painting at 2,566,492,* 1977–78
Oil and ink on canvas, charcoal on wall; canvas 94 x 76"
(238.8 x 193 cm)
Collection of Barbara and Eugene Schwartz, New York

Unfinished Painting *is tilted on the wall to throw off one's psychological state of balance or to challenge one's logic for viewing works. I was just reacting to the idea that making paintings has always seemed rather traditional to me; I've never liked the idea, on one level, because it seemed too rigid. I was always looking for a way to get paintings mobile, to get them physical, to twist them, to give them a kind of lightness, not a somberness or a kind of preciousness that a painting takes on when it is sold, displayed, and protected. I was trying to give painting some life.*

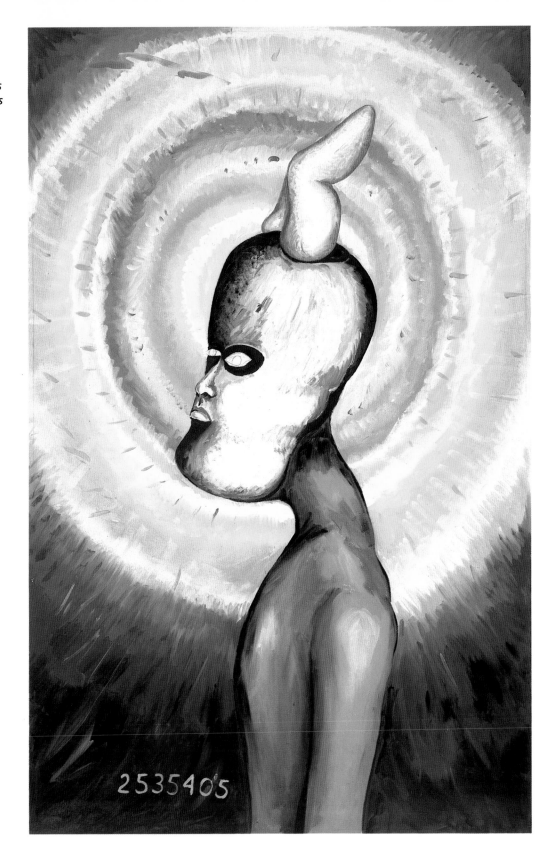

35. *Head with a Shape on It at 2,535,405,* 1978
Acrylic on paper, 78¾ x 52"
(200 x 132.1 cm)
Collection of Eddo and Maggie Bult, New York

36. *Horned Man at 2,550,117,*
1978–79
Acrylic on masonite, 58 x 36⅛"
(147.3 x 91.8 cm)
Museum Boymans–van
Beuningen, Rotterdam

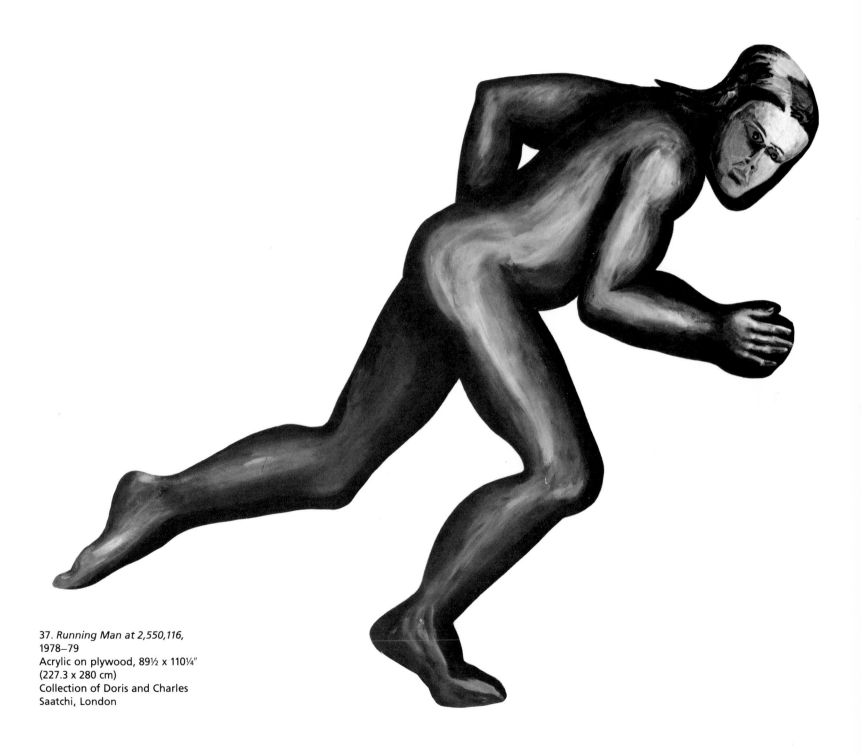

37. *Running Man at 2,550,116,*
1978–79
Acrylic on plywood, 89½ x 110¼"
(227.3 x 280 cm)
Collection of Doris and Charles
Saatchi, London

MY MALE SELF MY FEMALE SELF

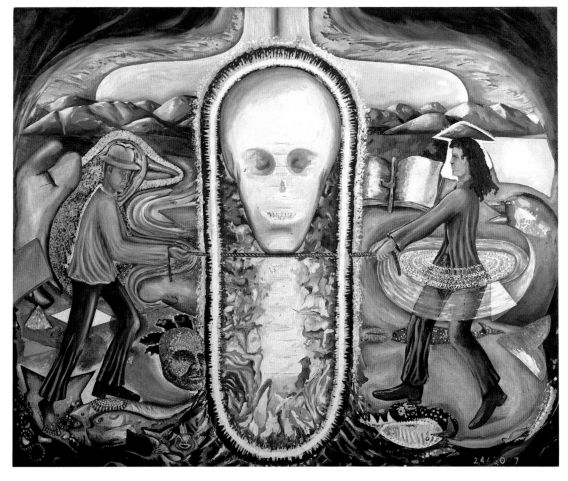

This is the first painting I did when I moved to California. It has a lot of bright colors and seemed to be very Californian or Mexican. It is a male figure and a seemingly more female figure, but both are me—one has long hair, one has a hat. The painting was finished in a much simpler form, but I kept working on it, and a lot of images started creeping in—a duck's head that comes around the male head, a lot of upside-down fish and a book, and in the center a flaming, hell-like shape.

There is a skull balanced on a rope that the two figures are pulling that implies some kind of birth, death, and rebirth in the way the skull is pushing up into the land-scape where the mountains are. There are also the shoulders and neck of a new figure at the top—a blending of my male self and my female self into a new form. There is a world of images at the bottom working their way up through death and rebirth. The words on the wall, "My Male Self, My Female Self,"

were added later because I had been thinking about it that way all along—and I wanted to make it more direct, and to make a statement about us all.

38. *My Male Self, My Female Self at 2,468,007,* 1977–79
Oil on canvas, charcoal on wall; canvas 63 x 78½" (160 x 199.4 cm)
Private collection

39. *Venice Boardwalk at 2,558,829,* 1978–79
Acrylic on paper, 66 x 59" (167.6 x 149.9 cm)
Collection of David P. Robinson, New York

64

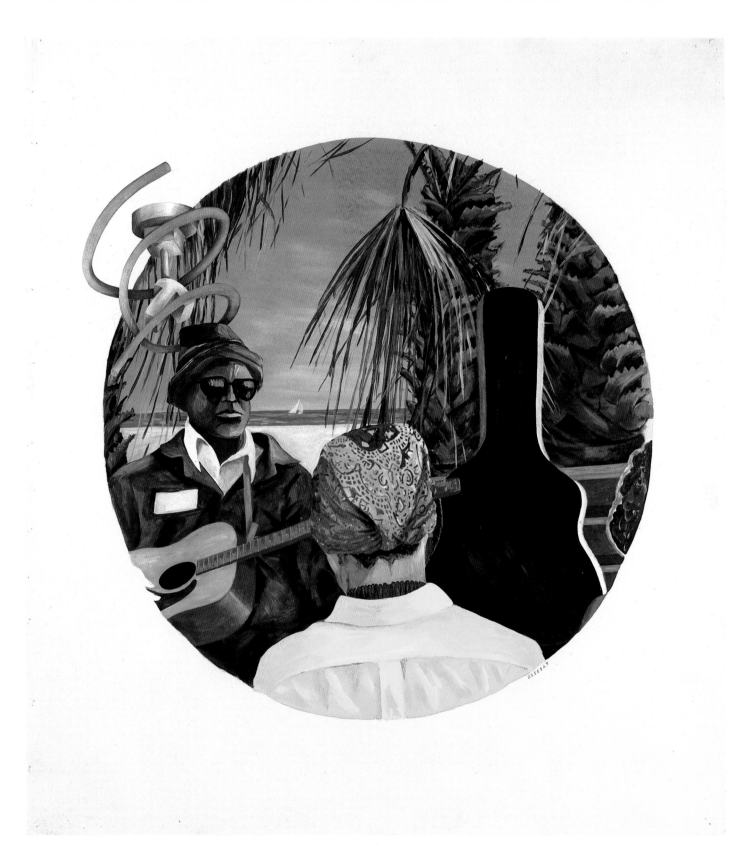

40. *When I awoke, with my eyes still closed, I saw this image at 2,566,489*, 1978–79
Saddle and velvet, charcoal on wall, 54½ x 49 x 30″
(138.4 x 124.5 x 76.2 cm)
Collection of the artist

When I awoke, with my eyes still closed, I saw this image

I had the Hitler dream when I first moved to Los Angeles, but I did not use it in a large form until a show in 1979. It was one of those dreams that seemed archetypal, so I gradually began to use it, and in increasingly larger forms. There were a few hundred dreams that I would carry around with me, but this is one that seemed particularly appropriate for my own dilemma. It was about my problem of feeling and being free. I see myself as the skater, as well as the Hitler-type person. In retrospect, in most dreams I seem to be every character—the victim as well as the oppressor.

41. *I dreamed that some Hitler-type person was not allowing everyone to roller skate in public places . . . at 2,566,499*, 1979
Ink on wall, 127 x 114″
(350.5 x 289.6 cm) (approximate)
(Paula Cooper Gallery, New York, 1979)

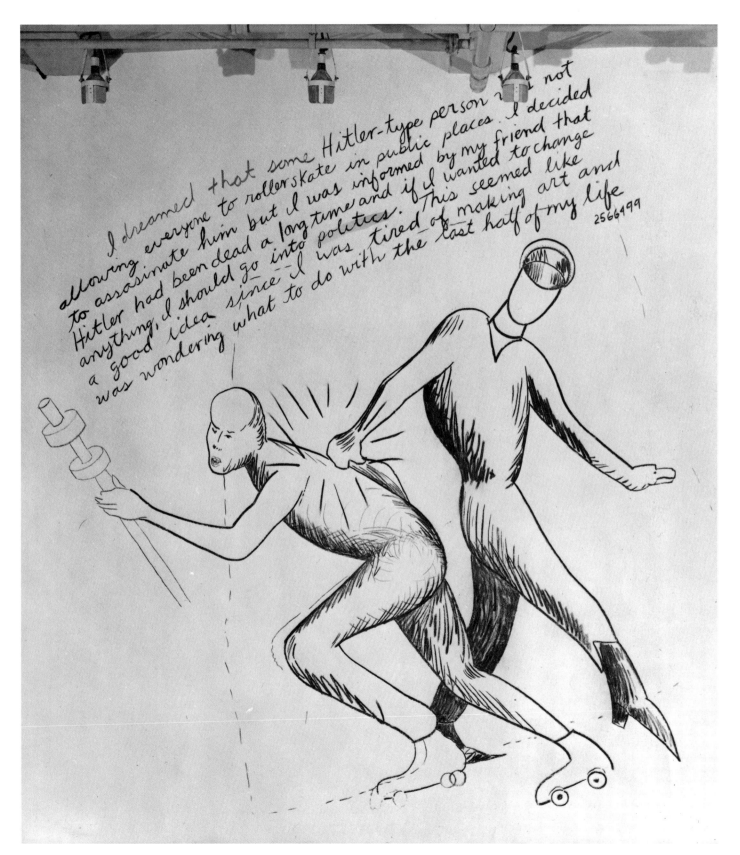

67

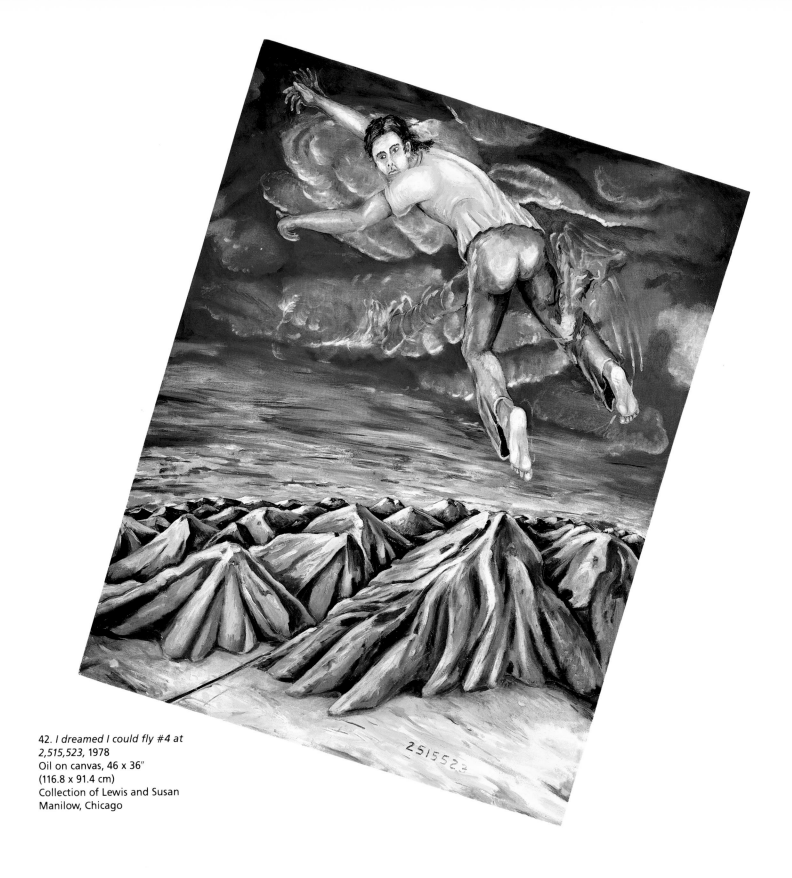

42. *I dreamed I could fly #4 at
2,515,523*, 1978
Oil on canvas, 46 x 36"
(116.8 x 91.4 cm)
Collection of Lewis and Susan
Manilow, Chicago

For Man in Space *I made two stretchers that fit together to make a corner. Because I was painting so many images directly into corners, it seemed interesting to make a corner that was transportable and on which I could spend more time. I like the idea of doing paintings as corners because you can walk around them and see the backs, like a sculpture. As you walk from side to side, the figure becomes distorted accordingly. Only from the center facing the corner, can you see it without distortion.*

The painting depicts a giant man standing in the desert with tiny mountains. The figure is being enveloped with ribbonlike forms that refer to the space around him—either imprisoning or defining him.

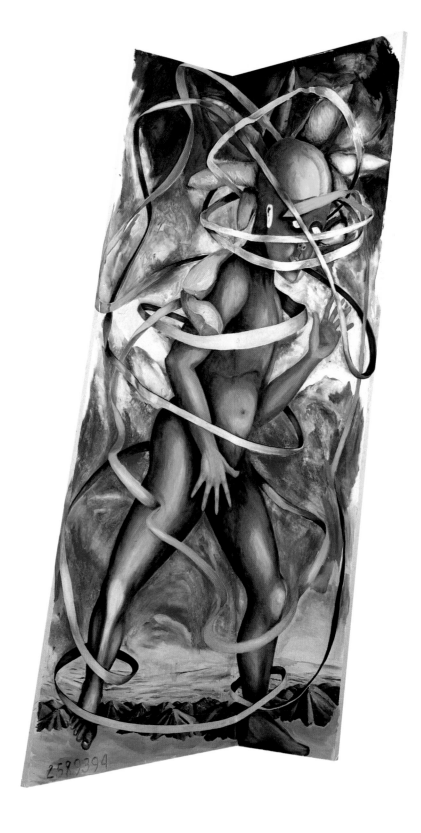

43. *Man in Space at 2,589,394,* 1978
Acrylic on shaped canvas, 132 x 57¼ x 24″ (335.3 x 145.4 x 61 cm)
Museum Moderner Kunst, Vienna

44. *Boy with Lemons at
2,562,628,* 1979
Conté crayon and pastel on
paper, 60 x 51½" (152.4 x 130.8 cm)
Private collection

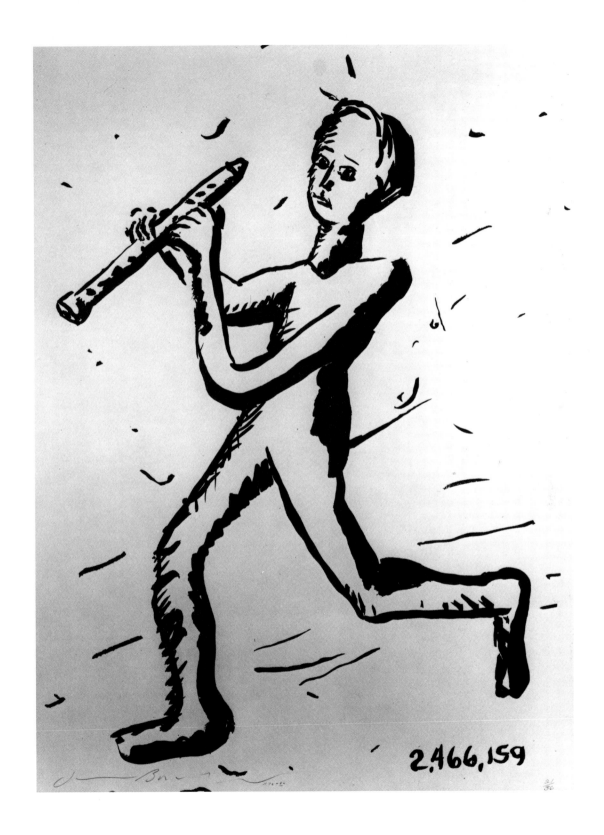

45. *Untitled at 2,466,159,*
1976–80
Silkscreen, 49⅞ x 36"
(126.7 x 91.4 cm)
Edition of 36
Collection of the artist

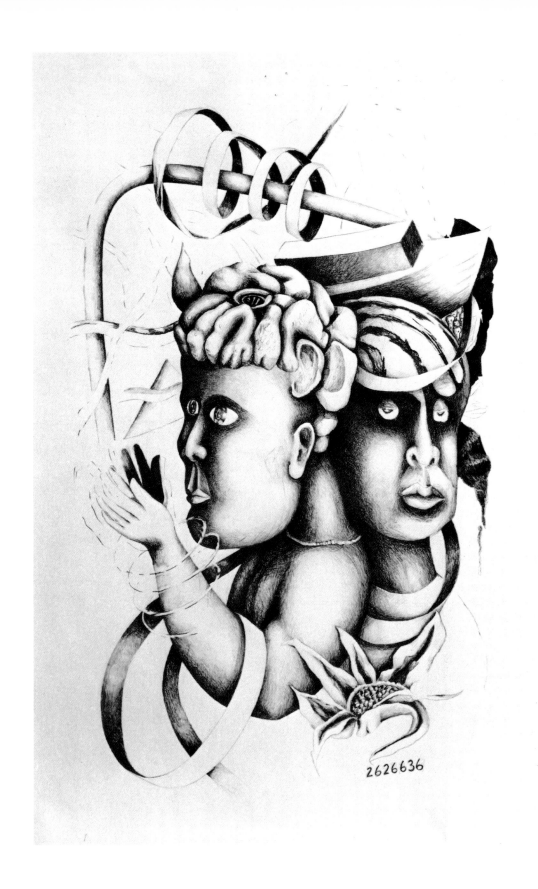

2626636

46. *Double Self-Portrait with Moving Hands at 2,626,636,* 1979–80
Conté crayon on paper, 67½ x 49″ (171.5 x 124.5 cm)
The Museum of Modern Art, New York; acquired with matching funds from Alexis Gregory and the National Endowment for the Arts

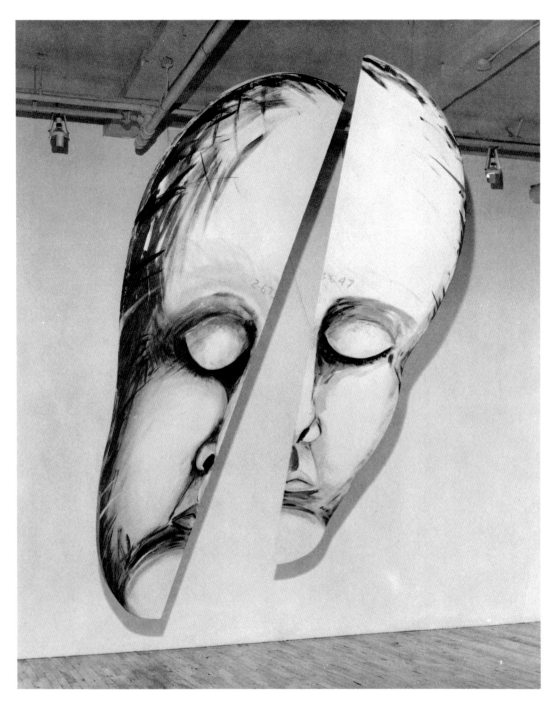

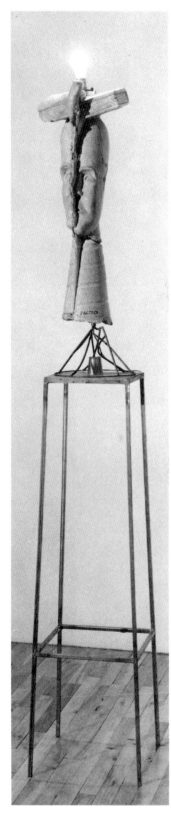

47. *Split Head at 2,673,047,* 1980
Acrylic on 2 shaped canvases,
133 x 43″ (337.8 x 109.2 cm) and
133 x 30″ (337.8 x 76.2 cm)
Collection of Richard and Lois
Plehn, New York

48. *Split-Head Urethane Lamp at
2,667,528,* 1979–80
Urethane foam, light bulb, and
steel base, 87 x 14¼ x 10½″
(221 x 36.1 x 26.7 cm)
Collection of Martin Sklar,
New York

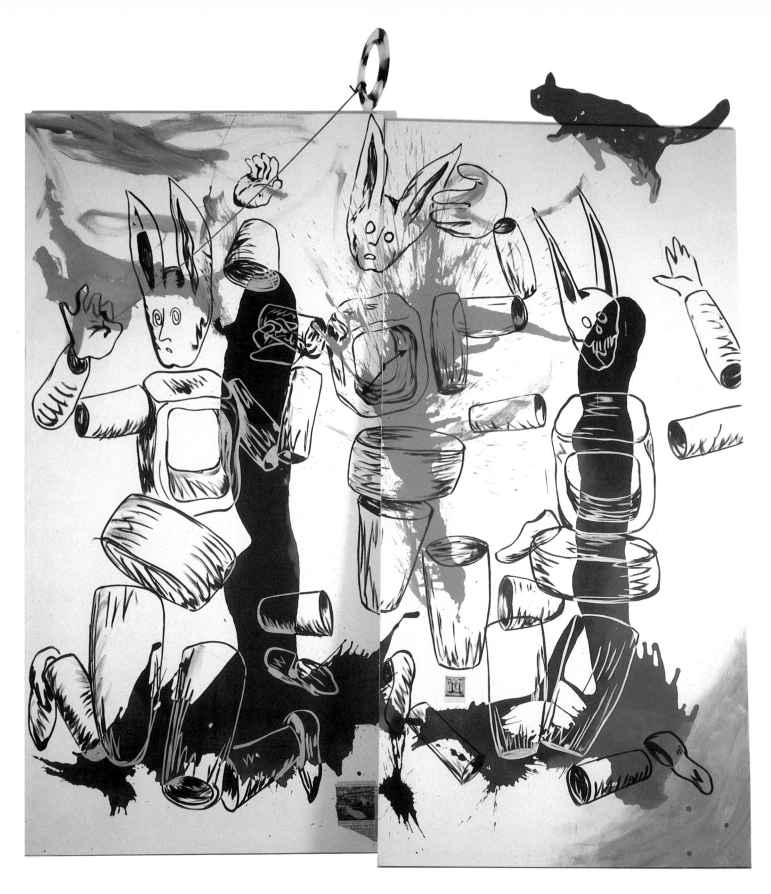

74

49. *Man in Space #2 at 2,783,196 and 2,783,197,* 1982
Acrylic on canvas and wall, newspaper, Polaroid photograph, plastic disc with cable; 2 canvases, each 120 x 60"
(304.8 x 152.4 cm), 129⅛ x 120 x 19" (328 x 304.8 x 48.3 cm) overall
Whitney Museum of American Art, New York; purchase, with funds from the Louis and Bessie Adler Foundation, Inc., Seymour M. Klein, President

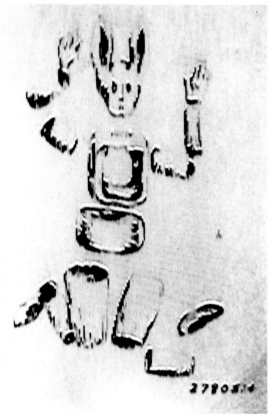 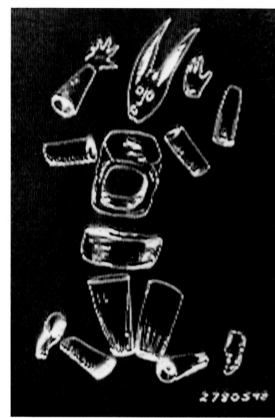

50. *Man in Space,* 1982
Black-and-white videotape
Collection of the artist

I began by laying the canvases on the floor, and mixed up a big bucketful of paint, which I threw across one of them. Then I duplicated it with another color and had these two huge, stained canvases. I put them up on the wall, and played around with which images to use. I chose three animated drawings of figures that show an evolution of form. The first figure seems to be the most conscious; the second one starts to break up and fracture as it goes across the center of the canvas; and the third goes into a type of death state—the head is a skull.

The figures repeat three frames from my video animation drawings, which show an animal-eared man in space, jumping around, fragmenting, and then coming back together again. The body parts are cylinders, either hollow or solid, like a puppet—pieces and fragments.

The long-eared figure comes from several sources, one of which is my relationship to animals. I have always had a lot of animals around me, including a goat and a few dogs. I watch their ears, and the role these play in tuning into their surroundings. I also focus quite often on just hearing sounds as a form of meditation, so that I'm stretching my own ears, too—emphasizing them. These figures are partly me and partly animal. At other times, these ears become antennae that can pick up energy or reach into space.

The cat is an image that I have also used at different times. Here it is painted half on the painting and half on the wall to circumvent the restrictive edges of the canvas just as the string and ring come out into the space. The ring is from a dream in which Megan and I are watching a parapsychologist do tricks with a magic ring and moving it through the air [pl. 15].

I have also added other elements to the painting. The part in the middle looks like something exploding and the newspaper clipping about nuclear war refers to this. I occasionally add Polaroid photographs to my paintings: in this case the Polaroid serves as a self-referential element.

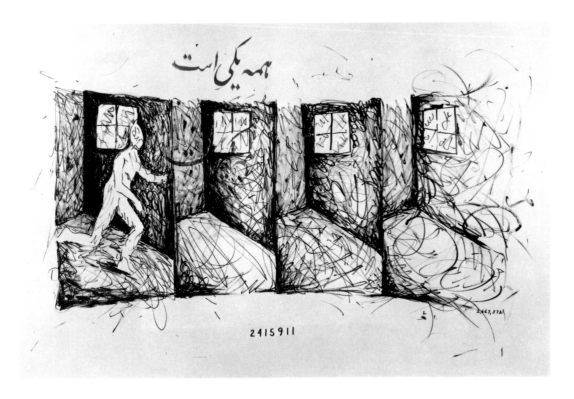

همه یکی است

2415911

51. *Running Man through Four Frames with Persian Script (All Is One) at 2,415,911 and 2,667,372,* 1976–80
Acrylic and ink on paper,
53½ x 84½″ (135.9 x 214.6 cm)
Collection of Dunkin' Donuts, Inc.

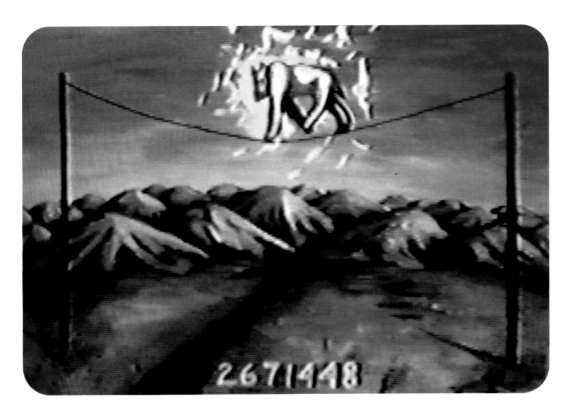

2671448

52. *I dreamed a dog was walking a tightrope,* 1980
Color videotape
Collection of the artist

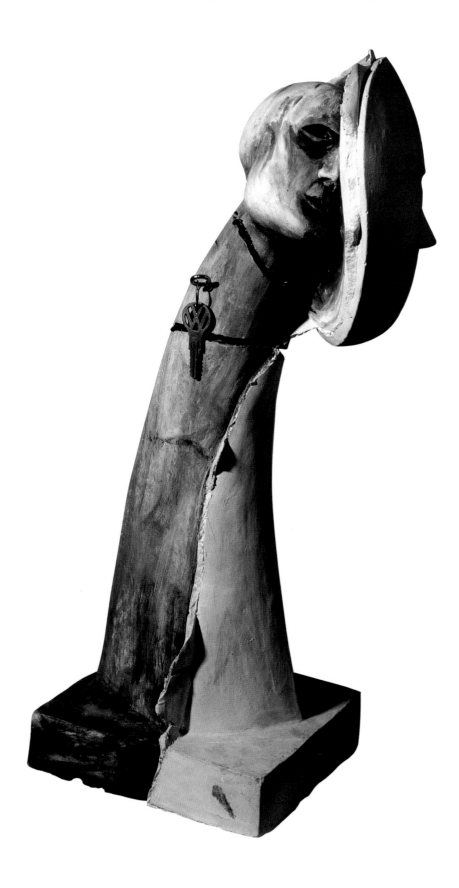

53. *Split Head at 2,723,117*, 1974
(painted 1981)
Acrylic on hydrocal, with screw
eye and key, 22¾ x 10½ x 9″
(57.8 x 26.7 x 22.9 cm)
Collection of Jules and Barbara
Farber, American Graffiti Gallery,
Amsterdam

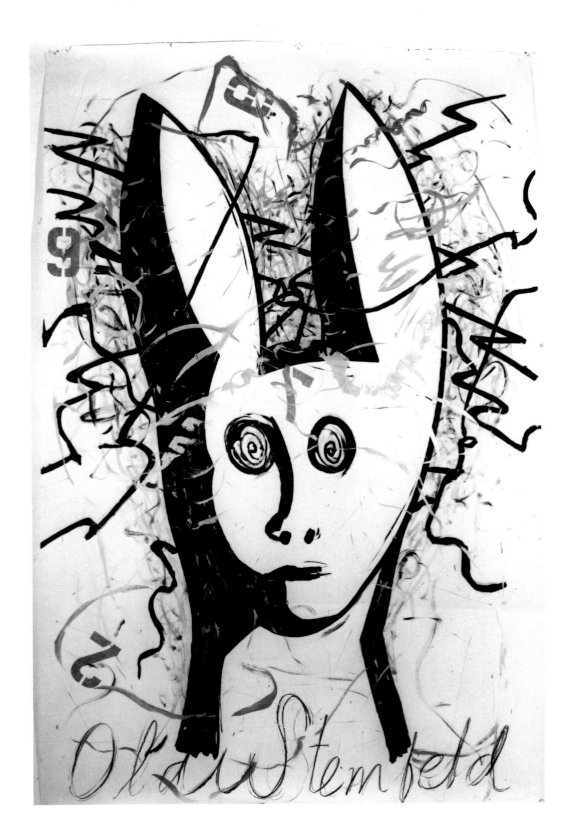

54. *Oldi Stemfeld at 2,738,441,*
1982
Acrylic, charcoal, and pencil on
paper, 91 x 60" (231.1 x 152.4 cm)
Collection of the artist

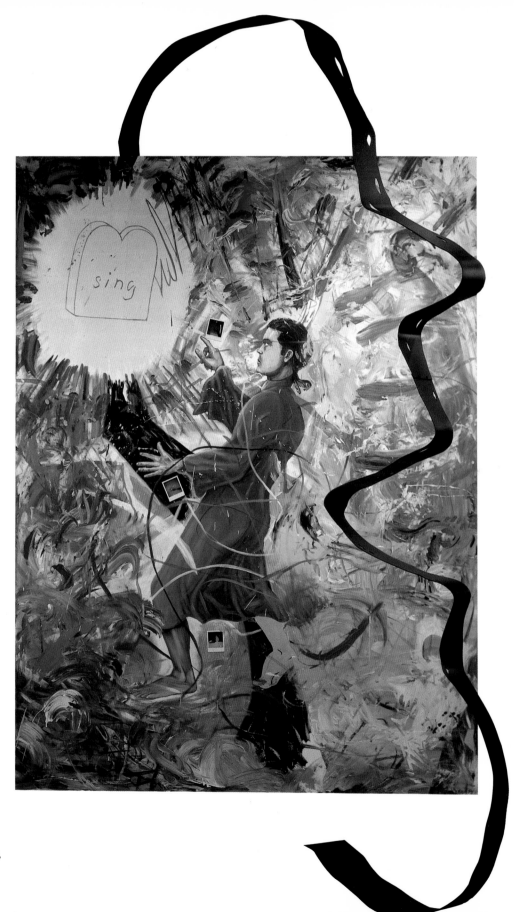

55. *Sing at 2,841,777,* 1978–83
Acrylic and 3 Polaroid photo-
graphs on canvas, with painted
aluminum, neon, stereo cassette
player with tape loop (compila-
tion of songs written by Jon
Borofsky; vocals and instrumen-
tals, Jon Borofsky; instrumentals,
Ed Tomney; mixing, Ed Tomney);
canvas 127 x 96⅛″ (322.6 x 244.2 cm),
144 x 96⅛ x 72″ (365.8 x 244.2 x
182.9 cm) overall
Collection of the artist

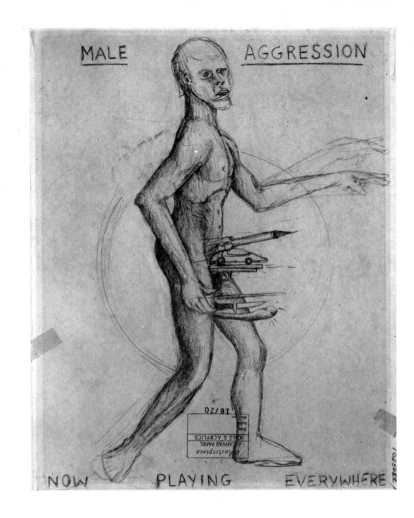

56. *Silhouette Cutout with Holes Drilled at 2,659,320,* 1979
Masonite, 2 pieces,
man 70 x 24 x ¼"
(177.8 x 60.7 x .6 cm)
Thomas Ammann Fine Art
Gallery, Zürich

The "molecule" pieces are more conceptual in derivation. They explore the idea that we are all made up of pockets of air and water, and I try to get that feeling into this series. I can relate it to artists, such as Henry Moore, who put holes through his sculptures, and Giacometti, who dealt with the space surrounding his figures. I was thinking about piercing the figure, making it lighter, and also about exploring the idea of flying and being pulled

down by the gravitational force of the earth. Another version was a wooden chair that I started drilling holes into—as many as I could to see how long it would take before the chair would crumble and collapse.

57. *Male Aggression Now Playing Everywhere at 2,733,801,* 1982
Pencil on back of canvas board and tape, 20 x 16" (50.8 x 40.6 cm)
Collection of John L. Stewart, Jr., New York

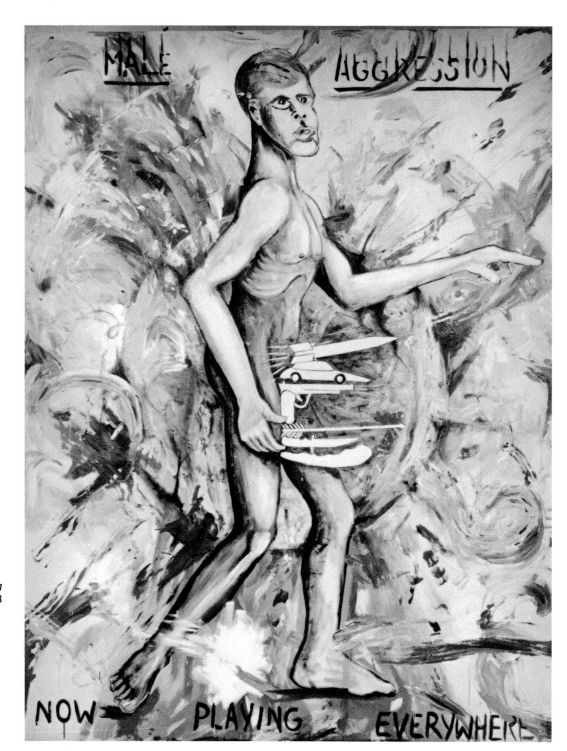

58. *Male Aggression Now Playing
Everywhere at 2,841,778*, 1981–83
Acrylic on canvas, 109½ x 83¾"
(278.1 x 212.7 cm)
Collection of Suzanne and
Howard Feldman, New York

59. *Man with a Briefcase at 2,838,771*, 1983
Ink on paper, 98 x 44"
(248.9 x 111.8 cm)
Collection of Thomas and Shirley
Ross Davis, Woodside, California

60. *The Maidenform Woman. You Never Know Where She'll Turn Up at 2,841,779*, 1983
Acrylic and pencil on canvas,
126 x 96¾" (320 x 245.7 cm)
The Edward R. Broida Trust,
New York

82

61. *Berlin Dream at 2,833,792,*
1983
Charcoal on paper, 60¼ x 75″
(153 x 190.5 cm)
Collection of Barry Lowen,
Los Angeles

62. *Green Space Painting with Chattering Man at 2,841,789,* 1983
Acrylic on canvas, with aluminum, wood, Bondo, electric motor, and speaker; canvas 112 x 72″ (284.5 x 182.9 cm), man 82½ x 23 x 13″ (209.6 x 58.4 x 33 cm)
Collection of the artist

63. *Dancing Clown at 2,845,325,*
1982—83
Acrylic on canvas, urethane foam,
fiberglass, and styrofoam, with
metal snaps, fabric, wood, steel,
monofilament, spotlights,
motors, stereo cassette player
with tape loop, and speakers;
height of clown 11′ (3.4 m)
Collection of the artist

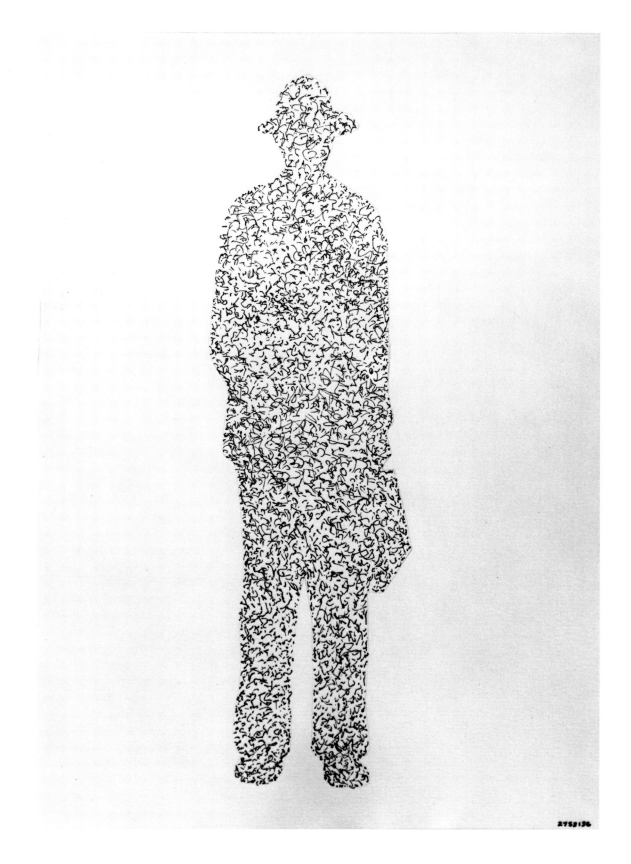

Jonathan Borofsky's Installations: All Is One Richard Marshall

"All is One," a phrase written in Persian script and first used by Jonathan Borofsky in a 1976 exhibition, best describes the underlying concept that governs his life and his work. He views all mankind as one, collectively united by universal values and universal truths, which are revealed through his art. Thus Borofsky becomes the universal man—one representing all. This same principle underlies the character of his installations: disparate components—different materials, forms, styles, and ideas—form one whole that transcends its individual parts.

Borofsky's installations over the last ten years reveal a complex, interrelated accumulation of images and meanings that form one of the major statements of recent art. Individual elements relate to one another on various visual and conceptual levels, while each installation contributes to the totality of one multi-dimensional artwork. Each successive installation seems to expand upon the previous one, while signaling the direction of the next.

Jonathan Borofsky, like many artists who began their careers in the early 1970s, attempted to break through the confines of the Minimal and Conceptual esthetics that dominated the art world at that time. These artists collectively sought ways to reintroduce personal subject matter and meaning into art. In 1972 Borofsky formally reviewed and assessed his own artistic achievement in his *Age Piece* (pl. 3), a work that traced significant stages in his art from age eight to thirty. *Age Piece* also revealed some of the features and characteristics that were to be explored more fully as Borofsky's career developed further. It is installational in that it exists only when assembled and arranged. It also foretells his use of the wall as support and his combination of two- and three-dimensional elements in different materials, textures, colors, and configurations. Like all his work, it is pointedly autobiographical, revealing the workings of his mind directly and honestly. *Age Piece* is arranged chronologically across forty feet of wall; although assembled of individual works when Borofsky was thirty, it allowed for the addition of works at ages thirty-four and forty, attaining an incremental balance of the separate pieces on both sides of the work that represented Age 24, and emphasizing the continuousness and evolutionary aspects of his art.

Borofsky's first oil painting, a small still life of fruit on a table top painted in 1951, when he was eight, makes up the first part of *Age Piece* (see fig. 34). With the encouragement of his mother, herself a painter of still lifes, he began private painting lessons in Maine around 1950, and continued taking weekly lessons in Boston until he was seventeen. There was little emphasis, however, on proficiency in traditional figure drawing. The second element in the work, an abstract painting done when he was fourteen, displays washes, drips, and smears that retain a vague reference to landscape. Age 18 is represented by a welded-steel object made when Borofsky was a sophomore at Carnegie Mellon University in Pittsburgh. During that year, Borofsky had decided to change his major from industrial design to art, objecting to the necessity of designing projects based on

Fig. 34 Age 8, 1951, from *Age Piece* (pl. 3)
Oil on canvas board, 10 x 14"
(25.4 x 35.6 cm)

1. Quotations and attributions of the artist's intentions were derived from taped interviews with Jonathan Borofsky conducted by the author, July 7 and 8, 1983.

88

someone else's specifications. He became more interested in sculpture at that time, and this steel object reveals the influence of Theodore Roszak and Seymour Lipton.

During the summer after his graduation from Carnegie Mellon in 1964, Borofsky studied figure modeling at the Ecole de Fontainebleau in Paris; because the school had no welding facilities, he experimented with plaster. The plaster piece representing Age 21 (fig. 35) was done during his first year of graduate school at Yale University. This work is from a series of welded structures covered with plaster. Borofsky made a number of separate forms—umbrellas, fruit shapes, geometric volumes—and organized them into one additive sculpture, which retained the identity of the individual parts, a feature that continues to characterize his work. A year later his work had become less surreal and more personal. He made a group of cast and painted fiberglass tree-trunk forms that contained holes as nesting places for imaginary birds—one of which was placed at Age 22, with a brass plate identifying the piece as "the Downy Woodpecker's Home." These pieces exhibited the primitive, handmade quality that still appears in Borofsky's work, and they introduced his use of bird and tree images. Borofsky's subject matter continued to become more specific and autobiographical; he constructed small objects on the theme of Camp Alton, a resort in New Hampshire where he went during the summers as a child. Age 23 presents one of these, a mysterious tombstonelike object, which incorporates words, photographs, and hooks for keys (see fig. 36)—all elements that would recur in later pieces.

Following his graduation from Yale in 1966, Borofsky moved to a loft on Chambers Street in New York, where he made larger and gaudier versions of the Camp Alton pieces. He also made his own versions of decorative objects—screens, panels, lamps—that revealed the influence of Pop Art, and Roy Lichtenstein in particular. Most of these works were destroyed, except for the piece that represents Age 24, described by Borofsky as a "Cubist Puerto Rican Lamp."[1] This object presages Borofsky's use of the lamp format, lights, and electricity in most of his later installations. The lamp is at the center of *Age Piece*, marking a compositional and stylistic break.

Borofsky stopped making objects in his mid-twenties and became more cerebral and introverted, exploring process and conceptual modes. He preferred to think about art rather than to make it, a change that was related to his move to New York City and to the radical sociopolitical mood of the late 1960s. Age 25 displays sheets of lined paper, taped together and hung on the wall, which represent the structured, procedural activity of covering his studio walls with blank sheets of paper that occupied Borofsky around 1967. He also began writing—random thoughts about the universe, philosophical truisms, conceptual diagrams, and numerical notations—a process that for him was a regimented activity. This thinking and writing exercise continued for almost a year. The completed pages

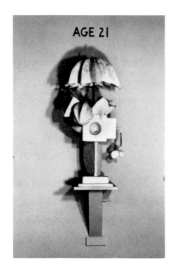

Fig. 35 Age 21, c. 1964, from *Age Piece* (pl. 3)
Plaster on welded steel, 37 x 15 x 16" (94 x 38.1 x 40.6 cm)

Fig. 36 Age 23, c. 1966, from *Age Piece* (pl. 3)
Lacquer on wood, with photograph under glass and key hooks 18^1/$_4$ x 19 x 4" (46.4 x 48.3 x 10.2 cm)

were photocopied and bound as the *Thought Book* (fig. 3), and one of its pages is included in *Age Piece* at Age 26. Although the Conceptual art movement had not yet been fully identified and labeled, these cerebral, immaterial activities seemed unique and exciting to him, especially if the results could be considered art. While recording thoughts and notations, Borofsky found himself writing simple repetitive numerical sequences—1, 2, 3; 1, 2, 3, 4; 1, 2, 3, 4, 5—as a break and release from the constant deluge of abstract thought and relentless "mind chatter."

Borofsky eventually became dissatisfied with the *Thought Book* exercise because it was too hermetic. He decided instead to count on paper continuously from number one, both to occupy his time and to regulate his thought and writing. Eight pages of continuous numbers are shown at Age 27. The pure, linear formality of counting appealed to him and fulfilled his need to do both something and nothing at the same time. However, after two or three years of this obsessiveness, he started to draw sketches and scribble on the counting pages and also to write down and sketch his dreams to break the monotony of numbering. In 1972 he made a small painting (his first in many years) from one of these sketches and assigned it a current number from his counting sequence, thus symbolically joining the two distinct, yet related, aspects of his psyche—the linear, conceptual, and numerical with the emotional, intuitive, and representational.

This first painting, the beginning of *Continuous Painting* (pl. 4), led to other small sketches and paintings, dream drawings, as well as *Age Piece* itself, and a diagram of this work represents itself at Age 30. Borofsky was assessing his evolution as an artist, attempting to foresee the direction of his work in the future. He admired Picasso's work for its stylistic variety and cohesive vision and found these characteristics in his own production—confirming his belief that "All is One." For the next two years he continued counting (although less compulsively) and working on a group of drawings, paintings, and sculptures that would become part of his important 1975 exhibition.

Although Borofsky had exhibited conceptual and counting work since 1969 (see figs. 37, 38), it was not until his first one-man show at the Paula Cooper Gallery in New York in March 1975 that he emerged publicly as an original talent (see figs. 39, 40 and pls. 64–66). Borofsky's small studio on the Bowery was full of paintings, drawings, sculpture, found objects, and conceptual works. He decided to fill the gallery with these works in a manner that would retain the raw energy, chaos, and casualness of their arrangement in his studio; nothing would be framed or put under glass. He wanted the exhibition to be dense and overloaded, with apparent unconcern for the individual object—a decision that practically precluded sales.

In the focus on an overall presentation, Borofsky's work recalled the environ-

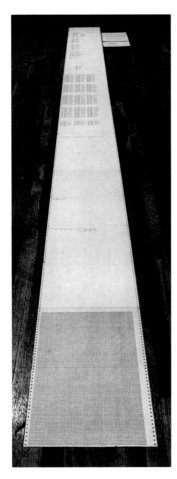

Fig. 37 Installation at Paula Cooper Gallery, New York, 1969

mental installations of Kurt Schwitters and the Happenings of Claes Oldenburg. But Borofsky wanted to be more radical in content and presentation—hence he pushpinned works to the gallery walls, covering them from floor to ceiling. He introduced images that were to reappear in later works: *Dream #1* (pl. 5) is an early instance of the anxiety-induced running figures that later emerged in wall drawings, *Running Man #2* and *Running People* (pl. 141); the ubiquitous sailboat image also made its first appearance, as did the unfinished, crumbling clay version of *Split Head*, which, in 1981, was cast in plaster (pl. 53) and, in 1982, in bronze. *Counting from 1 to Infinity* (fig. 38), first exhibited singly at Artists Space in 1973, was placed in the center of the gallery. Borofsky had considered but rejected attaching each piece with strings to the stacked papers to show that all the works had originated with this conceptual exercise. The works in the 1975 exhibition were not numbered consecutively, but were given whatever number Borofsky was up to when the work was made. The number was both a substitute for the artist's signature and a personalized time-structuring device. The subject matter was also personal, often about embarrassing dreams or about his mother, father, or girlfriends.

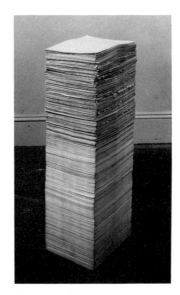

Fig. 38 Installation at Artists Space, New York, 1973

With his studio empty after having installed its contents at the Paula Cooper Gallery, Borofsky began to draw directly on his bare floor and walls. The earliest and largest wall work was done in charcoal in a dark, heavy, *Guernica*-like manner on a thirty-foot wall (pl. 70). Borofsky became obsessed with the drawing, which had taken him over a month of struggle and inner turmoil to complete and dominated his entire living space. The images, executed freehand in a rapid, graffiti-like manner, were from Borofsky's memory—figures, fish, turtles, upside-down animals, enigmatic symbols, and others from earlier paintings (such as the still life he did at age eight). Although he was intrigued and excited by the idea of drawing directly on a wall, the obsessiveness of this first attempt prompted him to paint over it soon after completion.

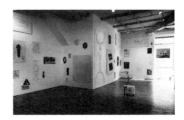

Fig. 39 Installation at Paula Cooper Gallery, New York, 1975

Wall painting appealed to Borofsky because it was extremely direct and unrestricted; he was not limited by the edge of a piece of paper or canvas. To draw around a corner, across the ceiling, or onto the floor was both challenging and frightening. Wall drawings seemed revolutionary to Borofsky—a reversion to primitive cave paintings and a method that removed his art from the realm of portable, salable objects.

Because the thirty-foot wall painting had taken him so long to execute, Borofsky sought a faster way of making images on a wall, while retaining spontaneity and directness. He experimented with opaque projectors, enlarging five-by-five-inch images onto the wall. He made drawings on paper to fit the projector, creating a pictorial repertory of images from his subconscious and from newspapers, photographs, magazines, and books. By 1976 Borofsky relied more

Fig. 40 Installation at Paula Cooper Gallery, New York, 1975

on the projector; he selected a wider variety of images from different styles, periods, and sources (including his conceptual drawings from 1968) and combined them on the wall.

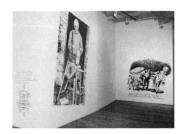

The first exhibition of Borofsky's wall drawings opened at the Wadsworth Atheneum, Hartford, in April 1976 (pls. 79–81). The images were projected individually and traced on the wall in black ink. The only object in this small exhibition was *Counting from 1 to Infinity*, placed in the center of the room and protected by a plexiglass cover. The installation was fairly tranquil in that the wall drawings were similar in scale and spaced equally around the room. Images were drawn from the psyche, which triggered the self-analytical text, *What Is Dragging Me?* (pl. 6), and from photographs and newspapers, which prompted the pair of Yugoslavian fishermen (pl. 29), the woman at a spinning wheel (pl. 27), an upside-down figure in a landscape, a silhouetted man with a pushcart, and a Running Man striding through two frames of a four-frame cinematic progression (pl. 51).

Fig. 41 Installation at Paula Cooper Gallery, New York, 1976

Borofsky's largest and most diverse exhibition of wall drawings to that time was held at the Paula Cooper Gallery in October 1976 (figs. 41 and 42). The artist had preselected and executed most of the images in his studio, resolving issues of scale, color, and media. Autobiographical "inner" images (*Turtle* and *Running Man through Four Frames)* were mixed with those from "outer" life, from photographs and newspaper clippings, often with cultural and political content—among them were an early Hammering Man in the form of a shoemaker (pl. 17), Chinese women (pl. 26), Yugoslavian fishermen, and a Greek beggar-woman. Borofsky also made color a pronounced element for the first time: bright Day-Glo green was used under *Man with Breadfruits*, light blue under *Blimp* (pl. 28), and bright yellow Day-Glo under an upside-down *Shinto Priest*.

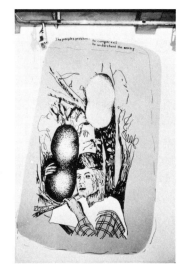

The projector, which could orient and situate images in any place he chose, enabled Borofsky to experiment with inverted imagery and to paint around corners and doors and onto the ceiling. He had done upside-down paintings on canvas—flowers (see fig. 30), women with geese (pl. 24), and a sailboat—but when he subsequently learned that the German painter Georg Baselitz was working with the same kind of inversions, he relied less on the device, although its radical and illogical impact still appealed to him. This desire for the unexpected is what Borofsky liked about wall drawings. Their ephemeral condition—overpainted as soon as the exhibition closed—challenged the viewer's notion of art as transportable, salable objects. Borofsky was more interested in keeping the scale of the images flexible, in conveying a sense of immediacy through painting on the wall, and in using the architectural space of the gallery than he was in selling.

Fig. 42 Installation at Paula Cooper Gallery, New York, 1976

The Paula Cooper exhibition also marked the first appearance of the saying "All is One," painted on the wall in two different styles of Persian script. *Counting from 1 to Infinity* was again placed in the center of the room to anchor the

presentation conceptually and to create a balance with the personal, emotional selection of images on the wall.

Borofsky's only major installation in 1977 was at the Art Gallery at the University of California, Irvine (figs. 43, 44 and pls. 88–96). It was the largest space Borofsky had yet worked, and he had approximately two weeks, the longest period yet, to complete the wall drawings. From the photographs and small drawings in his briefcase he selected older images that had been successful as well as new ones that had not yet been used; he arranged the entire room as if it were a four-sided painting. The space was to encompass the viewer, and primary lines of sight were to bring the whole room into play. From this point on, Borofsky would begin his installations by selecting the most interesting architectural feature of the space and using it as the focus of the exhibition. At Irvine he found staggered walls with an opening that divided two galleries; he projected *Blimp* onto three walls, which created a total depth of approximately twenty feet for the image. *Blimp* thus became a three-dimensional painting that could be walked into and through, and one that, conversely, countered the illusion of depth by flattening the architectural space.

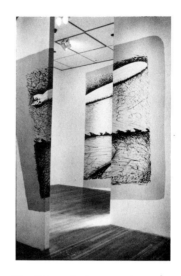

Fig. 43 Installation at University of California, Irvine, 1977

In both content and style, the Irvine installation offered a rich pictorial variety. Among the new images was a realistic drawing of two men working in a pit in New York City from a photograph taken by Borofsky. *Moose* also made its first appearance there; using a photograph of a moose in the snow, Borofsky made a small drawing, to which he added mountains and small, black, silhouetted figures inside the animal and projected it to fill an entire wall. Many drawings in this exhibition depicted workers of various nations: the woman at a spinning wheel, man carrying breadfruit, hammering shoemaker, New York City ditchdiggers, Greek beggar-woman, and a Chinese worker-teacher (pl. 16). They function as a metaphor for Borofsky, as the artist working with his hands (and moving away from the purely conceptual artwork that had occupied him in the late 1960s and early 1970s), and for universal man.

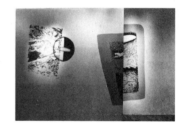

Fig. 44 Installation at University of California, Irvine, 1977

During the summer of 1977 Borofsky moved to California to teach for a year at California Institute of the Arts at Valencia. Prior to the move he had lived in New York for eleven years and had taught at the School of Visual Arts there. In California he rented a small apartment on the boardwalk in Venice; for a while he had a small studio in Santa Monica, and another at Cal Arts. He realized that his work could be produced anywhere—in his apartment or studio, or at the site of an exhibition; thus he could continue his career without returning to New York.

Borofsky's first installation of 1978 was at the University Art Museum in Berkeley as part of its Matrix program (fig. 45 and pls. 107–10). Borofsky proposed a collaborative exhibition with Megan Williams, an artist he had met and worked with at the California Institute of the Arts. The exhibition explored socio-sexual nuances of male-female relationships. Each piece had two components,

Fig. 45 Installation at University of California, Berkeley, 1978

one by Borofsky, the other by Williams. Borofsky placed a red Ruby (a motif that would recur frequently) inside a ribcage structure done by Williams. He also made a small cardboard cutout of a Running Man that was set inside Williams's three-dimensional spiral of string. The two-person effort suggested male-female roles—Borofsky objects inside spaces created by Williams.

In August 1978, Corps de Garde, an alternative exhibition space in Groningen, the Netherlands, invited Borofsky to create an installation (pls. 114–16). It was his second show in Europe, and he was given an entire room in which to work. The white walls, floor, and ceiling gave Borofsky his first opportunity to make a complete three-dimensional, six-sided installation. The Groningen show was dominated by images of the Ruby, and a new version of the Running Man, which was to become one of his best-known images.

By the late 1970s Borofsky was invited to do many exhibitions, in the United States and in Europe, often in close succession. This never presented a practical problem because the images were executed on location—no need for crating and shipping—and he now had a stock of well over three hundred images to choose from. Repetition was inevitable, and desired. Borofsky's installation for the Projects program at the Museum of Modern Art in New York (figs. 46–48 and pls. 117–21) was dominated by a large image of the Running Man used at Groningen, which set the tone for the rest of the room. The Running Man, painted across the ceiling, a structural overhang, an air-conditioning vent, and down the wall, was the first image one encountered when entering the room. The Ruby, the stacked *Counting from 1 to Infinity*, and the Persian script for "All is One" were the most familiar "old" images. The museum's Projects space was an awkward progression of corridorlike rooms, which Borofsky activated spatially and visually by including various images, subjects, and styles that jumped around the space and drew the viewer through the passages.

The 1978 Museum of Modern Art show presented an "art" dream about Carl Andre and Barry Le Va in which the formal rigidity and linearity of Andre's metal plates were interspersed with Le Va's scattered and intuitive felt pieces. The work represented Borofsky's own attempts to combine his linear conceptual attitude with the psychological aspects of the wall drawings. A political statement was reflected in a wall drawing derived from a newspaper photograph about the killing and skinning of baby seals (pl. 14). Other works depicted personal dreams about his childhood camp, a black child in the subway, and a surreal horse saddle before a curtain. The saddle, first shown as a sketchy drawing at Groningen, was a more fully rendered painting in New York, with the saddle placed upside down. Some of these dreams he had written down in the early and mid-1970s; Borofsky had, for example, kept the subway dream drawing on paper for a number of years. He rendered the dreams directly on the wall in a free, loose, and graffiti-like manner, intending to retain the quality of the original drawing, which was

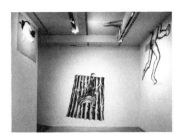

Fig. 46 Installation at The Museum of Modern Art, New York, 1978

Fig. 47 Installation at The Museum of Modern Art, New York, 1978

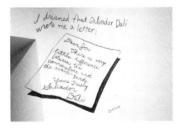

Fig. 48 Installation at The Museum of Modern Art, New York. 1978

contemporaneous with the occurrence of the dream. The number he assigned from his ongoing counting coincided with either the dream, or its execution at the exhibition. Thus, although the conceptually based number remained an integral part of his work, its strictly linear progression began to break down.

Borofsky's first installation of 1979 was at the Whitney Museum of American Art's "Biennial Exhibition" (pl. 122). He was given an L-shaped wall on which he decided to represent a dream about a young man (himself) in a wheelchair who scribbles on glass. Borofsky projected and drew the dream across the corner of the walls, visually flattening the space. A piece of glass with the same lines that appeared in the dream drawing was propped against the wall to add a sculptural element that made part of the dream real and physical. This "inner" dream centered the installation and was surrounded with "outer" political images, including a drawing of the Ayatullah Khomeini, and the name Biko in large, bright orange letters (referring to the death of Steve Biko, a leader of the black anti-apartheid movement in South Africa).

Borofsky's third exhibition at the Paula Cooper Gallery, in March 1979, combined elements from his first two shows there (figs. 49–51 and pls. 123–27). Whereas his previous five installations were almost exclusively wall drawings, this one presented different types of work: paintings on canvas, large and small drawings on paper, wall drawings, and sculpture. The show included a plaster version of *Split Head* (pl. 53), which had appeared in crumbling clay in his 1975 installation; a large cutout of the Running Man (fig. 49); and a three-dimensional representation of the saddle (pl. 40), which had evolved from earlier depictions in Groningen and at the Museum of Modern Art. The underlying theme was Borofsky's Persian phrase, "All is One": the conjunction of various styles, sizes, media, and subjects in one space as a reflection of one person—the artist. Borofsky wanted to fill the room with a comprehensive illustration of his simultaneous states of mind. Across a long wall and below the ceiling he inscribed "Wasted in fear of one another," a reference to the exorbitant military defense expenditures of the United States, the Soviet Union, and China, sums that appeared on an adjacent wall. Borofsky, using numbers with real meaning, interjected a political observation and offered a simple analysis of the arms race and nuclear stockpiling. But his statement also had private resonance: fear on a multinational level is but an aggrandizement of fear on a personal level. This integration of "outer" and "inner" attitudes is typical of the artist's attitude and is represented in all his installations.

Where and how things are placed in Borofsky's installations reflect his efforts to make the entire space one three-dimensional work of art. Decisions about placement, although intuitive, are designed to establish connections among works. In the Paula Cooper installation, for instance, a dream about shaped canvases, drawn over a three-dimensional feature of the wall, abutted a

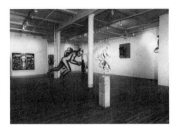

Fig. 49 Installation at Paula Cooper Gallery, New York, 1979

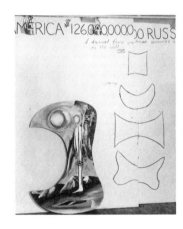

Fig. 50 Installation at Paula Cooper Gallery, New York, 1979

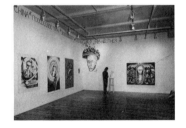

Fig. 51 Installation at Paula Cooper Gallery, New York, 1979

three-dimensional painted canvas that evolved from the dream. The first and largest cutout of the Running Man was placed in the center of the space (along with *Counting from 1 to Infinity*) and, from one vantage point, overlapped the view of a skating figure in a similar escaping or running posture. This figure, from *I dreamed that some Hitler-type person was not allowing everyone to rollerskate . . .* (pl. 41), constituted Borofsky's largest dream drawing to date, and it made a subliminal connection to an esoteric *Oven* sculpture (fig. 22) with writing on it that said "Gast in German means guest." This installation seemed less chaotic than earlier or later ones in that Borofsky emphasized individual works that maintained their integrity within the overall installation.

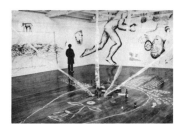

Fig. 52 Installation at Portland Center for the Visual Arts, 1979

Borofsky's 1979 piece in the "Ten Artists/Artists Space" exhibition at the Neuberger Museum in Purchase, New York, was the first to use the ceiling exclusively (pl. 135). The artist confronted a gallery that was partially filled with another installation on which he did not want to intrude, and a wall that did not meet his usually flexible requirements. Moreover, the walls were not structural, and Borofsky preferred to work with permanent architectural walls. The large ceiling in an adjacent gallery became an appealing alternative because it was locked into the architecture of the building.

Borofsky decided to forgo the use of a projector; instead, he used charcoal tied to the end of a stick to draw a fish shape on the ceiling. During the following six days, he made an outline of the fish, and painted it in with a long-handled paint roller. He used the familiar Ruby as the fish eye, from which a light bulb was suspended. Although the fish image had never appeared with such prominence, it was not new to Borofsky's repertory.[2] Both fish and birds appealed to him because of their aerodynamic shape (such as that of the *Blimp*) and the contrast of elements (water and air) in which they lived. By putting a fish in the sky, Borofsky obliterated and reconciled basic opposites.

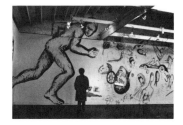

Fig. 53 Installation at Portland Center for the Visual Arts, 1979

Borofsky's last installation of 1979, one of his largest, was at the Portland Center for the Visual Arts, Oregon, in a cavernous space with exposed beams (figs. 52, 53 and pls. 136–41). The artist filled the space with wall drawings and props hung from the rafters in a two-week effort that took on aspects of a marathon. Borofsky worked day and night, overloading the space with images in an obsessive and exhaustive manner. The Portland installation included the familiar Running Man, now over fourteen feet tall, but was especially notable for the appearance of new images—actually, older images put into service for the first time. *Running People,* first done as a small sketch in the same drawing of 1977 that included the original sketch for the Hammering Man, was a bold, black silhouette over twenty-eight feet long that spread across structural breaks in the wall and onto the ceiling. Also making their debut as wall drawings were *I dreamed a dog was walking a tightrope, Cambodian Mother* (which was taken

2. The large, dark wall mural done in his studio in 1975 contained many fish; the Museum of Modern Art installation included *I dreamed that I had two goldfish . . .* , and at the Halle für Internationale Neue Kunst exhibition in Zurich a fish had been painted on the floor.

from a newspaper photograph), a loose and graffiti-like depiction of boat people, a cardboard cutout of Saturn, and a television set.

The television was suspended from the ceiling, close to the wall, and emitted black-and-white commercial broadcasting. The viewer had to get close to the wall, turn away from the wall, and look up to see the television. In another media-related strategy, Borofsky hired an unemployed man to pose in documentary photographs of the installation. The same silhouetted figure is seen viewing the works in all the Portland Center photographs and presages the sculptural *Chattering Men* done in 1983. Borofsky's first Flying Figure also appeared in the form of a cut-out silhouette hanging from a skylight. The entire confused installation of contradictory images—fast and slow, beautiful and ugly, clean and messy, large and small, public and private—could, nevertheless, be experienced as an ensemble.

In early summer of 1980, Borofsky completed an installation for the Venice Biennale (fig. 54 and pls. 144–49). In a small, boxy space with high ceilings, he combined a number of familiar images: a Running Man, the large bird last seen in Portland, a Ruby, a Saturn, *Cambodian Mother* (with a gondola oar projecting from her forehead to a fish drawn on the floor), a partially drawn Man in Space who also appeared as a large, shaped canvas, and a realistically painted vase of flowers similar to the one that first appeared upside down in a 1976 painting on canvas (fig. 30). New images included a large red "fingerprint" face and a long-eared, spiral-eyed self-portrait. Most startling was the painted fiberglass *Venice Lamp with Book on It*—suspended in the center of the space—which functioned as one of Borofsky's first Flying Figures. The electric cord that powered the light bulb was plugged into the center of the bird's head, connecting these two images just as the oar conceptually and physically connected the fish and *Cambodian Mother.*

Most prophetic was the entrance of the Hammering Man image. Borofsky took the small drawing, done in 1977, to Venice, where he intended to project the image on a large scale on the wall. When the space seemed inappropriate, he transferred the image, making several hundred photocopies and hanging them on the wall with a sign instructing visitors to take one. Thus the visitor could retrieve an image from an otherwise fixed and static exhibition. While manipulating a cutout of the image on the return flight from Italy, Borofsky envisaged the hammering arm moving in a three-dimensional version of the figure. As soon as he returned to Los Angeles, he made a full-scale model for the sculpture; with an assistant's help he fabricated an eleven-foot Hammering Man with a motorized arm.

This Hammering Man was a major element in Borofsky's next exhibition, at the Paula Cooper Gallery in October 1980 (figs. 55, 56 and pls. 150–55). The

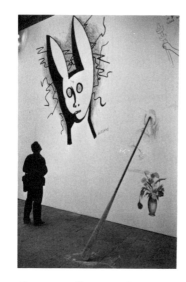
Fig. 54 Installation at Thirty-ninth Venice Biennale, 1980

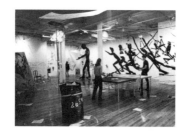
Fig. 55 Installation at Paula Cooper Gallery, New York, 1980

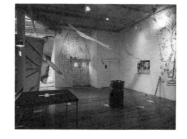
Fig. 56 Installation at Paula Cooper Gallery, New York, 1980

installation was his most ambitious, chaotic, complex, and perplexing. He had no preconceived plan, but sent a number of completed pieces to New York for possible use. He placed three key works—*Hammering Man, Ping-Pong Table (Feel Free to Play),* and *Cambodian Mother*—in a large triangular configuration that helped to center and anchor the gallery space; then he worked around these, filling in the remainder of the room. A man hammering a shoe had first been seen in a wall drawing at the 1976 Paula Cooper exhibition; although this new black silhouette in three dimensions was a different type of Hammering Man, the image still served as a metaphor for the artist working with his hands. The actual movement was novel in an installation dominated by numerous images that implied movement. Near the Hammering Man, and echoing the black, silhouetted figure in movement, was an expansive wall drawing of the Running People first presented in the 1979 Portland installation. Now, however, the nervous, wavering lines were extended to three dimensions by rough-edged black plastic strips that ran from the wall into the space. He also translated the Cambodian Mother image into a sculptural painting on canvas, propped up by a bamboo pole extending from the woman's forehead to the floor.

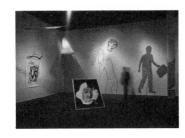

Fig. 57 Installation at Hayden Gallery, Massachusetts Institute of Technology, Cambridge, 1980

The Ping-Pong table, a startling inclusion in an art exhibition, was a sculptural realization of the defense budgets written on the wall in Borofsky's 1979 show at the Paula Cooper Gallery. The top of a Ping-Pong table was painted black and white, plus and minus signs were stenciled on the surface, and a sign, "Feel Free to Play," was hung over the table. The work served as a metaphor for human interaction on a personal or global level; it recalled concepts of winning and losing, yin and yang, competition and cooperation, and expressed the tense military/political situation between the United States and the Soviet Union. The viewer thus became a participant—part of the installation itself. When in use, the Ping-Pong table introduced sound into the experience of the installation, adding another sensory stimulation to the visual cacophony of painted, drawn, and sculptural imagery.

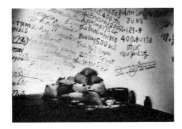

Fig. 58 Installation at Whitney Museum of American Art, New York, 1981

In addition to *Cambodian Mother*, four other paintings revealed Borofsky's interest in making a traditionally two-dimensional work into a sculptural entity that exists in space rather than on the wall. These four works were placed in a dense arrangement in one corner of the gallery, as if overlooked. Dominating this area was the tall, corner-shaped canvas, *Man in Space* (pl. 43), an image that appeared partially completed as a wall drawing at the 1980 Venice Biennale. Although Borofsky had projected images into corners to take advantage of architectural elements and to explore perspectival distortions, this was the first time he made a portable corner of stretched canvases that became a walk-around painting. The *Portrait of Descartes after Frans Hals on Four Surfaces . . .* (see fig. 57 and pl. 161), an open pyramidal shape into which the image had been projected and painted, was originally intended to hang freely in space so that the

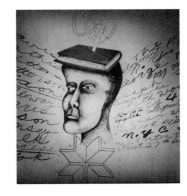

Fig. 59 Installation at Whitney Museum of American Art, New York, 1981

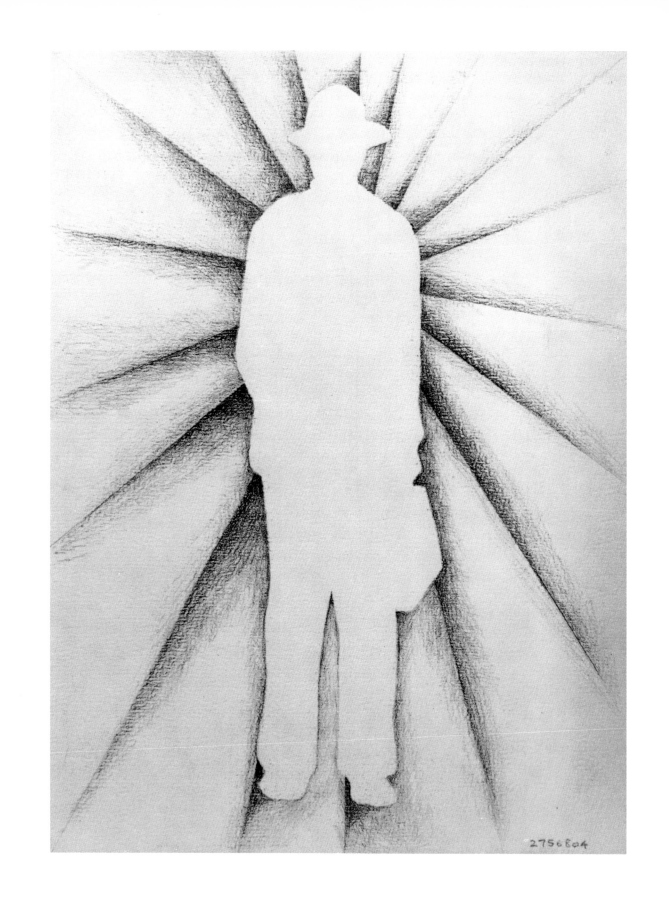

2756804

image would distort or focus depending on the viewer's vantage point. Because of restrictions of space, however, the piece rested on one side on the floor and inadvertently became a receptacle for stray Ping-Pong balls (see pl. 153).

Acrylic on Unprimed Canvas with Bubble Wrap and Duct Tape (pl. 31) depicts a partially executed still life of flowers in a vase. Borofsky had planned to finish it before the New York exhibition, but changed his mind and propped the wrapped canvas against a pole in the gallery. For this reason, it interjected a sense of evolution to the installation because the painting looked as if it were still waiting to be moved somewhere else. *Split Head* (pl. 47), a fourth painting in this cluster of works, implied motion, as if one of the two shaped canvases that form the head were spinning on an axis.

An unexpected element of this installation consisted of papers, which reproduced a plea for nonlittering, strewn about the floor. Borofsky had found the original on the street, made photocopies, and, ironically, littered his entire show with them. Borofsky used the litter leaflets to create an allover atmosphere, imposing visual cohesion and bringing a part of the city into the gallery.

Borofsky's last installation in 1980 was at the Hayden Gallery of the Massachusetts Institute of Technology (fig. 57 and pls. 156–61). The exhibition, although primarily wall drawings, included the Ping-Pong table, *Portrait of Descartes, Counting from 1 to Infinity,* and a Coca-Cola dispensing machine. The Running Man image dominated the space and ran across the ceiling, wall, floor, and a supporting column. Borofsky projected the image from the point where most visitors would see it as they entered; it thus became a centering device for the installation. The Runner, from the prime vantage point, seemed to stand in the middle of the space. A view from a different angle, however, revealed that the ceiling and floor sections were tracings of the elongated distortion caused by the projection of the figure across these horizontal planes; the Runner's right leg below the knee, for example, actually extended some twenty feet across the floor. The 1980 defense budgets for the United States and the Soviet Union appeared on the wall near the Ping-Pong table and Coca-Cola machine—directly reinforcing the analogy of the arms race to the game. In addition, Borofsky included mathematical, perceptual, and theoretical diagrams from his 1968 *Thought Book.* These had never been used before, but seemed appropriate to the academic specialization of M.I.T.

Borofsky's installation for the Whitney Museum's 1981 "Biennial Exhibition" was more enigmatic and restrained than his previous ones (figs. 58, 59 and pls. 162–64). The enclosed gallery space assigned to him was smaller than usual, and he decided to project writings he received seven years before but had never used. They had been dropped anonymously into the mail slot of his New York studio around 1974. Each batch of pages was filled with names (sometimes with addresses and weights), among them black boxers, such as Floyd Patterson and

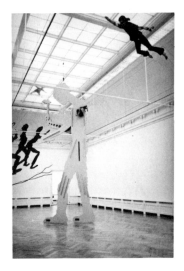

Fig. 60 Installation at Kunsthalle Basel, 1981

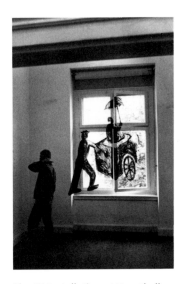

Fig. 61 Installation at Kunsthalle Basel, 1981

Buster Mathis. These obsessive lists seemed related to Borofsky's own compulsive counting, as well as his inner-directed "mind chatter." At the Whitney Museum installation, he filled three walls with the lists, projecting them and tracing the handwriting so that the names became elongated and distorted.

Borofsky projected information and diagrams from his *Thought Book* on the fourth wall of the gallery; thus his inner dialogue was surrounded by an unknown but related dialogue. A statement about defense budgets again appeared, inscribed near baskets and bags of wheat stacked in a corner. These new and unexpected sculptural devices made reference to the rest of the installation: wheat farming is one of the oldest forms of labor (represented by the Hammering Man at the opposite end of the room), and grain trading was the major collaborative activity between the United States and the Soviet Union. The installation also included a bucket of water that contained Borofsky's paint brushes, a reference to the artist as laborer. Three other manifestations of the artist appeared: a self-portrait painted on the wall as the silhouetted Molecule Man with a Briefcase, a head with a book balanced on top, and the Hammering Man.

Borofsky's installation at the Los Angeles County Museum of Art (pls. 180–83) was related to earlier ones in its saturation of images and styles and in its planned and spontaneous composition as one experience made up of numerous elements. A large pointy-eared "self-portrait," which had also appeared in the "Westkunst" exhibition (pls. 172–76), was drawn on the wall and painted bright red in an alcove-like space so that it extended across the ceiling and floor, and seemed as if it were suspended in space and much larger than the area that contained it. A pulsating strobe light flashed into the viewer's eyes, causing momentary light blindness, afterimages, and the sensation of movement—another way in which Borofsky attempts to make art participatory and surprising.[3] The Los Angeles installation also included a Hammering Man—the second Borofsky made—in a slightly larger scale, and painted red. The word *strike* stenciled onto the torso referred to the motorized arm striking and alluded to labor strikes, particularly in Poland.

Borofsky's third Hammering Man, the main feature of his 1981 exhibition at the Kunsthalle Basel (figs. 60–62 and pls. 177–79), was twice as large as the previous two. A twenty-four-foot figure dominated a spacious gallery with high ceilings and skylights. He determined the height of the piece by projecting the small drawing to the desired size on paper; using this as a template, he then cut out sections of the figure from laminated wood. The motor and body sections were assembled and secured with bracing—the last step in a process that was done at the site of the exhibition. One side of the colossus was painted neutral beige so that it would not interfere with the silhouetted Running People, presented larger than ever before; they raced across the walls, around a corner, up and across elaborate ceiling moldings. From the opposite side of the gallery, the

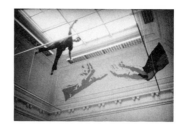

Fig. 62 Installation at Kunsthalle Basel, 1981

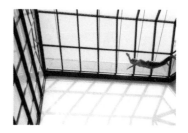

Fig. 63 Installation at Kunstmuseum Basel, 1983

Fig. 64 "Westkunst," Cologne, 1981

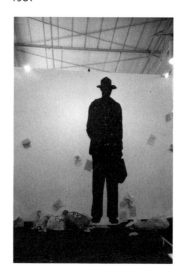

3. Borofsky first experimented with light by placing a bulb behind *My Male Self, My Female Self*, 1977–79, (pl. 38), in his studio. In the 1982 "New Work on Paper 2" exhibition at the Museum of Modern Art, New York, he installed an electronic dimmer that continuously changed the intensity of light cast on the drawing in fig. 69.

great figure was seen as a bold, black silhouette, majestically and rhythmically striking his right arm downward.

Figures flying or floating in the air or on water have always appealed to Borofsky. His earliest exhibitions included images of sailboats, birds, blimps, and dreams about flying. His 1979 Paula Cooper Gallery exhibition included a small painting of himself, *I dreamed I could fly #4* (pl. 42), which was hung at an angle from the ceiling and was the direct precursor of the three-dimensional figures. Here, as elsewhere, such forms were self-portraits. The 1980 Venice Biennale installation included Borofsky's self-portrait lamp suspended high in the space; both his 1980 Paula Cooper and M.I.T. installations contained suspended Flying Figures—flat, cut-out silhouettes of painted plastic sheeting. It was logical for Borofsky to develop this idea into a life-size carved and painted styrofoam figure of himself for the Basel installation. These suspended figures suggested dream states and outer-body experiences. Symbolically, the artist was viewing himself and his work from above; esthetically, the figures reflected his desire to transform two-dimensional imagery into three dimensions and to draw attention to unused exhibition spaces in innovative ways.

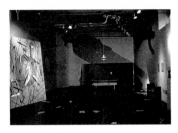

Fig. 65 Installation at Institute of Contemporary Arts, London, 1981

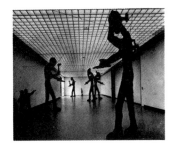

Fig. 66 Installation at Museum Boymans–van Beuningen, Rotterdam, 1982

The Man with a Briefcase dominated Borofsky's next three exhibitions. In 1979 he had made a drawing after a newspaper advertisement for men's business suits and numbered it 2,630,059. This image first appeared publicly in the Cologne ("Westkunst") installation in 1981 (fig. 64). Like the Hammering Man, it represents an archetypal worker and, like the majority of his images, it is also a self-portrait—a metaphor for the artist as worker—with Borofsky carrying his own drawing-filled briefcase. For an exhibition at the Institute of Contemporary Arts in London in 1981 (fig. 65 and pls. 184–87), he projected this image, which he called *Shadow Man*, diagonally across an entire end of the gallery and painted it on the walls in gray acrylic. The figure, approximately thirty feet from head to foot, spread across seven different architectural surfaces and was projected into a lower-ceilinged alcove of the exhibition area; the illusion, however, was of one, continuous flat surface.

For an installation at the Centre Georges Pompidou in Paris (pls. 188–90), Borofsky was again given a small space with temporary walls that did not meet the ceiling; he painted the primary figure—Man with a Briefcase—across the exposed pipes, grating, and ductwork of the ceiling. Although Borofsky also did wall drawings, the image on the ceiling and the drama he perceived in the lone figure determined the nature of his next exhibition.

The Museum Boymans–van Beuningen in Rotterdam had offered Borofsky two large, skylit, rectangular galleries for an exhibition in early 1982 (figs. 66, 67 and pls. 191–93). He used only two images—Hammering Man and the Man with a Briefcase—which had appeared in recent installations and which he felt were powerful enough to stand alone. Because he was confident that these images

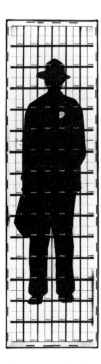

Fig. 67 Installation at Museum Boymans–van Beuningen, Rotterdam, 1982

could fill and hold an entire gallery, Borofsky experimented with the space; he presented only one idea and one image in each gallery. The exhibition was entitled "Workers," and one gallery contained five towering Hammering Men situated at different angles, each striking down his hammer at a different time. The second gallery contained the largest single image Borofsky had created—a 100-by-27-foot Man with a Briefcase covering the entire ceiling. Again, Borofsky's objective was to envelop the viewer completely in an environmental experience.

For the "Documenta 7" exhibition in Kassel, West Germany (fig. 68 and pl. 197), Borofsky worked with the same five Hammering Men shown in Rotterdam. He originally intended to place the five figures in a site-specific atmosphere—an old trainyard building used to repair railroad cars and engines. When he could not get approval for the plan, which would have juxtaposed these towering mechanical workers with massive locomotive engines, he situated the figures in a museum setting. The gallery also contained paintings by other participants in the exhibition and permanently installed nineteenth-century white-marble statues. Despite the congested look of the space, the five Hammering Men hypnotically pounded away, commanding and creating their own environment by activating the whole space and drawing the other works into an overall visual effect.

Borofsky's installation for the "Zeitgeist" exhibition in West Berlin in October 1982 was his seventh European installation in eighteen months (figs. 70, 71 and pls. 200–206). The exhibition took place in the Martin-Gropius-Bau, a war-scarred nineteenth-century building that borders the Berlin Wall and looks into East Berlin, thus creating a dramatic and politically charged atmosphere. For this exhibition Borofsky created three distinct pieces, which he placed inside and outside the building. He installed the Man with a Briefcase on the seventy-foot-high skylight in the main, central hall. The scale and the technique differed from those used in Rotterdam, where the figure on the one-hundred-foot-long ceiling could not be perceived in its entirety. In Berlin, Borofsky took advantage of the cavernous space and high ceiling, making the silhouetted figure approximately forty feet tall; the full form hovered over the space ominously. Instead of painting on the ceiling, Borofsky cut the full-size figure from black cardboard and cut that into sections corresponding to the grid structure of the skylight. These pieces were laid on top of each glass pane in a mosaiclike fashion; thus the single man was constructed from numerous pieces.

In a small corner room that faced East Berlin on one side and the former site of Gestapo headquarters on the other, Borofsky filled the walls with paintings of "red" Rubies (they were actually pinkish in color)—his symbol for the heart—to add as much warmth and beauty as possible to counteract the grim associations of the location. Outside the window, he suspended a Flying Figure (previously exhibited in Basel) that appeared to be jumping toward the Berlin Wall, thus

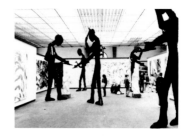

Fig. 68 Installation at Documenta, Kassel, 1982

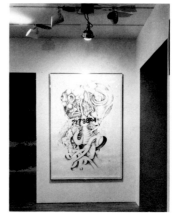

Fig. 69 *Head at 2,779,854,* 1978–82
Pencil and acrylic on paper, with automatic rheostating device, light bulb, and aluminum shade, 84¼ x 57½" (214 x 146 cm)
Collection of Mr. and Mrs. Harry W. Anderson, Atherton
(Installation at The Museum of Modern Art, New York, 1982)

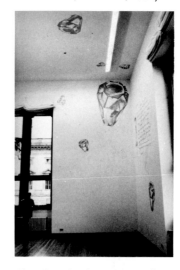

Fig. 70 "Zeitgeist," West Berlin, 1982

creating a startling human presence on the facade and its surroundings.

Borofsky's most forceful visual statement was made outside the exhibition building, directly on the Berlin Wall. He made a wall drawing of the Running Man, whose meaning was enriched by its placement on the wall. In this sense, too, the Running Man is not only a self-portrait, but also a universal type—man and his anxiety, psychological and political. Borofsky spray-painted the word *karma* on the already graffiti-covered wall to acknowledge his belief that the positive or negative force generated by a person's actions has consequences in the next life.

Borofsky's most recent exhibition at the Paula Cooper Gallery in November 1983 (fig. 72 and pls. 213–22) returned to an installation more dense in images and meanings than the preceding ones, and also more personal and self-reflective. Dominating one area was *Dancing Clown* (pl. 63), a three-dimensional version of the 1981 drawing, *Entertainer (Self-Portrait as Clown)*. The eleven-foot female figure with a clown's head stood on a stagelike platform against a curtained backdrop. The right leg of the clown-ballerina was motorized in the hip socket so that it rotated in a figure-eight dancelike motion. This entertainer represents Borofsky's public persona as a sad-faced performer—a clown presiding over the carnival-like atmosphere of the installation. The piece introduced movement and sound (the taped song "I Did It My Way" emanated from the clown). The figure was the predominant self-portrait in the installation (like the Running Man and Hammering Man in previous exhibitions) and was characterized by both male and female attributes, which often appear in Borofsky's depictions of himself. The element of sound was evident and calculated throughout the entire installation.

Chattering Men, larger-than-life-size adaptations of a stick-figure construction, were placed throughout the installation, and their jaws moved as they chattered in front of individual works. These figures functioned both as multiple self-portraits and as a surrogate audience; they provided visual and aural unity to the raucous scene, like the litter leaflets or five Hammering Men had in earlier installations. The chatter represented the obsessive internal dialogue that Borofsky sought to repress in his early *Counting from 1 to Infinity*—and later to release through dream drawings, random scribbles, sketches, and full-scale environmental installations. This exhibition, like all Borofsky's major endeavors, offered a multidimensional view of the artist's mind, expressing his esthetic, psychological, social, and political concerns and reinforcing his dictum that "All is One." The installations can be perceived as parts of a larger, evolving expression of the whole artist and, by extension, of the whole world.

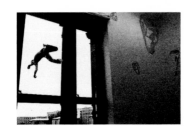

Fig. 71 "Zeitgeist," West Berlin, 1982

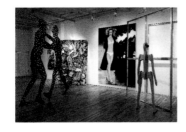

Fig. 72 Installation at Paula Cooper Gallery, New York, 1983

Installations

I wish I could come up with a better word than "installation." For me, it has to do with an awareness of space, and making other people conscious of the entire space they are in, not just the space that the object occupies on the wall. I think of these as walk-in three-dimensional paintings—a stage set, only in this case the viewer is allowed on the stage to participate.

Paula Cooper Gallery, New York, 1975

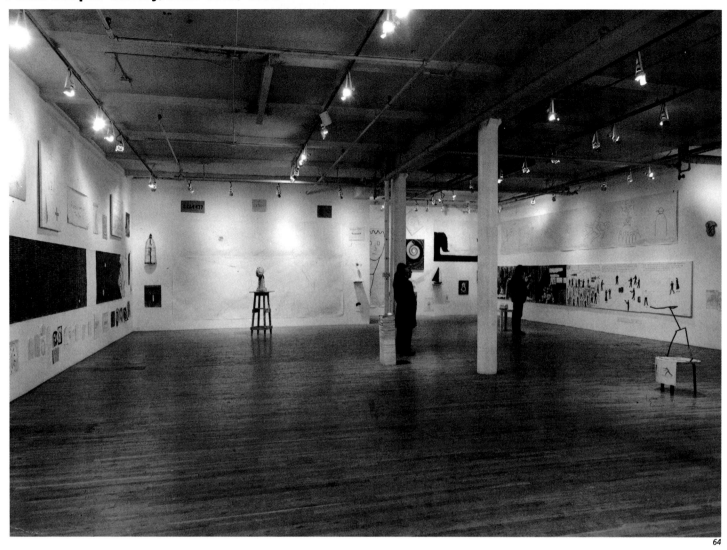

64

In my first show at the Paula Cooper Gallery in 1975, I was making so much work that it felt natural to jam it all into one space. This arrangement represented my attitude that everything is good—there was no real selection process, or if there was, it was minimal. I didn't pare my output down to the ten best objects and put them under glass or frame them in preparation for a sale. My show wasn't about that, but about bringing in all that I had been thinking about,

all that I had been working through in the last year (the little scraps of paper as well as the finished paintings). The show seemed to give people a feeling of being inside my mind. But it was also not unlike walking into a supermarket (which was a major dream I had had earlier), where there is just so much stuff all over, colors, and boxes of food, and prices and numbers and things hanging off the ceiling. It's just that kind of experience.

In part, the idea in my 1975 show was to reproduce some of the feeling that was in my studio. My work was very personal. I tried to illustrate the workings of my mind-dreams and various psychological states. Both conscious and unconscious were exposed for the sake of making human connections with others who had similar states of mind—a sort of psychological comparing of notes. There was a large mass of work, including sculpture and painting, in a lot of

different styles that were overlapping each other. They were tacked up all around my studio. I had work on the ceiling, on the floor, and on the walls, and I thought I would try to get that encompassed feeling at the gallery.

I'm always making parts of a whole, and my installations try to make that whole clear and complete. The parts can be read individually, yet at the same time there are

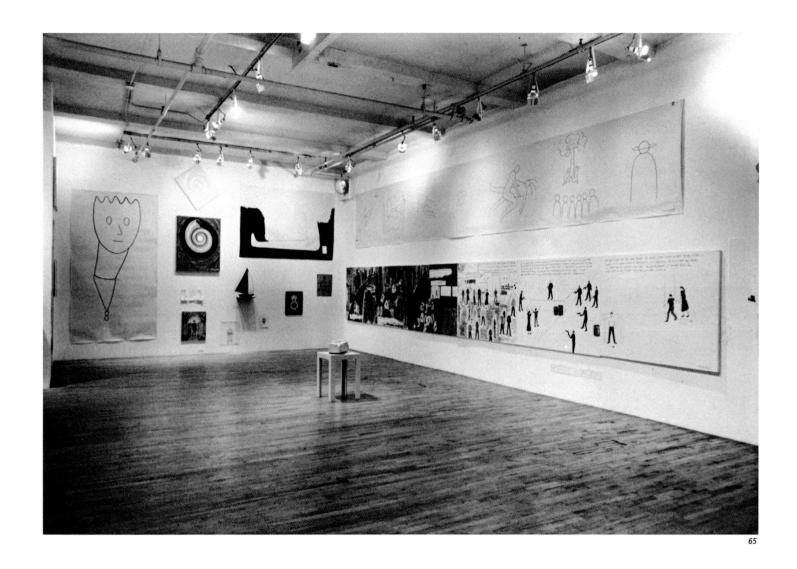

65

connections that complete them. This is implied by the placement of a number on each work in this show. In fact, I had considered tying a ribbon from each work in the gallery to the stack of numbers in the middle of the room to show that every-thing was coming out of or going back to this center.

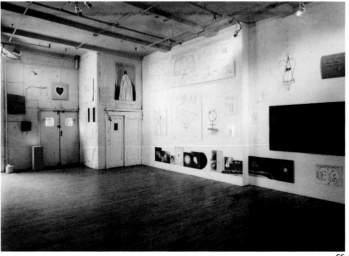

66

Fine Arts Building, New York, 1975

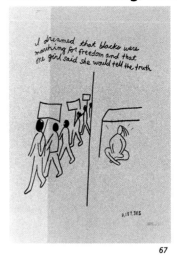

67

Paula Cooper Gallery, New York, Winter 1976

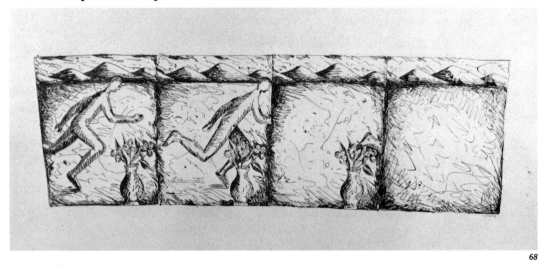

68

Biennale, Venice, 1976

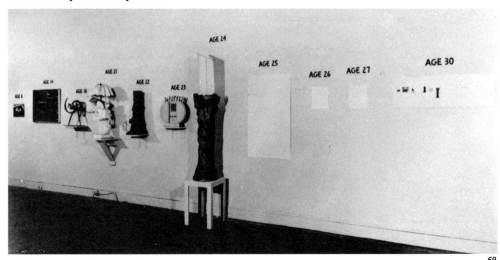

69

Artist's studio, New York, 1975–76

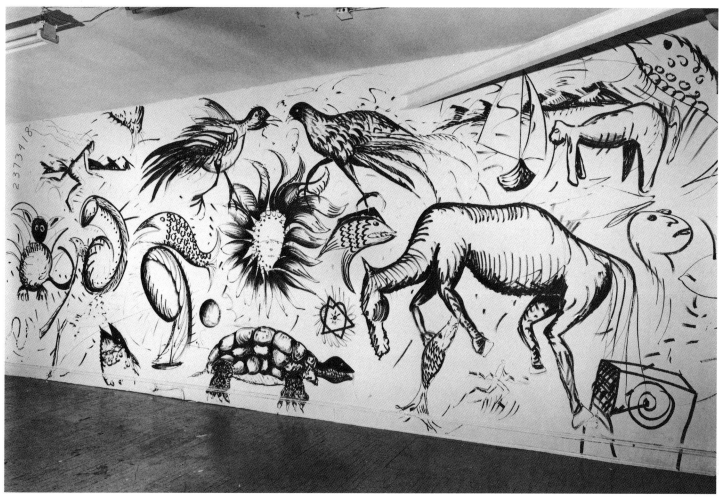

70

I wanted to do something very direct and personal, so I painted a large wall in my studio (about twelve by thirty feet). At the end of the month I thought, this is a pretty brave thing. It is more direct than I've ever worked before.

The wall painting in my studio was a personal Guernica, that is, a personal purging, it seemed, of a lot of anxiety and imagery. The painting was a personal protest rather than a public one. I stayed in my studio, almost always alone, for one month. I worked all the time, especially through the night and early morning hours when the city was quiet, and I would sleep in the same room some ten feet away. By working directly on the walls of this white room, I felt like a twentieth-century cave painter. At the end of the month all I could think about was painting the wall white again, which I did almost immediately, but not before a friend took some slides of what had been done.

Still, wall drawing seemed very exciting, and I wanted to bring this attitude into the art world—drawing images directly onto the wall. I later found a tool, the opaque projector, to help me, and I started to make hundreds of small drawings that could be carried in my briefcase to each exhibition and projected on the walls. This made the execution much faster than the month it took to do the original wall work in my studio. The projector stimulated me to make paintings in corners, on ceilings, or over windows.

I was very aware that I was making works that would be unsalable. One had to appreciate the work for its beauty and/or content at the moment it was being seen, for it was understood that it would be painted over at the end of the month. This seemed closer to the way life works—we are here for a short time and then we are gone. The idea of preserving a work of art forever has always seemed a little absurd to me although I can appreciate the need to give us historical perspective.

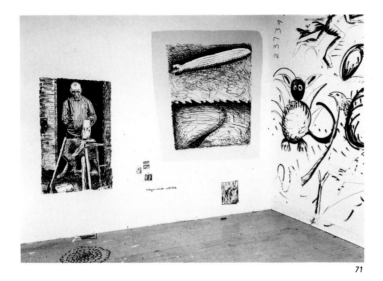

71

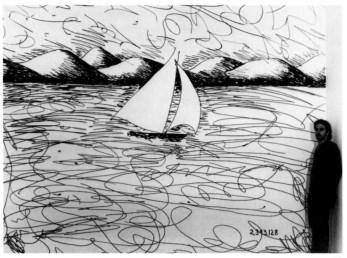

72

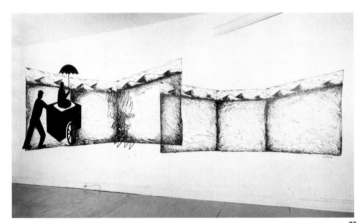

73

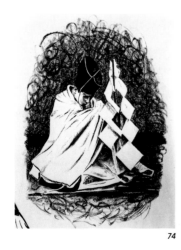
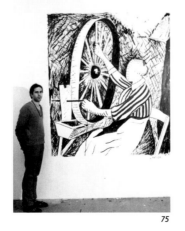

74

75

76

Artist's studio, New York

110

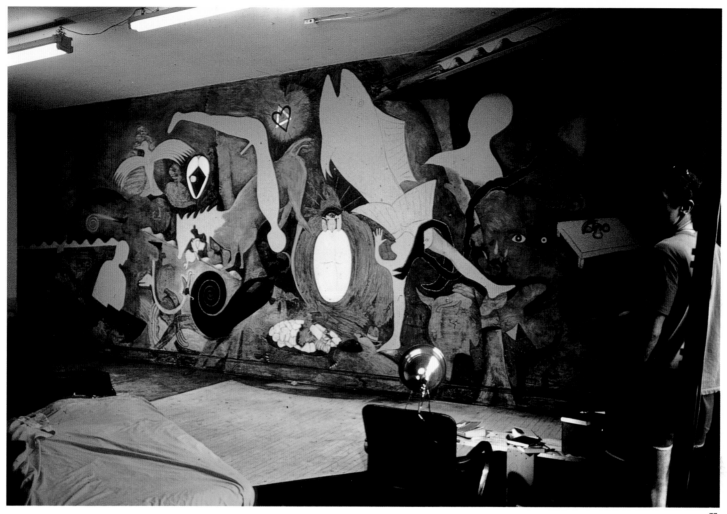

77

78

Wadsworth Atheneum, Hartford, 1976

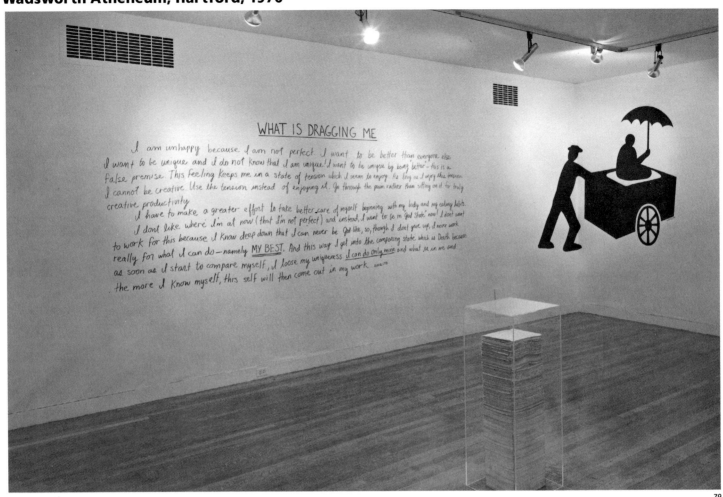

WHAT IS DRAGGING ME

I am unhappy because I am not perfect. I want to be better than everyone else. I want to be unique and if I do not know that I am unique I want to be unique by being better - this is a false premise. This feeling keeps me in a state of tension which I seem to enjoy. As long as I enjoy this tension I cannot be creative. Use the tension instead of enjoying it. Go through the pain rather than sitting on it for truly creative productivity

I have to make a greater effort to take better care of myself beginning with my body and my eating habits.

I don't like where I'm at now (that I'm not perfect) and instead, I want to be in "God State" now! I don't want to work for this because I know deep down that I can never be God like, so, though I don't give up, I never work really for what I can do — namely MY BEST. And this way I get into the comparing state, which is Death because as soon as I start to compare myself, I loose my uniqueness I can do only mine and what is in me and the more I know myself, this self will then come out in my work.

79

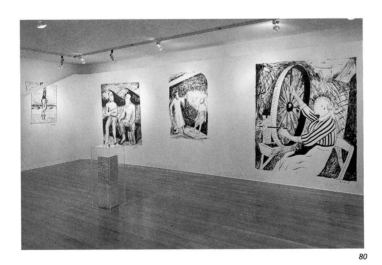

80

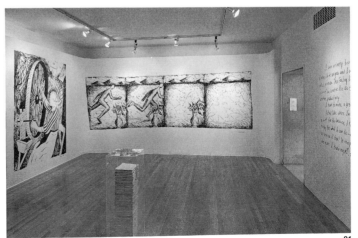

81

Paula Cooper Gallery, New York, 1976

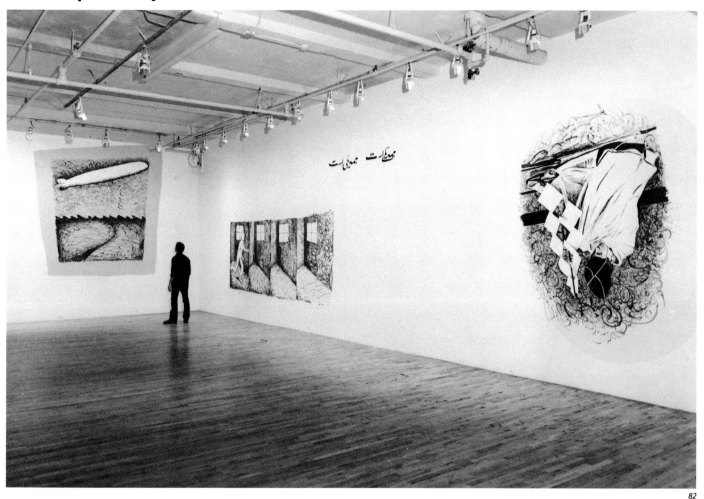

82

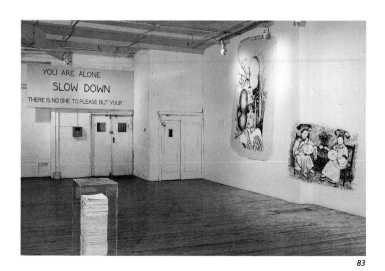

83

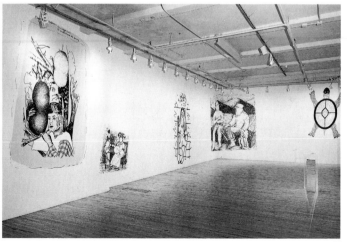

84

State University College, Buffalo, 1977

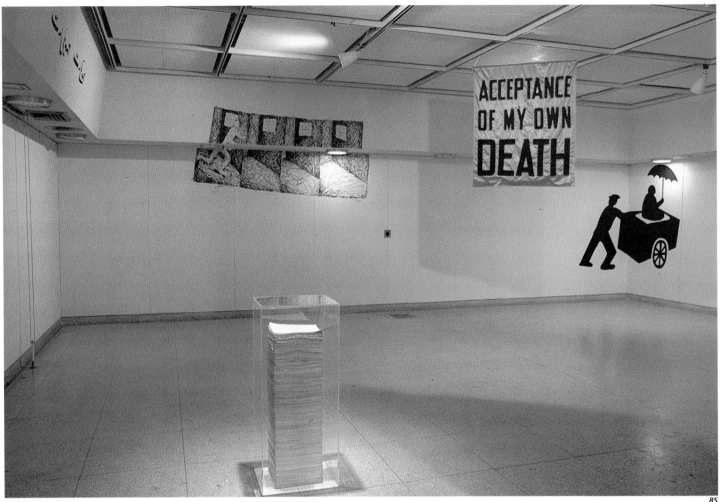

85

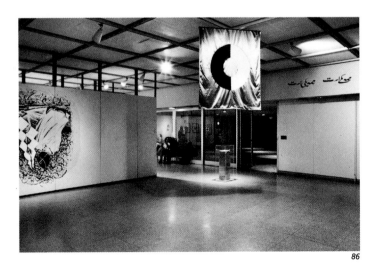

86

Men's shelter, New York, 1977

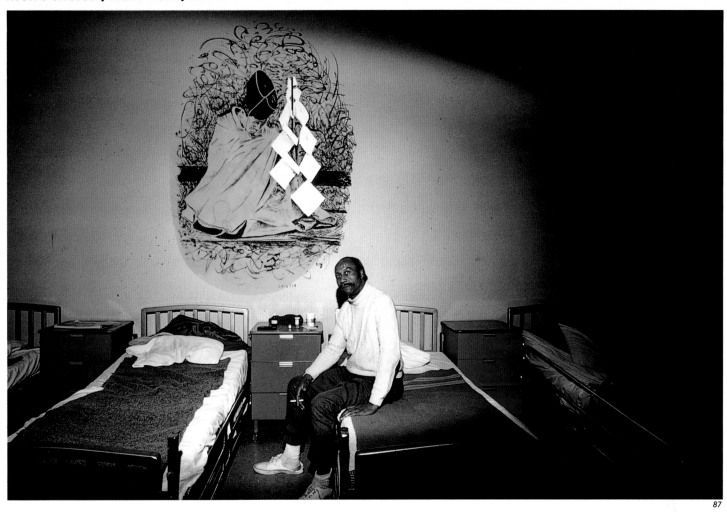

I felt very nervous, closed in, and self-conscious in the men's shelter because I was with a bunch of sick men who were lying in bed. I was talking to them, trying to make them comfortable, trying to make me comfortable and to figure out why the hell I was doing this in the first place. I didn't think I could do a whole installation—and the room was already an installation, for me, anyhow; it was as if there was nothing I could add. I thought I would try to do a very beautiful image in this rather difficult space. At first, I was going to do the Blimp (which for me was a very beautiful image) on a light blue background. It was just at the last minute, again with the potential of installation, that I projected the Shinto priest on the wall. It just seemed to be what I had to do. I wasn't sure the image was going to be right for these men, or what should be in a hospital, but I thought I had to do this subject. For me it is a healer, a healing image, and it's about meditation, but it is questionable what sense it makes —a Japanese Shinto priest in a hospital wing for homeless men. It was incongruous—for I ended up putting a very acidy green behind it on walls that were stained yellow, and ugly.

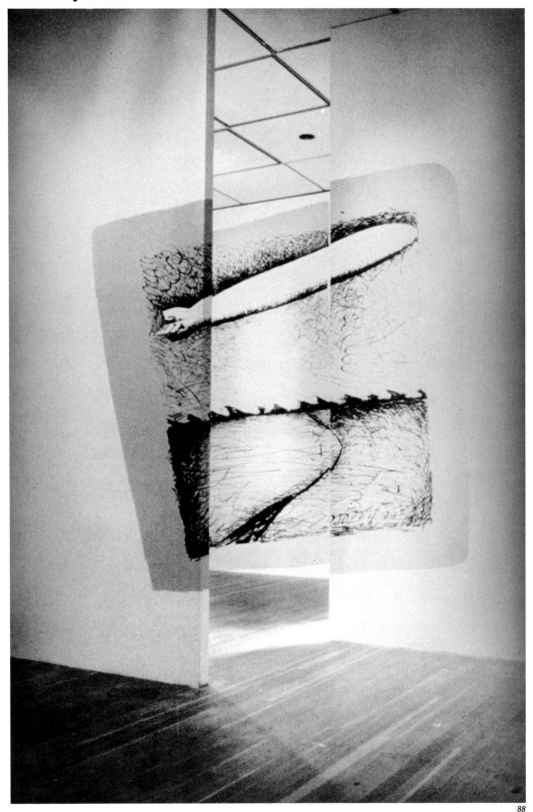

88

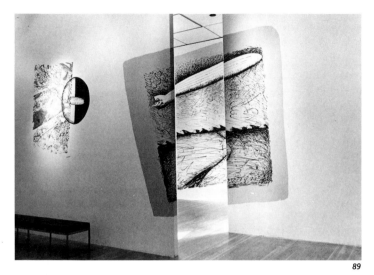

89

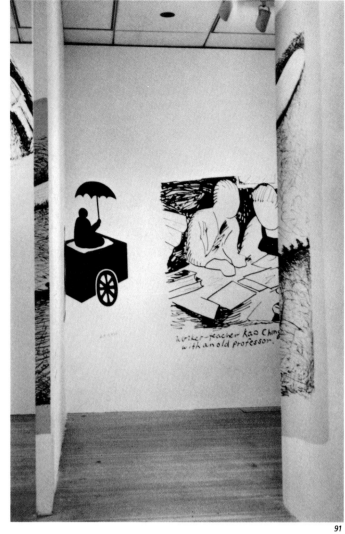

91

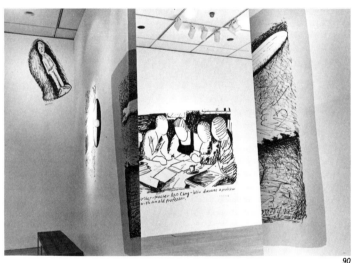

90

I would find the key point of three-dimensional architectural interest in a room, the one I could do the most with, and play with the two-dimensional possibilities of a painting, trying to bring the two together.

The Blimp was the major piece at Irvine. It was a unique painting that was on four surfaces. I had done it on three surfaces before, but Irvine was a breakthrough, for there you could walk through the painting. Only later did I begin to make imitations of some of these things with portable canvas stretchers, a corner canvas, and so forth.

I also wanted to activate the entire space, not just one point in it. I wanted to make you feel you were inside an environment. I began to work as if on a painting. I moved around, going from one part of the room to the other, trying to get some energy going everywhere. It was as if I were making a painting, but in six dimensions: four walls, the ceiling, and the floor. When people walked into the installation, the room was a beautiful work, as itself. There were green, pink, and yellow contrasts. When you turned inside the painting (the room) you got a three-dimensional effect. It happened to be a very big space, and I remember working day and night and pushing myself to my limits.

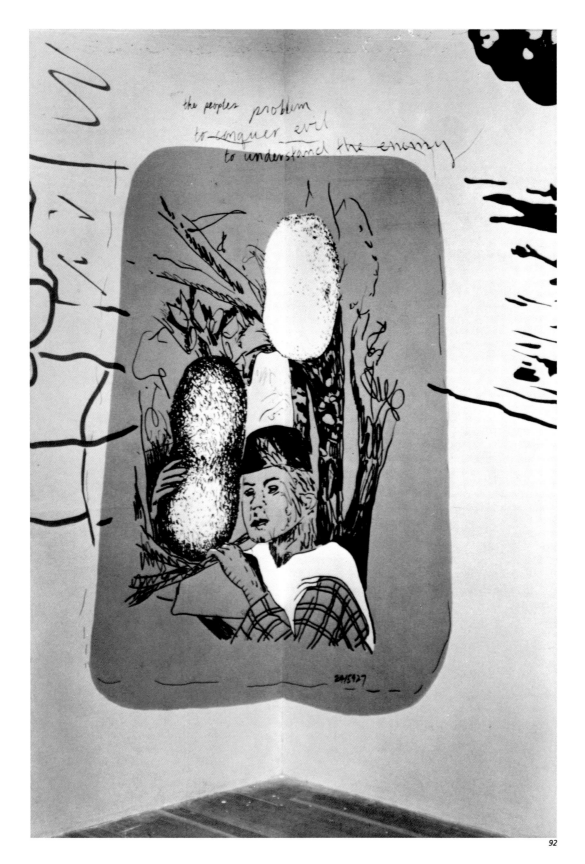

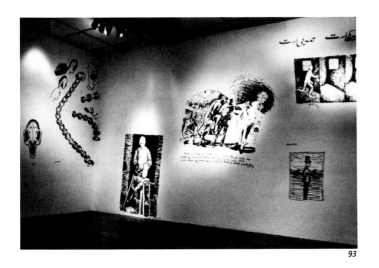

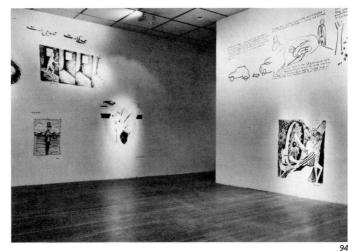

93

94

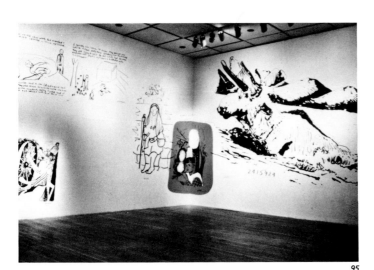

95

96

I was very conscious of the fact that this was a school campus, so I put the image of a Chinese teacher talking to his students in the first room. As I was working one day, two students came in to show me a bird's skull they had found. We laid it in the opaque projector and saw a beautiful set of shadows projected on the wall. I instantly drew them into place.

I like bringing a lot of drawings with me, some recent and others from much earlier. It allows me to go back and pull out an old image and bring it into context with new images. That always feels psychologically correct. It has a feeling of condensation of time.

Choosing and arranging images has to do with balancing inner and outer worlds; an outer image of someone working balances an inner dream image. So when you hop from one image to the next, some kind of tension is worked out.

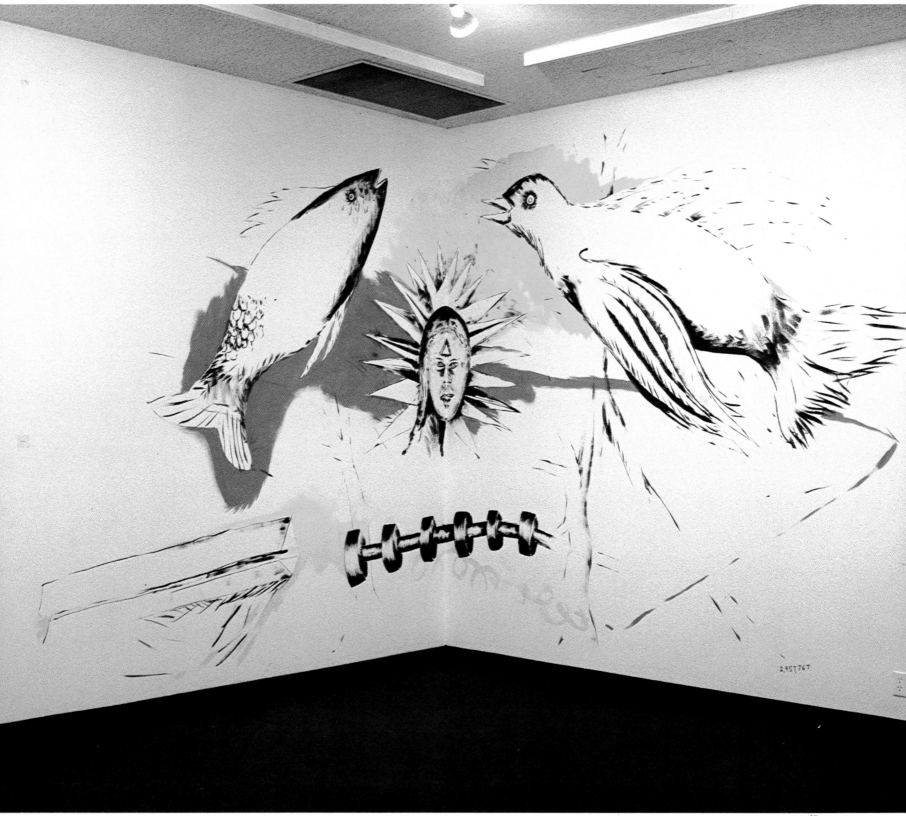

97

Protetch-McIntosh Gallery, Washington, D.C., 1978

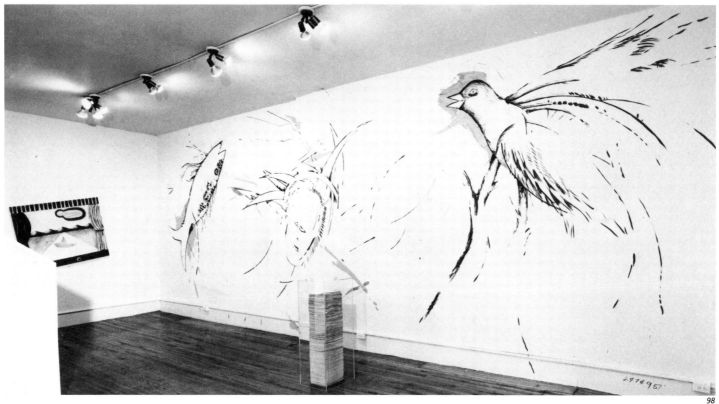

98

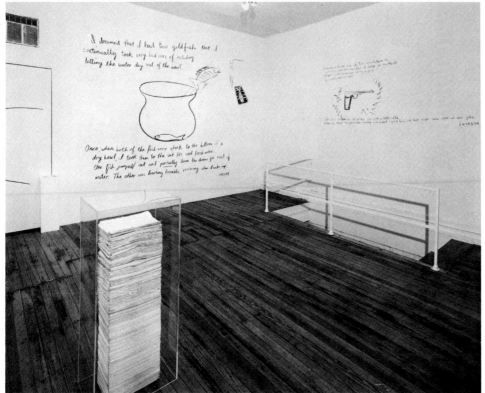

99

100

Writing on diagonal wall above desk reads "I dreamed that blacks were marching for freedom and one girl said she would tell the truth."

Thomas Lewallen Gallery, Los Angeles, 1978

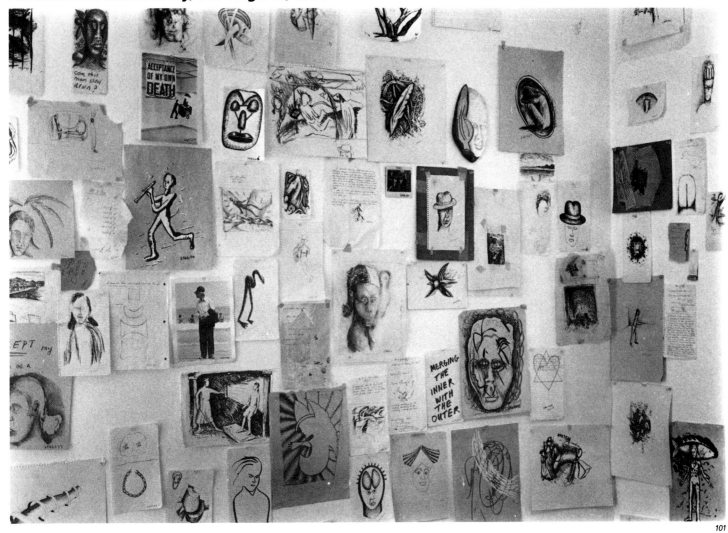

101

102

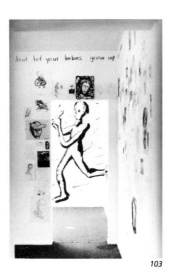

103

At the Thomas Lewallen Gallery I pushpinned a great many little drawings close together on the wall. With no frames, they seemed much more direct and less precious. I have nothing against frames. It's just that because the drawings will end up in frames sooner or later, it is my prerogative (while I still own them) to let people experience them firsthand. I had so many drawings that it seemed like an exciting and honest way to present myself and the work. The precedent for this attitude had already been set at my first show at Paula Cooper's in 1975 and continued at the Museum of Modern Art in 1982.

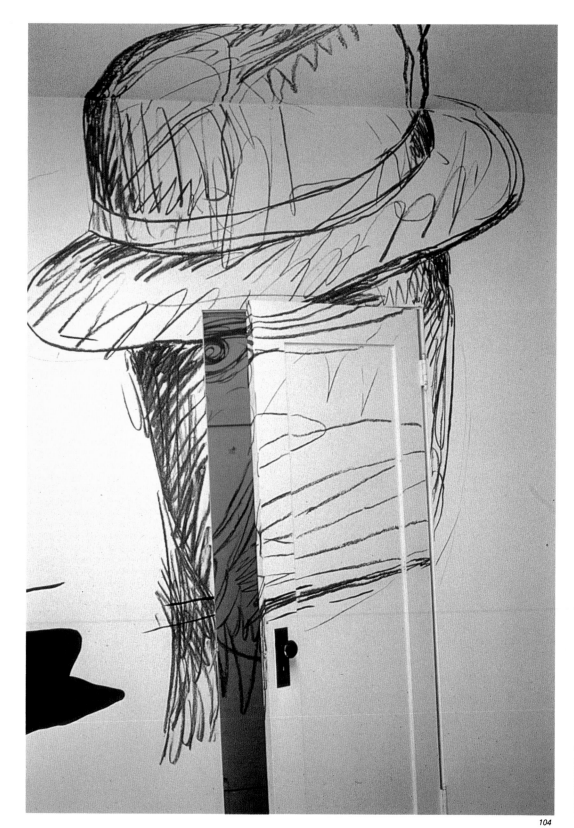

104

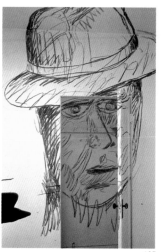

105

123

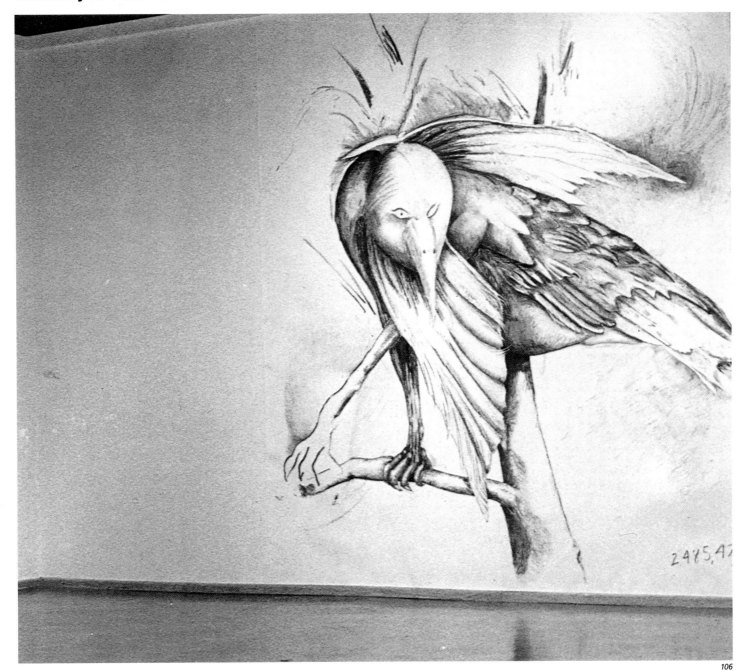

106

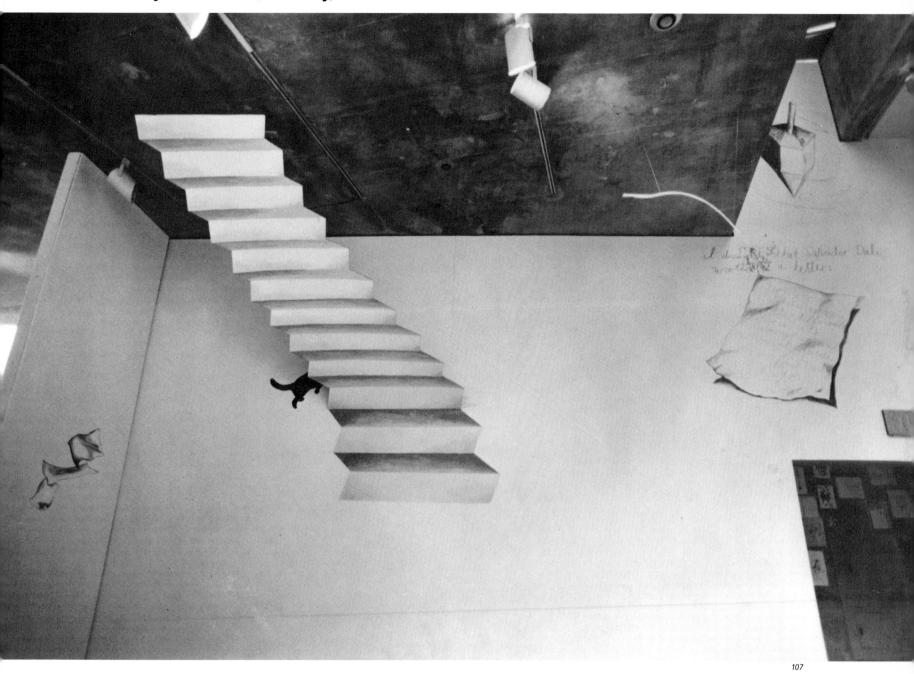

107

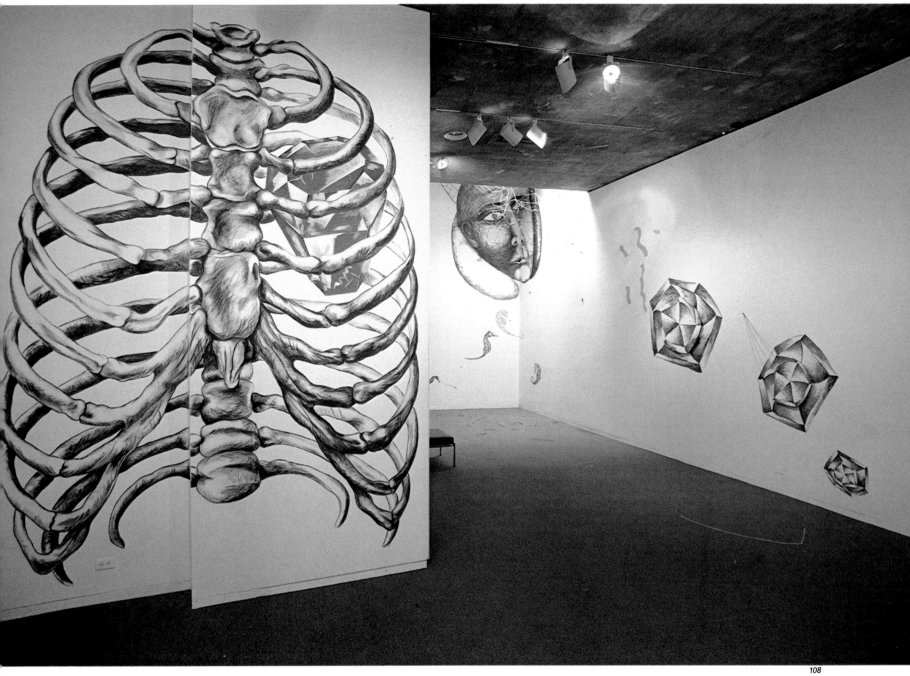

108

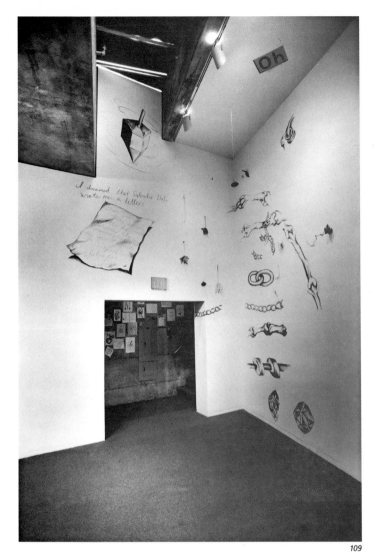

109

I started to learn from my students, who were painting in different ways, but I learned things through the interaction of working together, too. I was less a teacher than a leader and a student. It seemed that there was a future in this "group action" for me and I wanted to continue that. When it was time to do the Berkeley show, I considered bringing the whole crew up from Cal Arts. Eventually, however, I decided that was too much. Since Megan Williams is very talented, and we were going to travel anyhow, I wanted to work with her.

Megan and I would sit down every day and make sketches and throw out ideas. We continuously came up with the idea of one image inside another, for example, the Ruby inside the ribcage. I projected a head in the far corner, and she was going to do a string head around it, in her style. I don't know where the idea for the Running Man in the spiral came from, but it was probably more from her. This was the first cutout of the Running Man. I just slapped paint on a sheet of cardboard and she made a great spiral that was running through space; that led me, within the year, to make a big cutout of the Running Man. Out of that show came the Ruby, which I had never painted before and which I had designed specifically for it. Those are the two major works that came out of this collaboration.

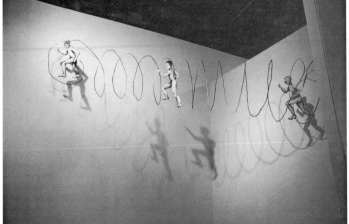

110

California Institute of the Arts, Valencia, 1978

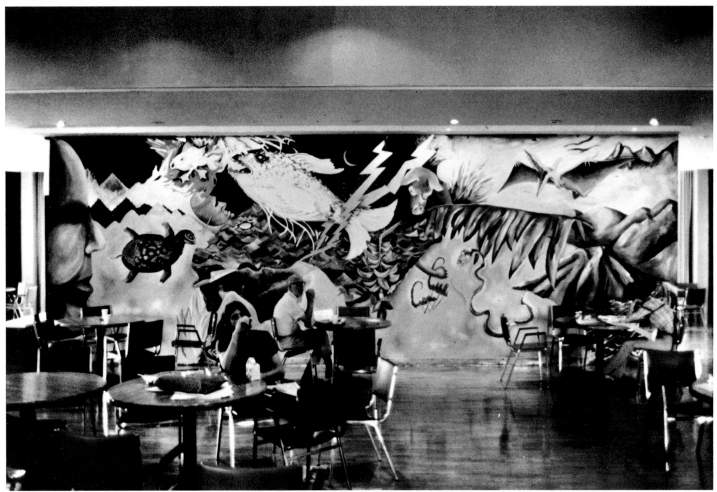

111

112

Drawings on cafeteria walls were
the collaboration of Borofsky and
his students.

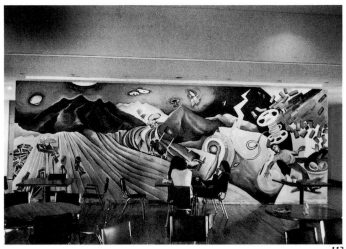

113

128

Corps de Garde, Groningen, 1978

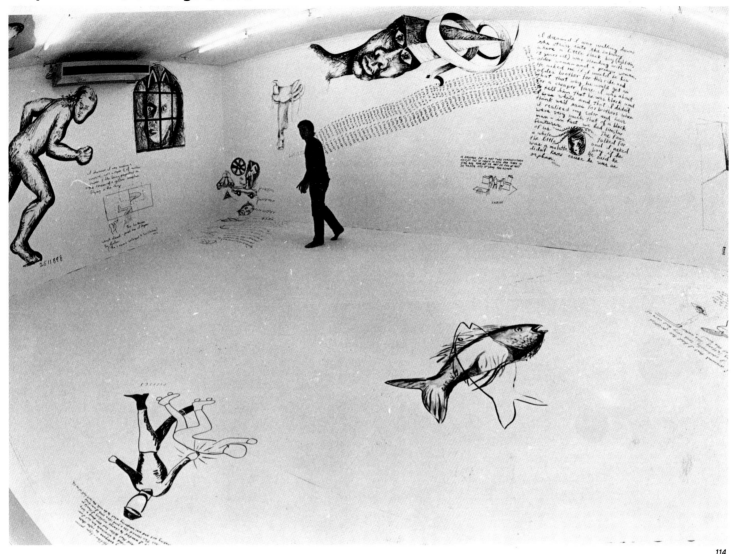

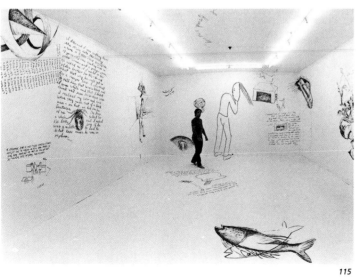

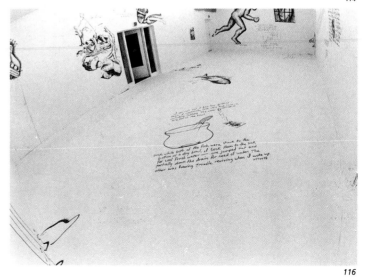

114

115

116

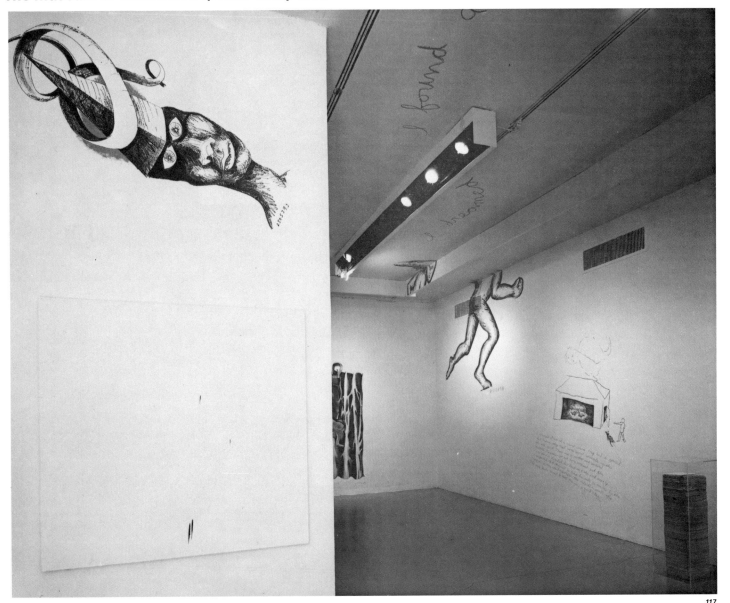

117

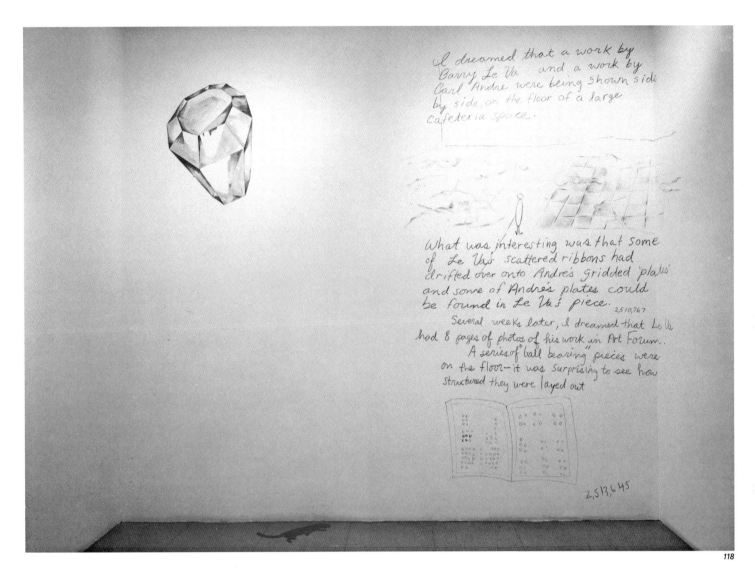

118

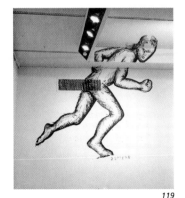

119

120

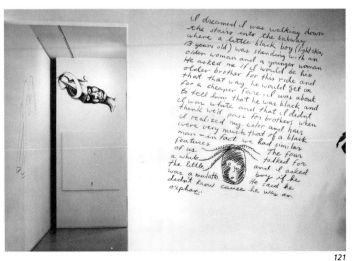

121

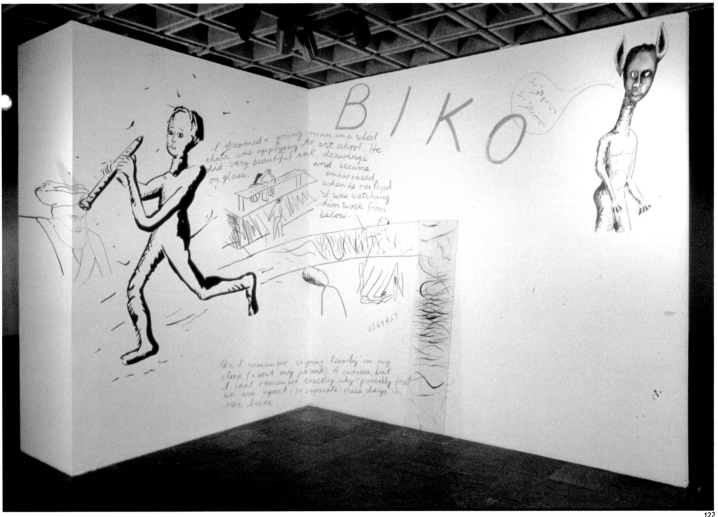

122

The installation for the 1979 Whitney Museum "Biennial Exhibition" dealt very clearly with both my inner and outer anxieties. The inner was in the center, in a dream about being an artist in a wheelchair and making ink drawings on glass. I actually made an ink drawing on a large piece of glass and leaned it against the dream. There were other personal references—some to my mother and father. The installation extended outside to some events of the time, including Khomeini and a weird little figure spouting the statement "All is One, All is One" in Persian. Nearby appeared the reference, in large graffiti-like Day-Glo letters, to Steve Biko, the South African leader who was killed in his cell. Among all these references to both inner and outer anxieties was my self-portrait, in a sense, walking through this landscape as musician—a flute player.

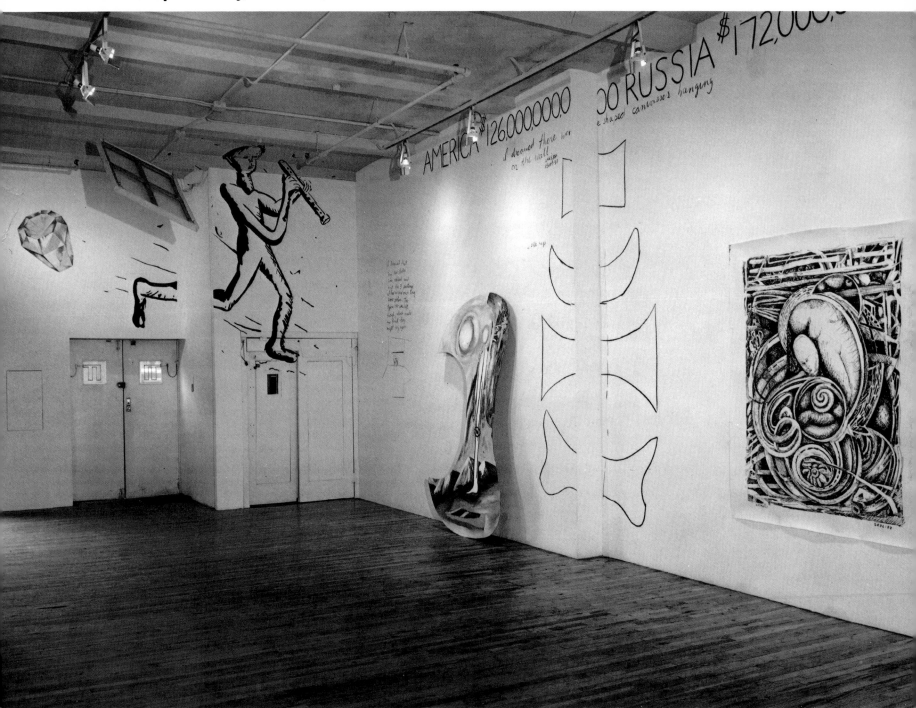

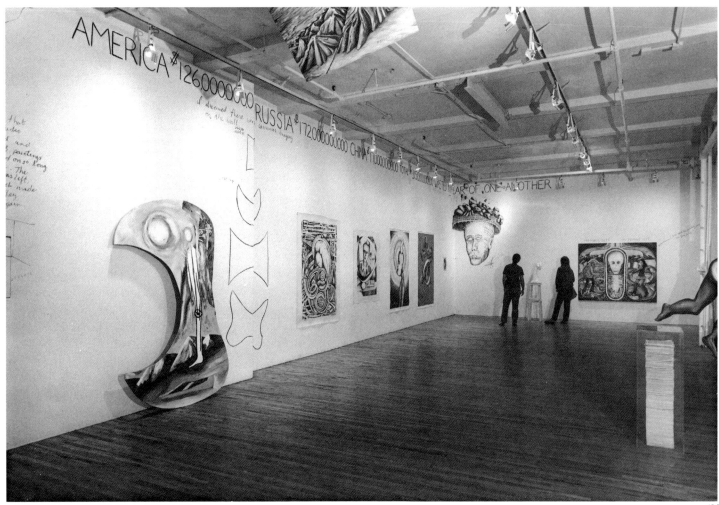

124

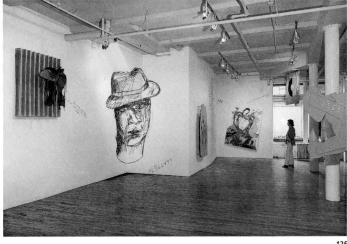

125

Paula Cooper Gallery, New York

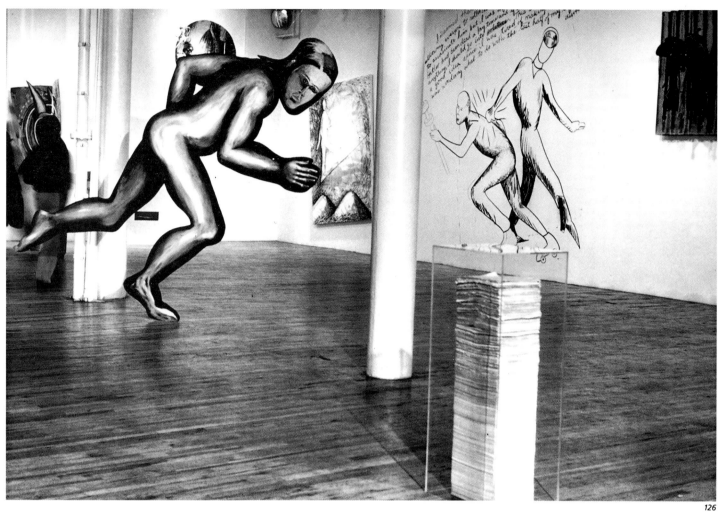

126

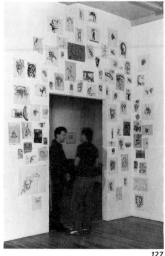

127

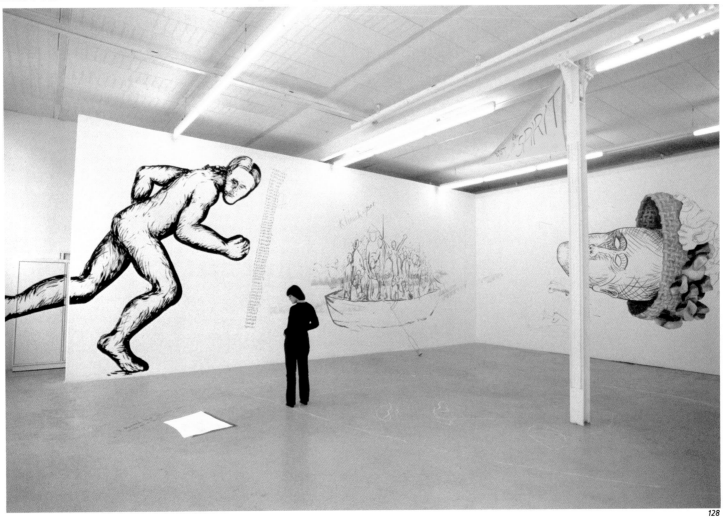

128

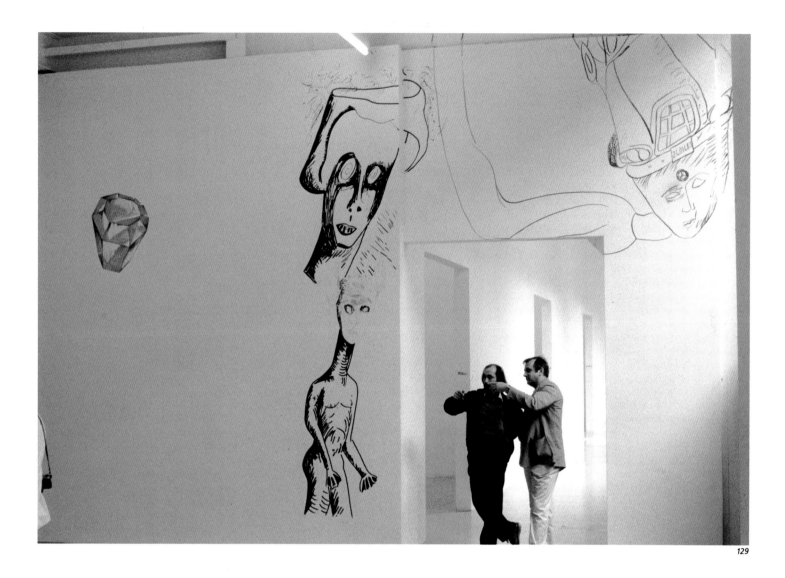

129

130

131

132

137

Ben Shahn Gallery, Wayne, 1979

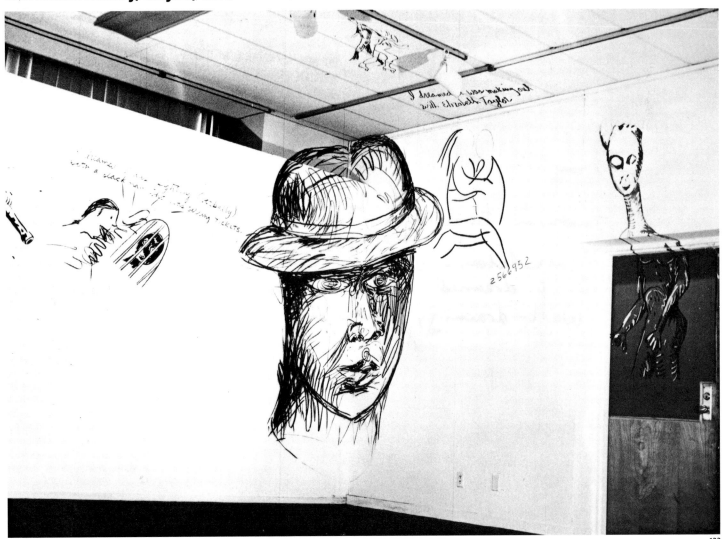

133

Paula Cooper Gallery, New York, Fall 1979

134

Neuberger Museum, Purchase, 1979

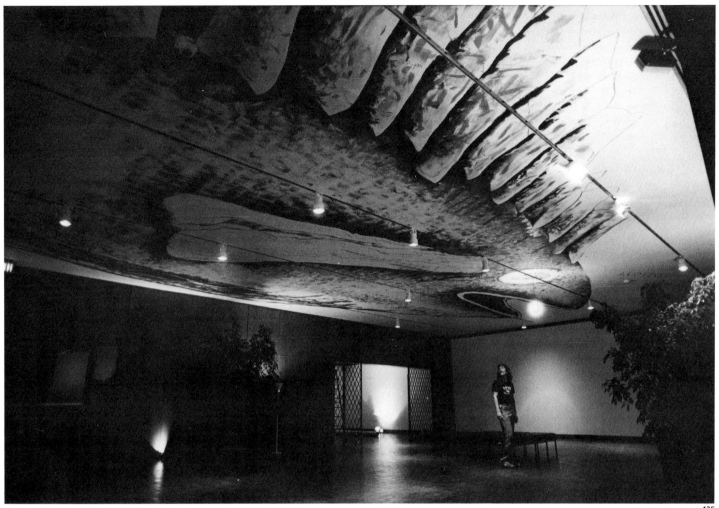

135

The ceiling was about one hundred feet long and I had only seven days to work. Too short a time, really. I used large rollers for most of the painting. The Ruby was put in for the eye of the fish, and the light bulb hung out of the eye to break up the space. The Ruby is my symbol for beauty and the heart. It first came to me in a dream.

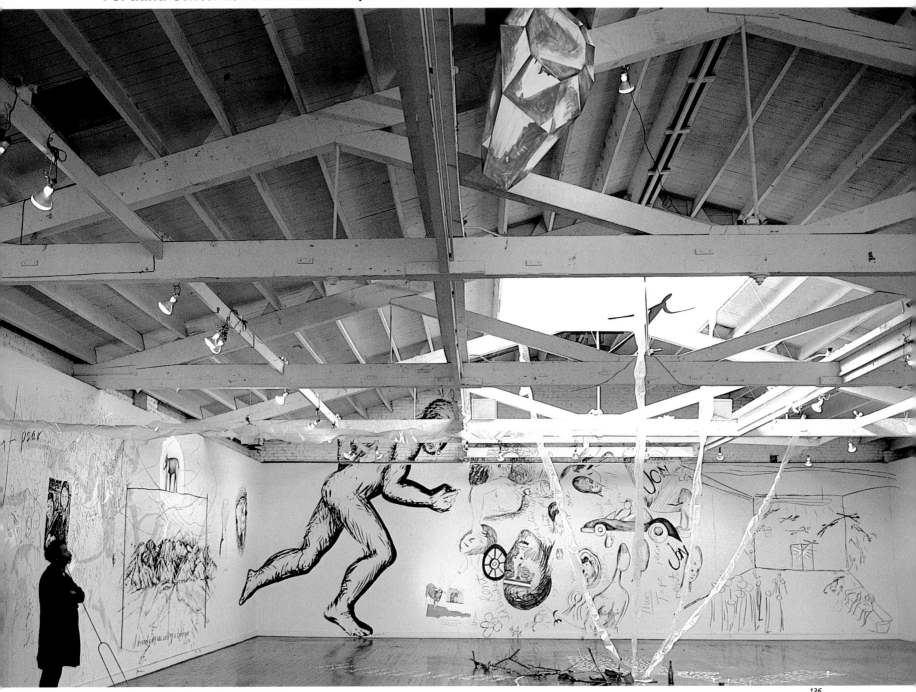

136

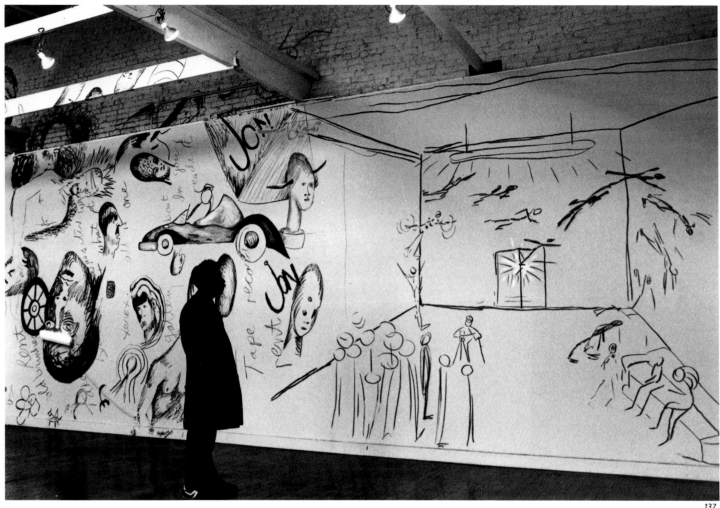

Portland was about my biggest undertaking: over twenty-four major paintings on the wall done in about fourteen days of work. I worked for two weeks, day and night, filling the huge space with various images from my inner self as well as images referring to outer political states. There was a skylight near the center of the room in which I made a cardboard silhouette cutout —the first *Flying Figure*.

The "boat people" kept popping into my head, like everyone else's, because it was on the front page of the newspapers. It had secondary meanings for me, being a boat person myself—that was an extra psychological vantage that I could bring to it. But it is not necessary that other people know this or that a boat for me always symbolizes freedom and escape.

The *Running Man* became Bigfoot for most people in Portland because of the local legend of a giant running through the woods. Even though I hadn't known about this myth, the figure took on that meaning. That's an example of what can happen to anybody who uses the same image in different contexts. I like my images to have the possibility of several different meanings, though I might have a specific one in mind for myself. The work is successful if it attracts meaning.

I was making almost a three-dimensional theater set, but not for people to view from their seats; they walked into it, were on the set, and therefore, began to be the actors in a sense. I was trying to create a picture of the universe, in this installation especially, and I included planets as part of that conception. There's the real world right here that's facing us every day, politically or personally, and then there's the outer world as it extends into the heavens. So I wanted to suggest it all.

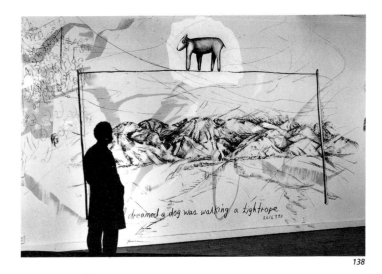

138

139

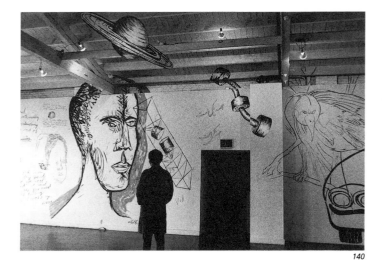

140

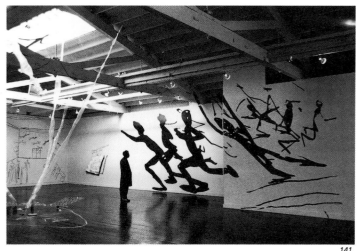

141

When I walk into a space and I'm not sure what I'm going to do, there is excitement and tension because the work has not been solved in my studio. What I am about to do may succeed or fail. All I have done is made some preparations, done a little practice, warm-ups, and hope that things will fall into place. So I take that tension, which is very much in the present, right into the production of the show. I start to feel the territory, the people I am dealing with, the people who are going to see the show, the city I am in, and what my feelings are. All this can be slowly felt out and incorporated into the large painting-sculpture that I am making in the space at that time. This is different from making a painting in a studio, deciding that it's successful, and hanging it in an exhibition. Installations are a little more tense, a little more anxious, a little more uncertain.

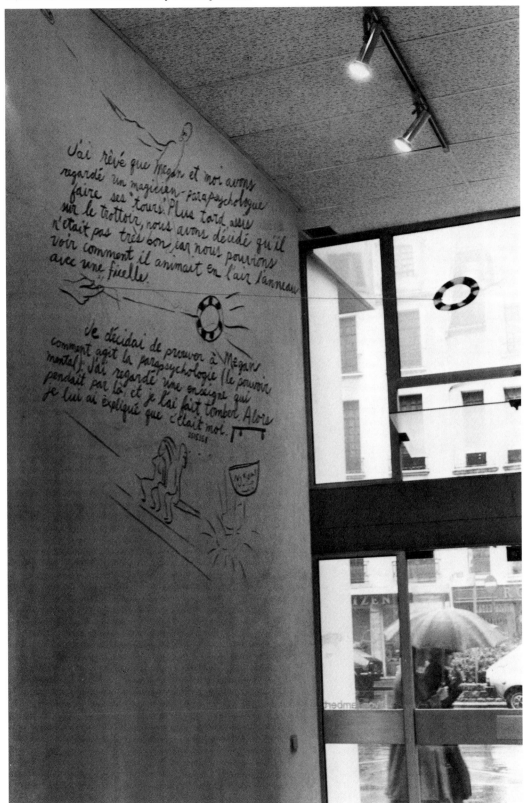

142

143

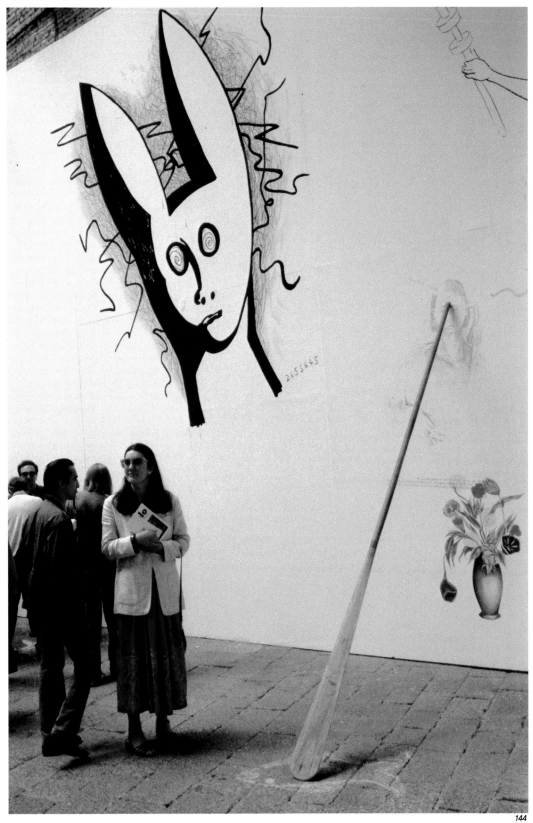

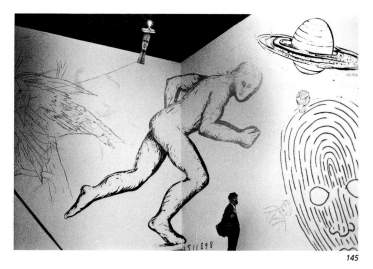
145

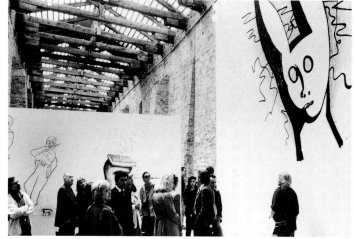
146

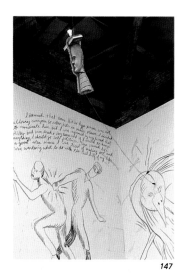
147

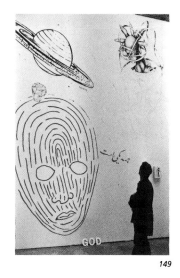
148

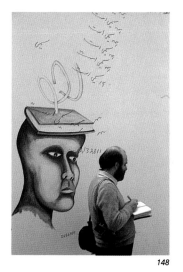
149

A vase of flowers is beautiful and better than any sculpture I could probably put together—and it is like my mother to me. She paints a lot of vases of flowers, and there's some connection with mother to the vase of flowers. It's also the idea that a vase is a hollow vessel like a head and out of it comes flowers—beautiful thoughts. Those are connections you make afterward, but I think that I needed color in the Venice Biennale—and what's more colorful and has more

beautiful forms than some flowers. But flowers are also funereal, and in Venice I painted the beautiful flowers under the Cambodian woman holding her dead baby. You know, I could find four or five different reasons why it's the correct image to have there.

I included a Cambodian woman holding her dead child (drawn in pencil on the wall) with a gondola oar coming from her forehead to the fish on the floor. The pole leans against her

forehead in the third-eye spot as a transmitter of her energy to the earth, or vice versa.

The first Hammering Man appeared here as a drawing that I photocopied in thousands [pl. 196] and put on hooks below a sign reading "Take one please."

I'd been playing Ping-Pong at Cal Arts, and it seemed a relevant idea for an artwork. When you're playing sports and you make a bad shot, you can become angry with yourself. If you're losing, there's anxiety. If you're doing well and winning, you're happy about life. There are all sorts of parallels between sports and the way one leads one's own life. You have to risk a bad shot to make a great one. If the player you are playing with doesn't play well, it's usually a drag for you; if he or she is equal to you, or better, it's a better game for you. As we know in life, if both parties are having a good time and take it as a game, even praise the other player for making a good shot, that's one kind of attitude; but if you've got to beat the other player at all costs, that's another kind. All the flavorings of what goes on in the real world—anger, jealousy, anxiety, or working together—seem to be condensed in that game.

Two sides of a table with a net in the middle, not unlike other sports, signify the division. The net is symbolically the center of activity. It was logical to make it into a painted sculpture that one could actually use and play with. It would also incorporate life, action, and sound into this set, or this three-dimensional painting that I created. People could not only walk through the installation, but also take part in it—and at one point be the action as somebody else watched. They would be actors in this set. I had a lot of possibilities for how it could work, and for me it's rather a profound piece. In one version, I painted a white "plus" on the black side of the table and a black "minus" on the white side. Some people preferred to play only on the positive side. If you have only the plus side playing with no minus side, you can't have a Ping-Pong game, and vice versa. You have to have both sides playing, and that's when it's a question of getting the energy going between you, an equal kind of energy, preferably, for a good game.

I tried to keep the table near the defense budgets written on the wall. In Basel I painted the defense budgets for the USSR and U.S. right on the table. The key to the table is the light hanging over it with a sign saying "Feel Free to Play." That, obviously, has a double meaning. Can you feel free to play on this planet when the arms race is going on around you? Do you feel free as a human being and can you feel free enough? Or it has the other meaning: feel free to play at this table—you are welcome to play in this museum today. The Ping-Pong table is everything: installation, content, sculpture, painting, sound, and participating piece. It's an ultimate work for me.

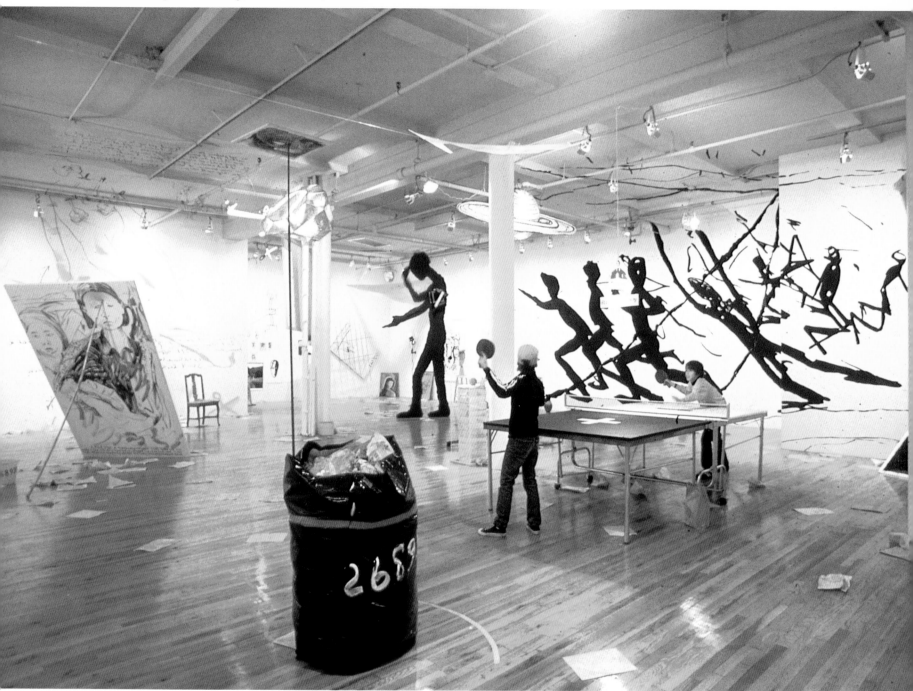

150

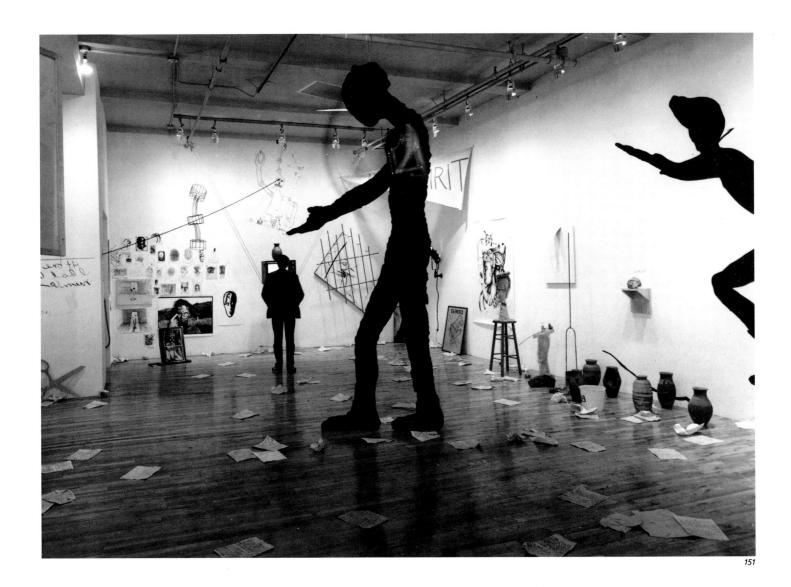

151

My images come from two sources: inner and outer. The deepest inner source is, possibly, my dreams. Other inner images come from my subconscious, such as telephone scribbles and drawings that I make on the beach. All these I see as photographs of different states of mind. The outer images are derived from photographs or life experiences.

The image of the Cambodian mother is taken from a newspaper photograph, which I projected onto a canvas. The pole was always a part of the painting, but I added the bucket and leaflets at this showing.

Paula Cooper Gallery, New York

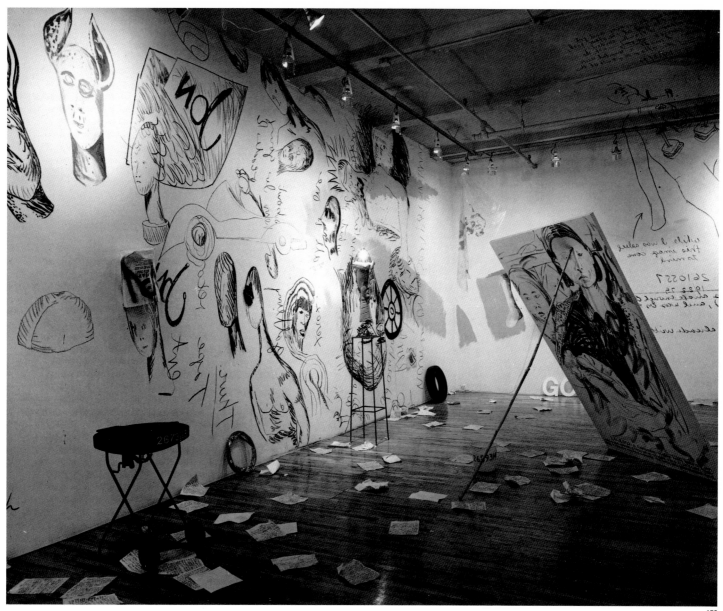

152

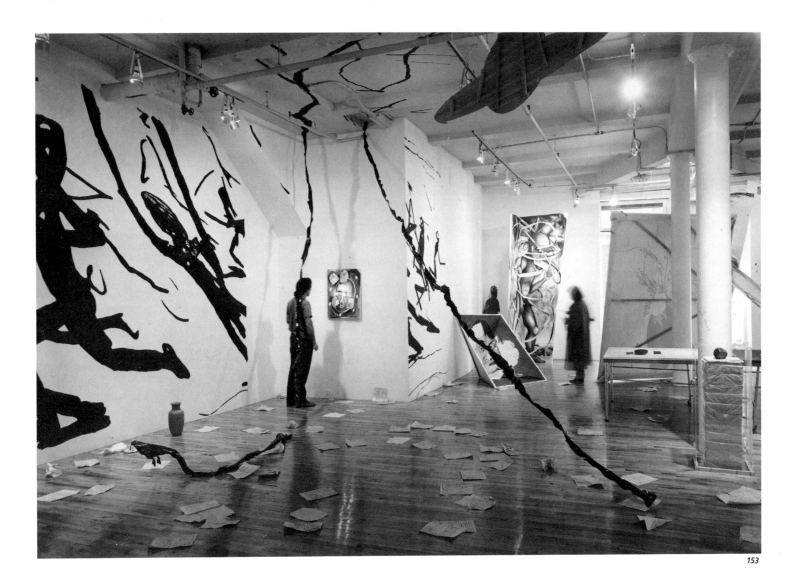

153

154

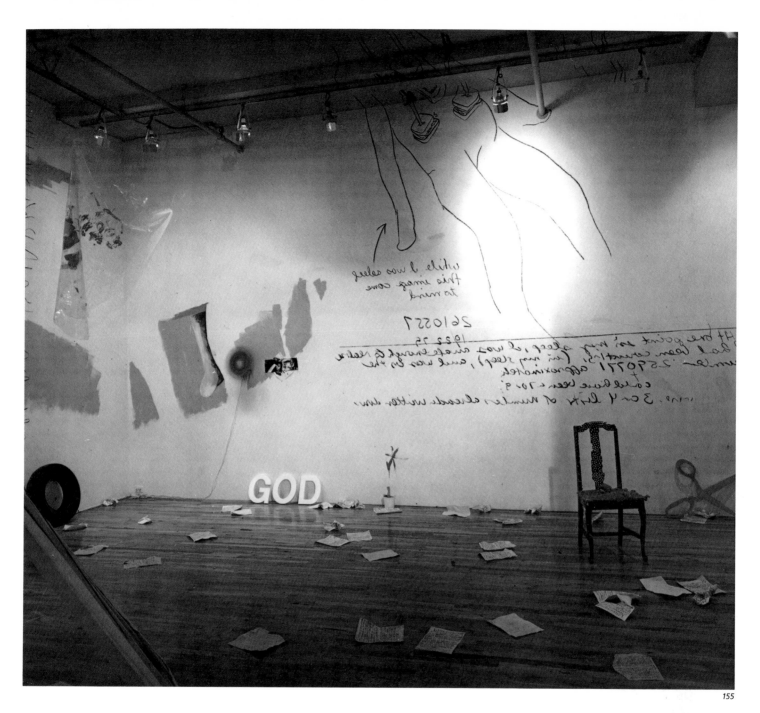

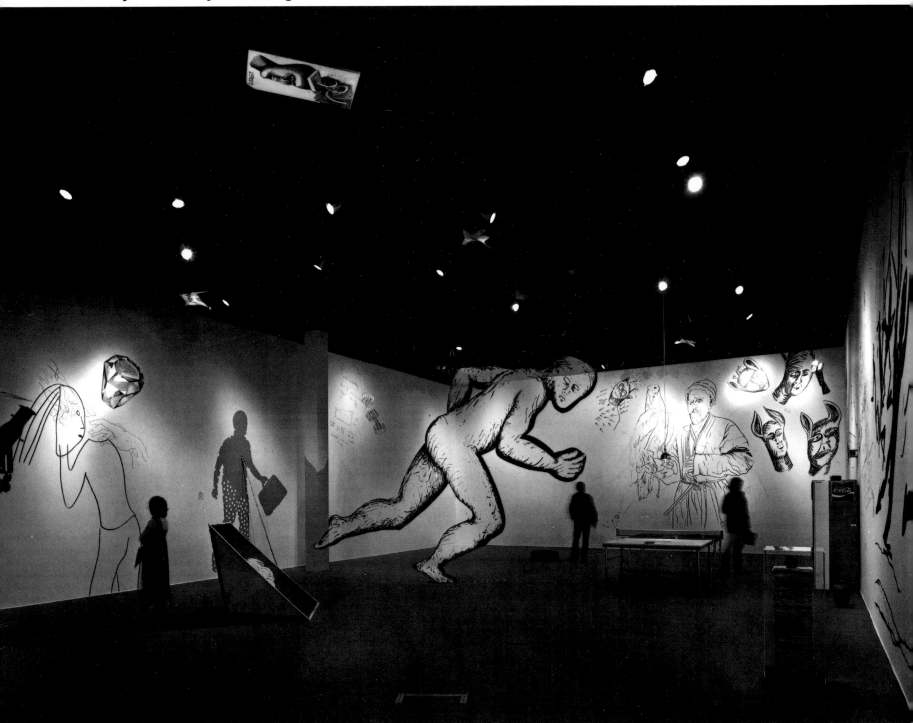

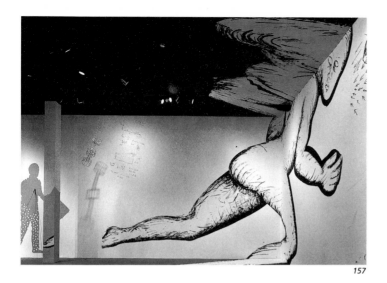

157

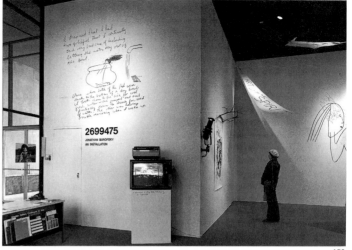

158

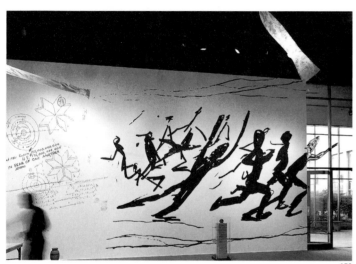

159

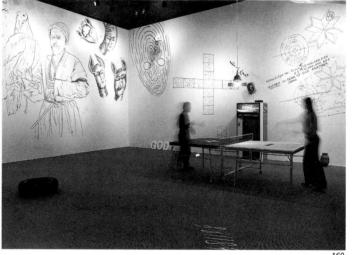

160

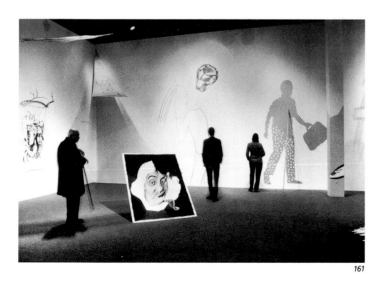

161

I asked them to bring a working Coke machine into the gallery space and place it in the Ping-Pong area. It was a college campus with a lot of students walking around, so I knew the machine would add to that flavor. I included a lot of mathematical, M.I.T.-looking drawings from my conceptual period (1968–69) along the walls as well, with the hope that the students would relate. Again, Feel Free to Play was here along with the defense budgets. Some people played there quite a bit.

I wanted to fill up the whole room and get a swirling effect, to imitate a galaxy, get an energy through the room, and activate the space with images, ideas, and sounds.

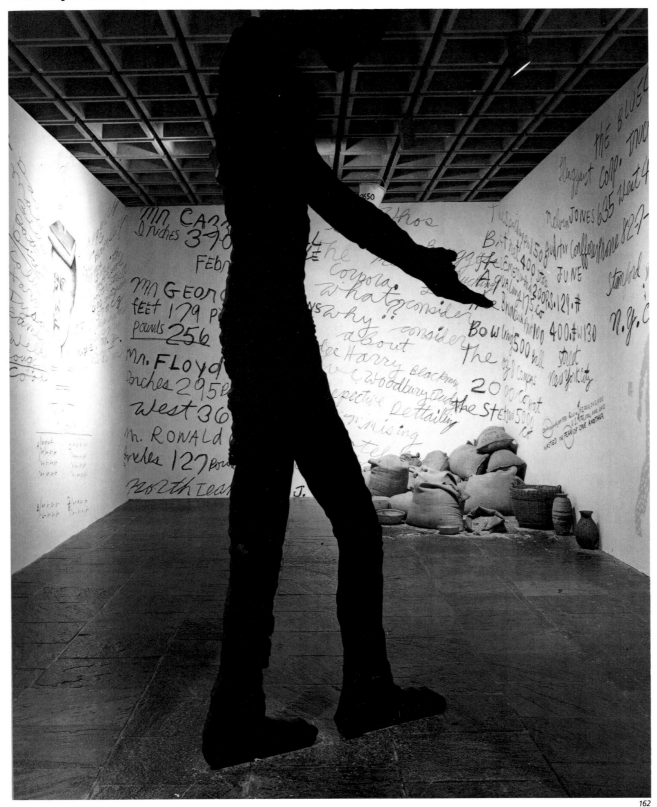

162

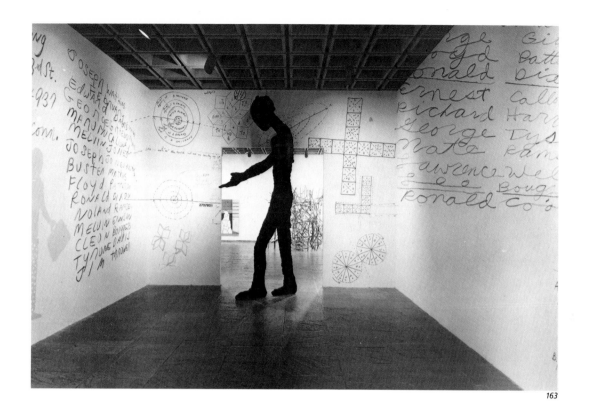

163

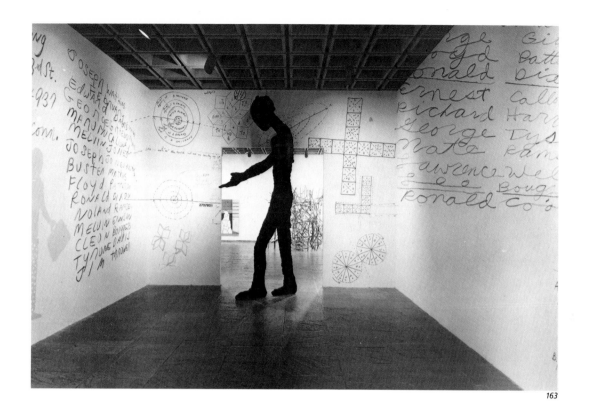

164

I planned to express the political turmoil going on in my mind. There had been discussion in the news of a wheat deal with Russia, so I got hold of some bags of wheat to place in the corner. Again, the defense budgets were written, but now next to the bags of wheat, and I added a Hammering Man.

Someone used to drop obscure notes with different names in my mailbox. I traced his writings onto the wall of the museum, using a projector to blow them up.

It's this so-called crazy man's writing, all black men's names, some successful boxers and basketball players from the past like Floyd Patterson and Cazzie Russell. On the fourth wall were the geometric drawings from my conceptual period to balance that out.

Contemporary Arts Museum, Houston, 1981

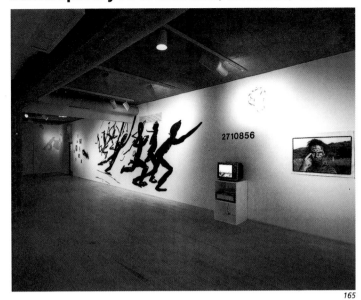

165

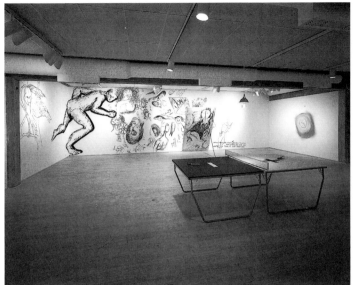

166

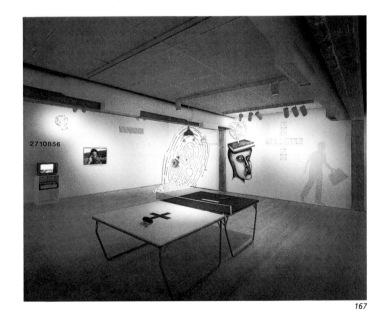

167

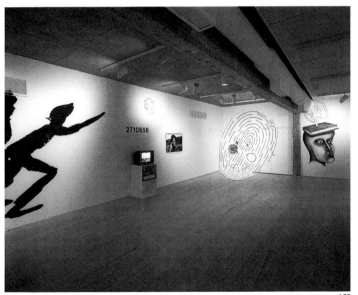

168

Galerie Rudolf Zwirner, Cologne, 1981

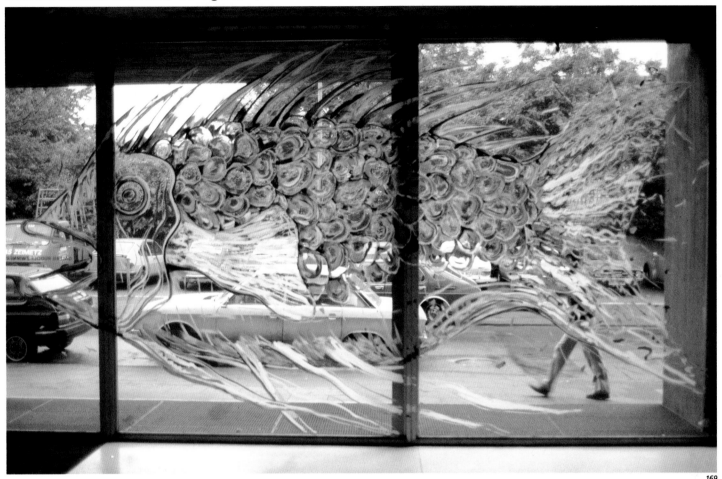

169

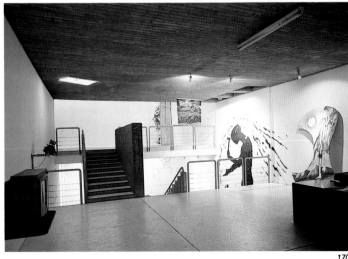

170

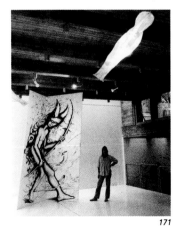

171

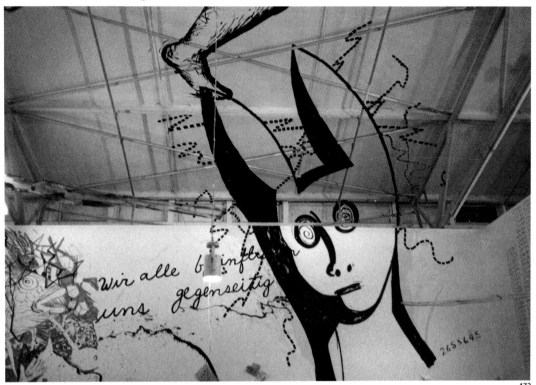

172

173

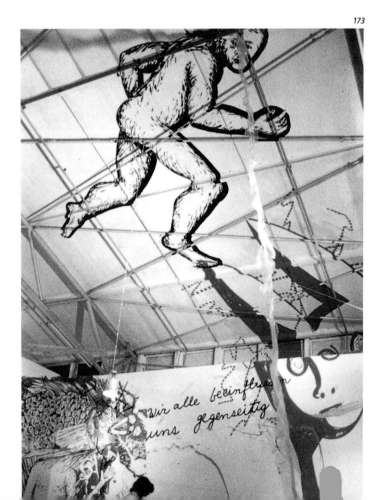

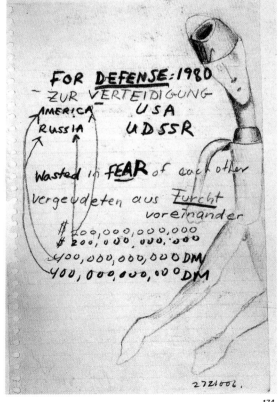

174

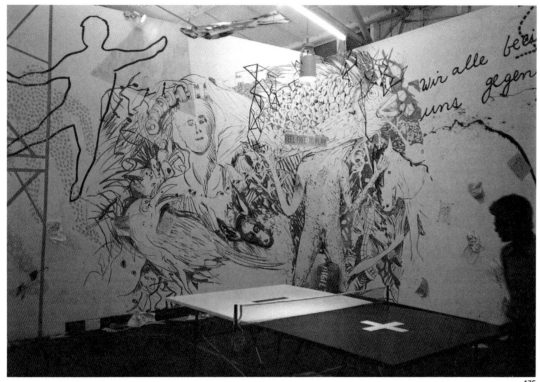

175

176

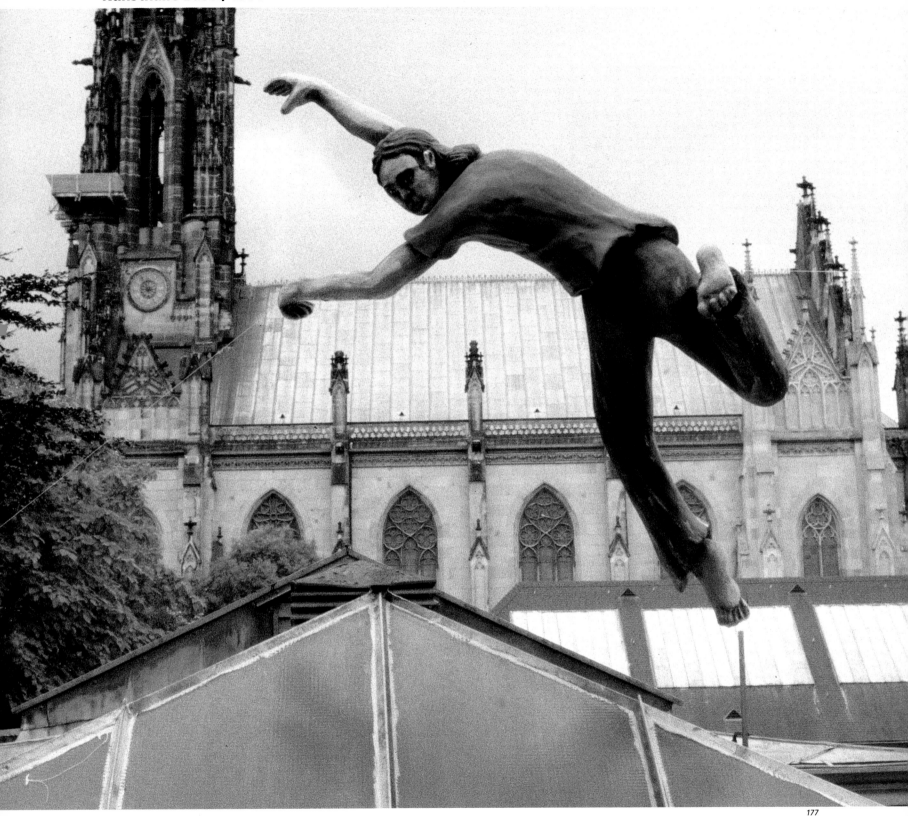

Kunsthalle Basel, 1981

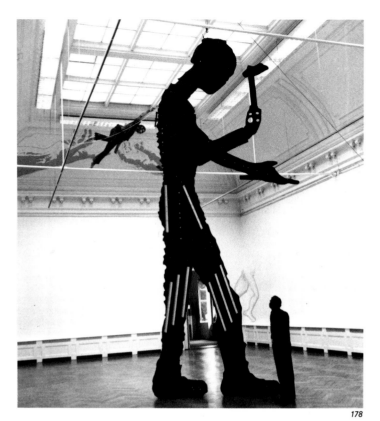

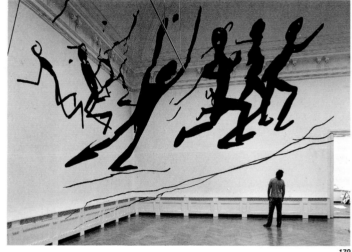

A local youth group, AJZ, was rioting at the time—throwing stones through windows because they wanted a center for youths. (There were riots in Zürich as well.) When I got to Basel I went to a couple of AJZ meetings just to hear what was going on and to get a sense of the problem. I had considered opening up the whole Basel space to them for the month of the show, but I quickly nixed that because I wasn't too impressed with them. I was still impressed with the cause, however. It didn't make sense that $200 billion were being spent by Russia and the U.S. on war once again this year, when money could be going to other causes, such as youth houses. So I made the defense-budget theme more obvious by painting it right on the Ping-Pong table instead of trying to be indirect. I wasn't totally absorbed in AJZ while I was there, but it was a point of interest that tied in with a larger scheme. The major thought I had been carrying with me for several years was the great problem on the planet. These two huge countries are causing a lot of tension and are meddling in a number of smaller countries—all for their own personal power. And if both nations would just ease off and get to know each other, if we had leaders from both sides, Russia and the U.S., who were good, open, fearless, honest human beings, they would be able to call each other on the telephone and say, "Listen, let's meet in the Caribbean. Bring your family, but no news reporters or TV crews. Let's sit down there for a month and thrash this through and figure out ways to make everybody happier on the planet because we seem to be the two most powerful people and we seem to be causing a lot of problems." If you had the right leaders, this could be done. That might sound terribly naive. You need two—one won't do it—but we have neither. That is the way our political systems are set up. Nobody's enlightened; the leaders are just reflections of the society they represent. Sometimes it's very disappointing that people have so little feeling for each other, and lack a sense of humanity. I'm surprised we don't have a real jerk sending missiles right now. Yet you hope the leader you choose will be someone who is enlightened and without fear. Any leader who builds weapons is full of fear.

The Flying Figure is looking down on the planet, sort of surveying. I don't feel like I'm trying to escape the world, as much as trying to get above it for an overview of the larger issues—to try to see it as a whole—the tensions and the beauty, the touch of God. I want to see both together, to understand the workings of the planet.

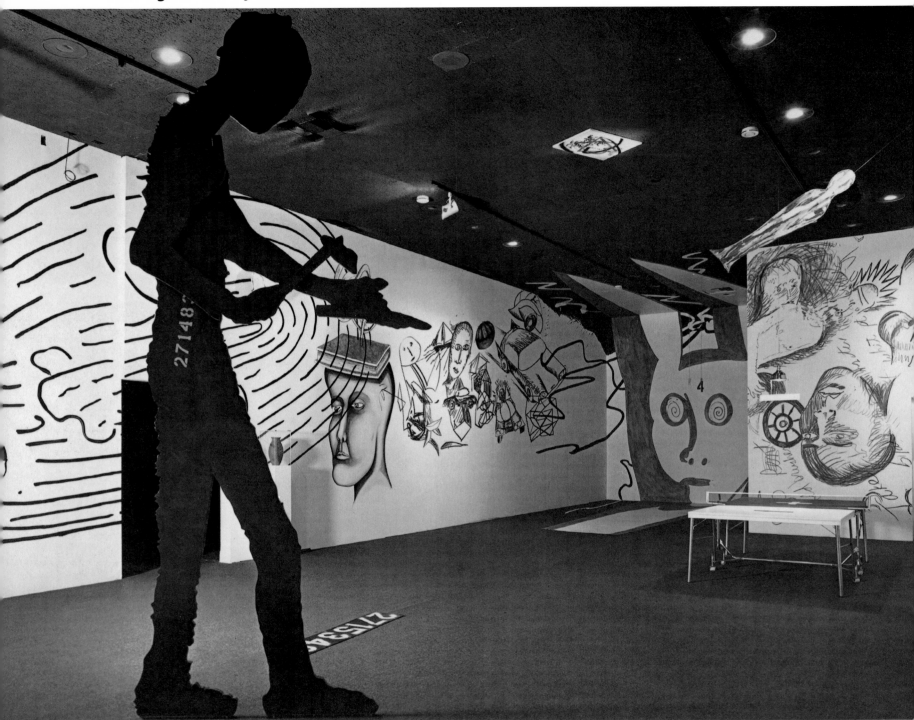

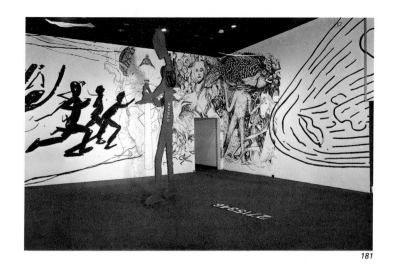

181

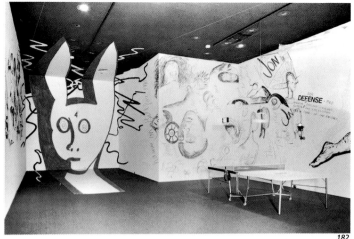

182

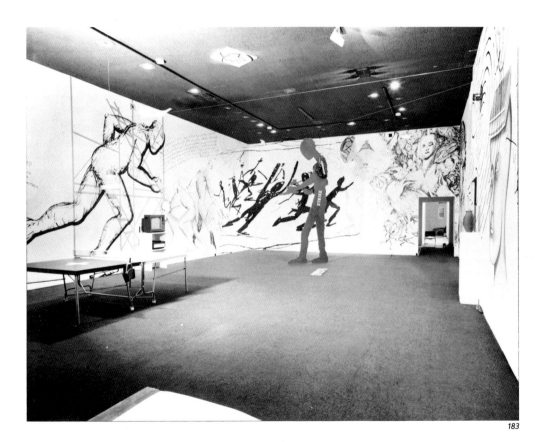

183

163

Institute of Contemporary Arts, London, 1981

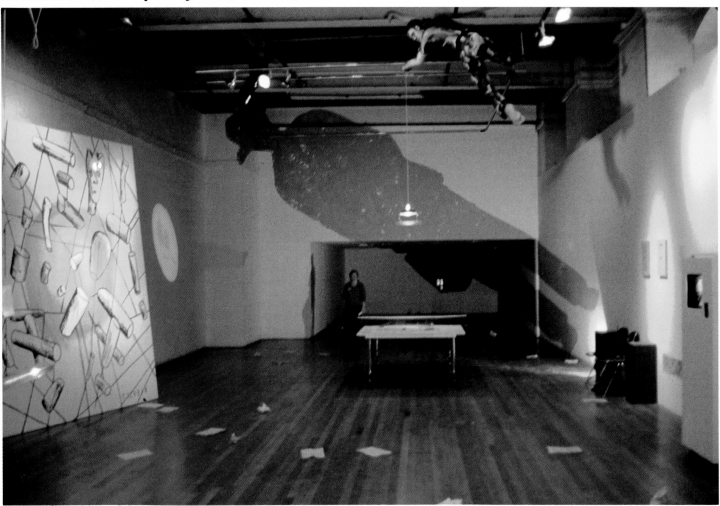

184

I was thinking about the conflict in Ireland, which was in the news at the time. A photograph that I cut out of the paper showed Irish women banging ashcan covers on the street after one of their people had died in the riots. I didn't know what the hell was going on in Ireland and still don't understand these groups. But it was another of the absurdities on the planet that get to me, and although I didn't quite understand why they were banging those ashcan lids on the street, I just knew what it was about. It is like scaring off the evil demons by making a lot of noise. The photograph showed them on their knees, and I thought I had to bring this image into the work. I think I saw it in the newspaper about three weeks before I went to London. I called a friend and asked, "Can we rig up an automatic, motorized device that will smash an ashcan cover to the floor, about three to five times a minute?" He came up with something that was only semi-successful. It operated for the first day, but not the second; finally, it worked at the opening and the first two days of the show. The banging lid drove a lot of people out of the opening. The mechanism would raise the ashcan lid up slowly on a string and then release it from the top. The can came smashing down onto the wooden floor. It was totally offensive, shockingly loud, and embarrassing.

In addition to a number of wall drawings, I had a pure light painting in the London show. A plain white canvas was hung on the wall. Then I got a theater light, and cast an oval light beam (a very hot magenta gel was used) on the canvas. This was called Light Painting. It was a very formal, beautiful, hot area of color in the room, while everything else was rather chaotic and sloppy. It was a beam of pure colored light that looked very beautiful and set off everything else.

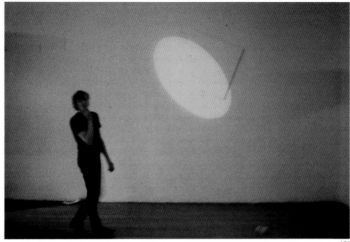

185

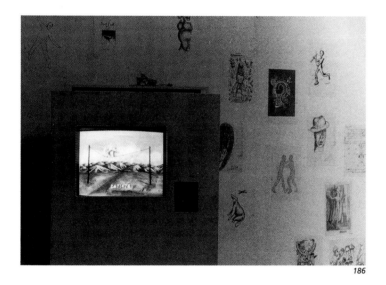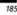

186

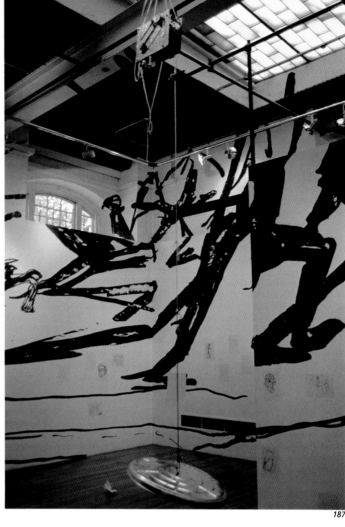

187

The gallery space was below ground level, with windows near the ceiling that let in air and light from the street, and traffic and pedestrian sounds. I had been hearing sounds of the street all the time I was working, and by the end of the week I asked if we could amplify that. I put a couple of speakers in the gallery and a microphone by the window. All the noise of the street was then amplified into the space, and it became a cityscape interior.

Centre Georges Pompidou, Paris, 1981

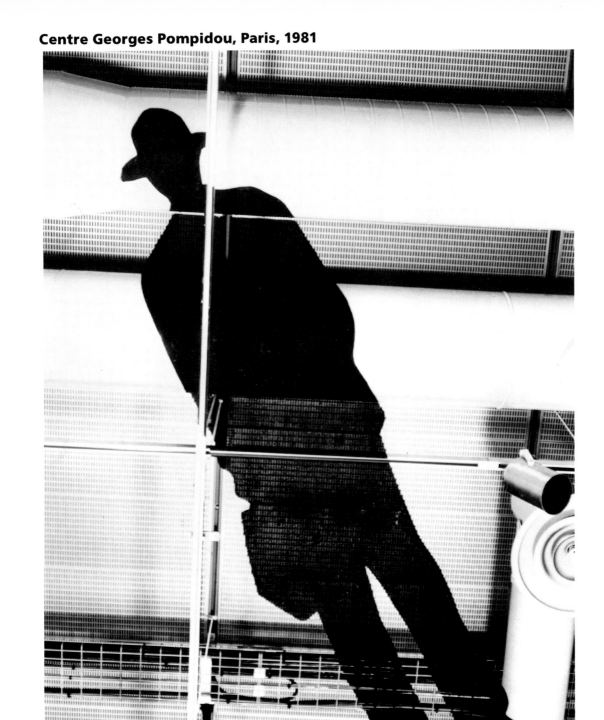

188

166

189

190

This was a "wall show," but I decided to use the ceiling, and avoid the walls completely. They were offensive fake walls and, besides, another artist had pulled a fast one and gotten out of his booth entirely. I was annoyed. It took three days to figure what to do with this crummy little booth that people just walked through. I thought, there are pipes up there and I've got the Man with a Briefcase image that would not be too hard to paint across the pipes and ceiling because it's a flat image.

I did other things that are difficult to see in the photographs. I was wearing a heavy leather coat that I never liked. I'd had it for many years, but I always wanted to get a new one. I took it off one day and heaved it over the pipes so that it was draped there, with a belt hanging down. Again it was an expression of spite toward those pipes. There was also a string coming out from a wall, a Megan Williams trick. I tied monofilament to the end of the string running across a room to make it appear as if the string was sticking straight out on its own. I had to do this because people were just walking through the booths and missing the major parts of my installation. The string pointed to the image of the Man with a Briefcase on the ceiling.

The major wall piece was for the workers of the world, entitled Not Made to Rule, but to Subserve. A week and a half after the show opened, the workers in the museum struck and closed it down for the rest of the show. My drawing was like a premonition.

167

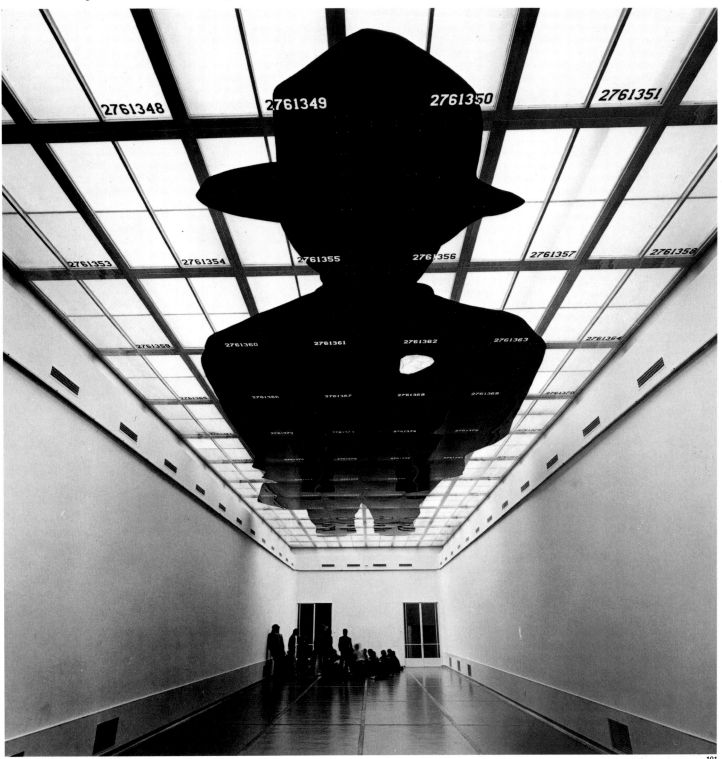

191

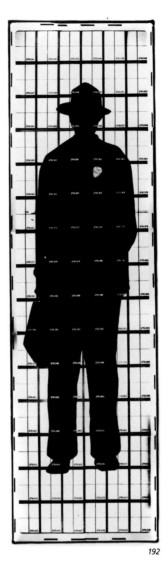

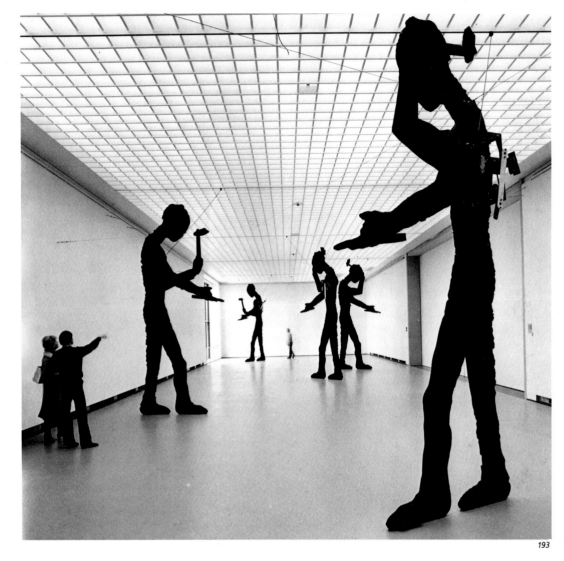

I had two large rooms to work with—each about thirty by one hundred feet. I had visited the museum a year earlier and made some preliminary plans. One room would have five Hammering Men set in different places (up to this point I had only made a couple of individual Hammering Men that were always placed in relation to other work). The second room, which had a skylight ninety-five by twenty-seven feet, seemed natural for a large skylight painting. I arrived in Rotterdam with two assistants, almost four weeks ahead of the opening date. We started from scratch to make a group of Hammering Men that would fit the room; the five motors had been pre-made in California and sent ahead. I spent most of my time working on the skylight piece since there were many unforeseen technical problems to overcome. For the skylight, ninety wooden stretchers were measured and built in the basement within a week and a half, and an equal number of plexiglass panels were cut and screwed to them. Megan and I transferred the small Man with a Briefcase drawing (via projector) onto these panels in sections and hand painted each one with black automobile enamel. The Ruby in the man's heart was left transparent but had Day-Glo red highlights, and each panel had a number on it. These panels were then bolted to the ceiling one at a time. When all ninety panels were up, we saw the ninety-five-foot image for the first time. In order to take it all in, since the ceiling was only twenty feet high, it was necessary to lie on the floor. We suggested leaving some mattresses in the middle of the room for this purpose, but otherwise the room was left empty. In one room were the Hammering Men, in the other, the Man with a Briefcase on the skylight. The whole exhibition was called "Workers."

Museum van Hedendaagse Kunst, Ghent, 1982

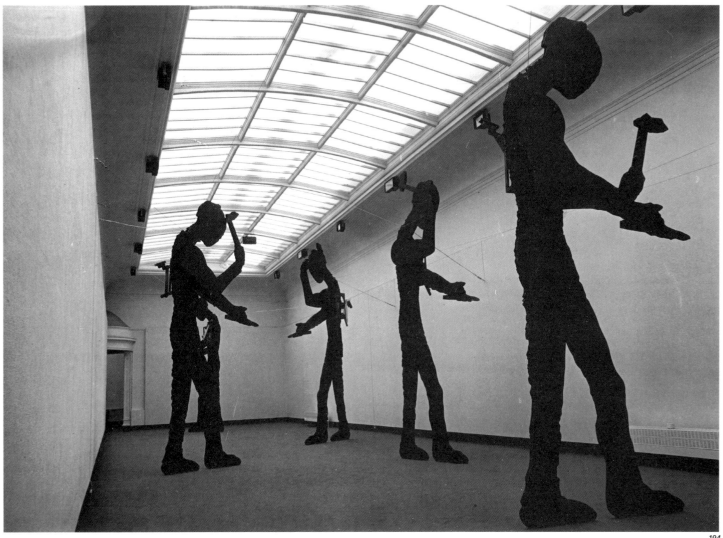

194

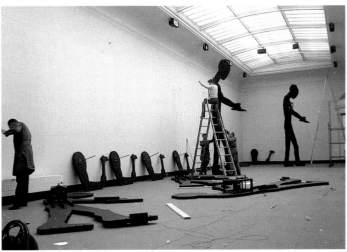

195

The Hammering Man is a giant, and it goes back to my childhood. I liked to sit on my father's lap and have him tell me giant stories—especially about friendly giants. The Hammering Man is also a worker, and I idolize the worker in myself because if I can get myself moving and start doing something physical, I usually feel good. The piece relates to that self. At the same time, it seems that the boring, monotonous repetition of the moving arm implies the fate of the mechanistic world. In a capitalistic society, the worker sits on the assembly line. There is also the hammer of the hammer and sickle; when I've painted the figure red, it could lead to some associations with Marxist ideology—it's the symbol for the working man. And finally, this figure symbolizes the underpaid worker in this new, computerized revolution. The migrant worker who picks the food we eat, the construction worker who builds our buildings, the maid who cleans offices every evening, the shoemaker—they all use their hands like an artist. Their work is essential, but their jobs lack glamour and financial support. In our society, mediocre entertainers are paid $20,000 per week for TV work while the teachers of our young feel lucky if they earn $18,000 per year.

The word strike, which has been used with the Hammering Man, has two opposite meanings—to hit something, and also, in terms of workers, to stop working. One means to act aggressively, the other to stop doing the act. Do you keep working or do you strike? Or, it can have a third meaning—the Russians literally striking the Polish with a blow. Traveling around the world I can sense that in all countries there is an empathy for the monotony of the worker having to do the same job every day. It's also an homage to the assembly-line worker who will be extinct in about fifty years, and so signifies the death of an age. It has all these possibilities.

196

Photocopied leaflet distributed at Biennale, Venice, 1980

While I was looking at a photocopy of the original drawing, it occurred to me to make a three-dimensional Hammering Man and to make the arm move. The first sculptural Hammering Man was black, and about 11½ feet high. It was first shown at the Paula Cooper Gallery in 1980 and was very successful. I then used it for another installation at the Los Angeles County Museum of Art, making it a little larger to fit the space, painting it red, and stenciling the word strike on it. The third one was made for the Kunstmuseum Basel, a twenty-four-foot-high Hammering Man. When looking over the Museum Boymans–van Beuningen for an exhibition, I decided to have five in one room—and nothing else. They were strong enough to hold the whole room, and they would create the feeling of a room of workers. My primary consideration in terms of placing the figures was to get the maximum use of the room, spatially and visually, for the viewer. I didn't want all the figures to face in the same direction. They had to be in an organic relationship—but not a symmetrical one—and I wanted the placement to be natural and intuitive.

The Hammering Man could be me, but I tried to make it both male and female by giving it a little extra hair on the back of the head. Although anything I make is "me" and since I am not that different from anyone else on this planet, I hope the images are universal or archetypal. Depending on its context, the Hammering Man, like any of my images, can take on more or less meaning. It could suggest a Polish worker, or it could be me at work. I want to use images that have multiple interpretations—that give the viewer, as well as myself, more to work with.

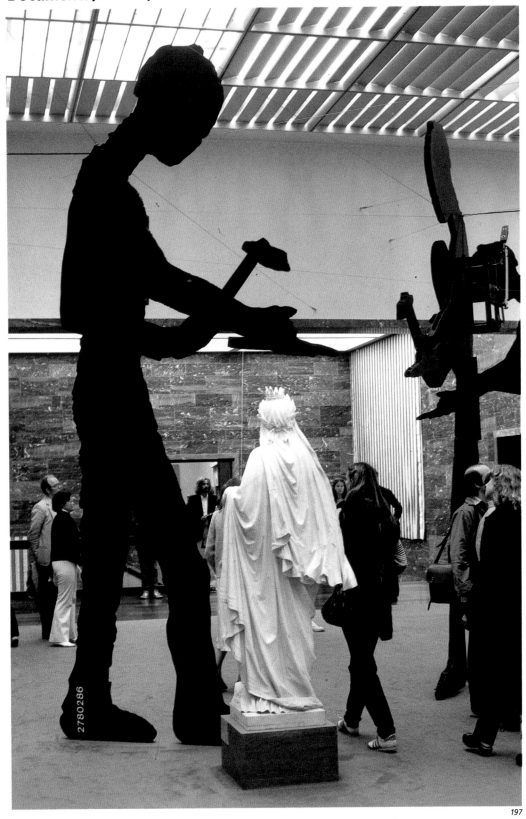

197

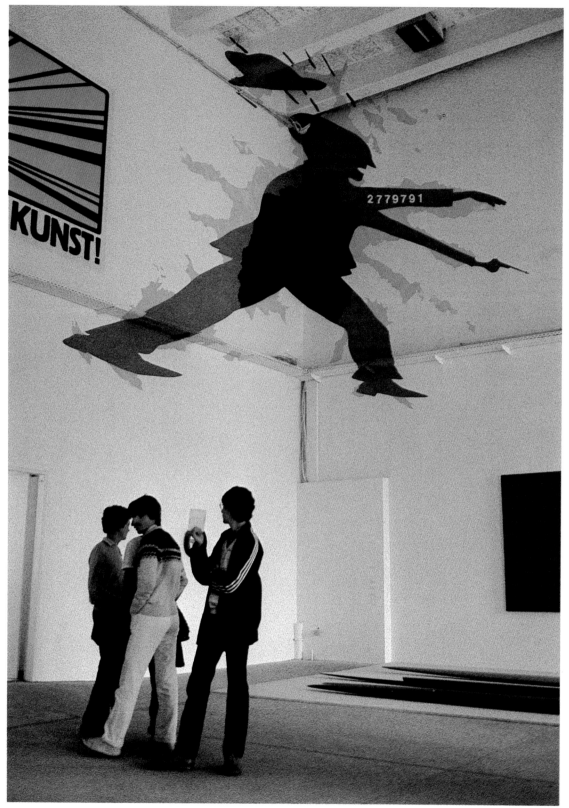

198

173

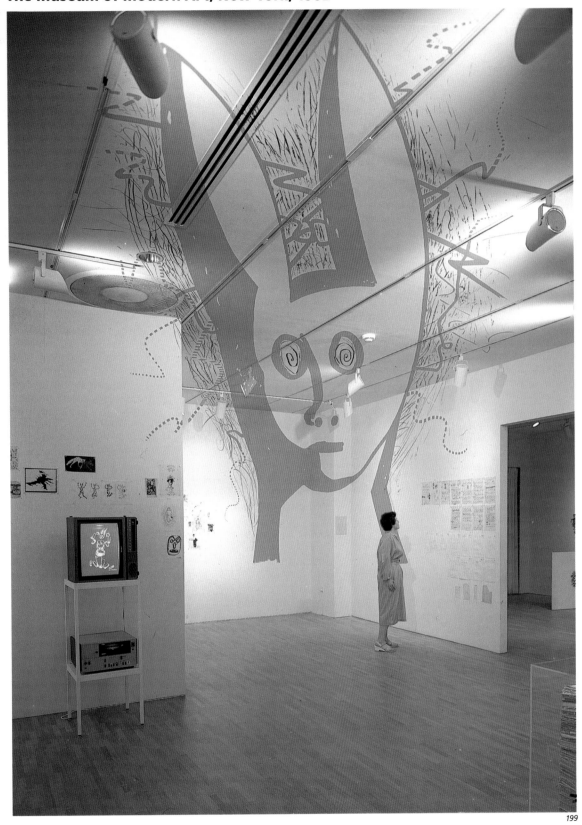

199

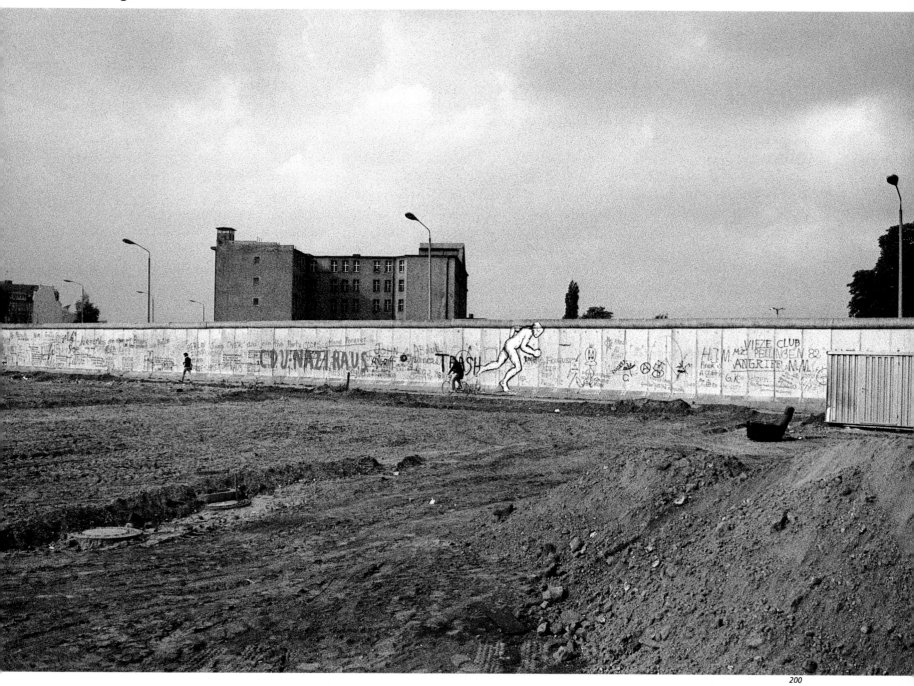

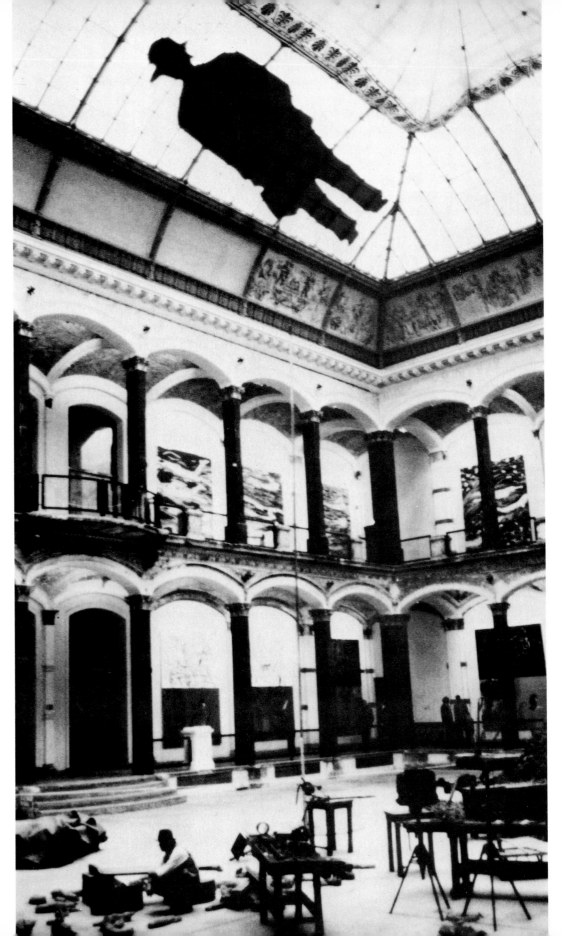

I see myself as partly everyperson and vice versa. Therefore, no matter how personal I get about myself, my work is going to have meaning for somebody else. It has archetypal relevance. So, this figure is me too—the traveling salesman who goes around the world with his briefcase full of images and thoughts. The briefcase has always been a metaphor for my brain.

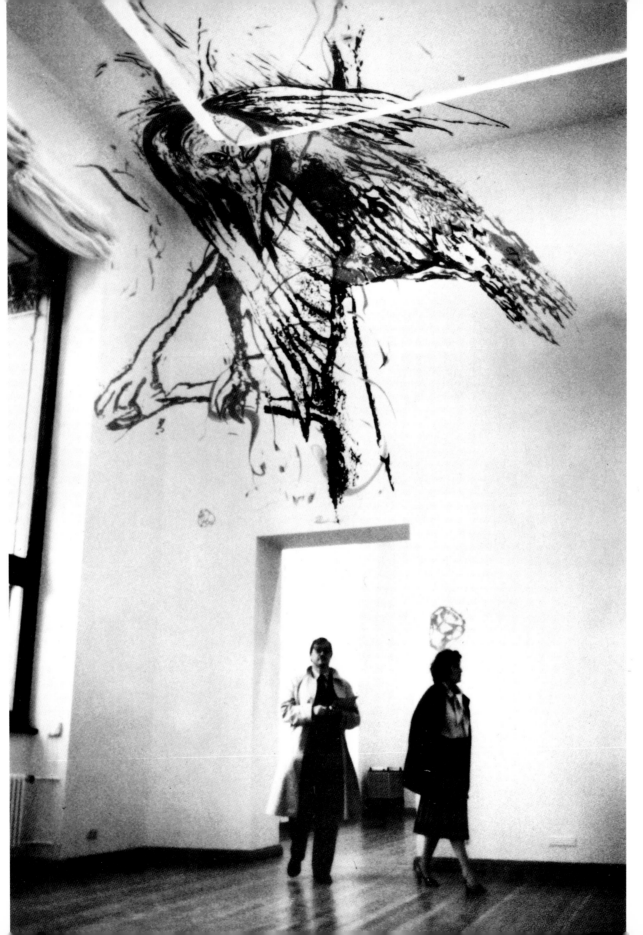

202

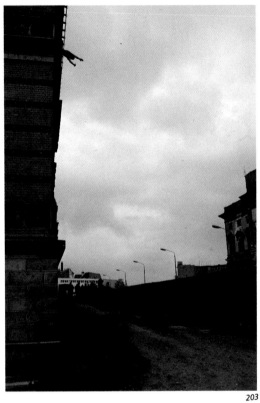

203

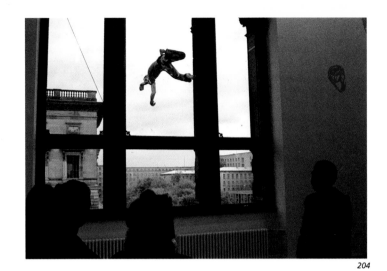

204

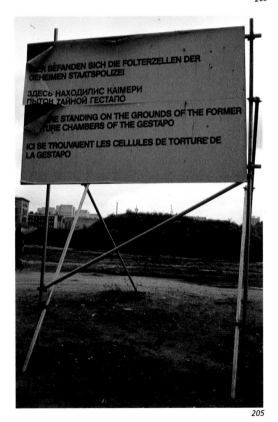

HIER BEFANDEN SICH DIE FOLTERZELLEN DER
GEHEIMEN STAATSPOLIZEI

ЗДЕСЬ НАХОДИЛИС КАІМЕРИ
ПЫТОН ТАЙНОЙ ГЕСТАПО

...NE STANDING ON THE GROUNDS OF THE FORMER
...URE CHAMBERS OF THE GESTAPO

ICI SE TROUVAIENT LES CELLULES DE TORTURE DE
LA GESTAPO

205

206

"Zeitgeist," West Berlin

Whitney Museum of American Art, New York, 1983

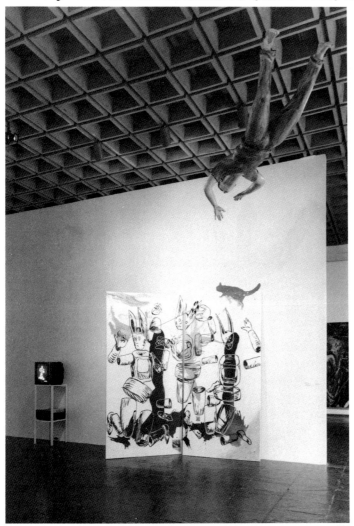

207

I wanted to combine a painting and video. In doing so in the Whitney Museum installation, I collaborated with Megan Williams. For instance, I gave her my drawings for the video piece and explained the effect of movement I wanted. Although I had made the animation for the dog-walking-a-tightrope video, I did not have time to make this one. She made the animation a little slicker and cleaner than I might have and did a few things with the hands that I might not have done. But this is what happens when you collaborate with other people, and it's interesting.

I traced Megan's drawings, made from my drawings, when I did the painting. The ring derives from a Megan dream, and the string in space is really a Megan invention that I usurped, although I had used lines in my earlier metal sculpture quite extensively.

The title is Man in Space #2, *which is not entirely clear. There is a sense of an explosion accompanied by the news clipping on the painting regarding the making of nuclear bombs, so one theme has to do with being blown up in space, like a traveler. I also think it's me in a frenetic, hyper moment. Maybe it's a person who's afraid of space.*

The source of the image is a fragmented figure with long ears and a clock for an upper torso. By coming apart, and then rejoining itself, the image is about fragmentation and losing one's sense of the body or the physical world, which one might do if one is focused on hearing. And this becomes the subject matter of the painting. So it might not be so much exploding the system, as coming apart and putting it back together.

There are various references, too, to self-awareness, including a photograph of the painting itself. It is as if you're aware of yourself in the painting and, in a sense, aware of the painting's awareness of itself.

179

Kunstmuseum Basel, 1983

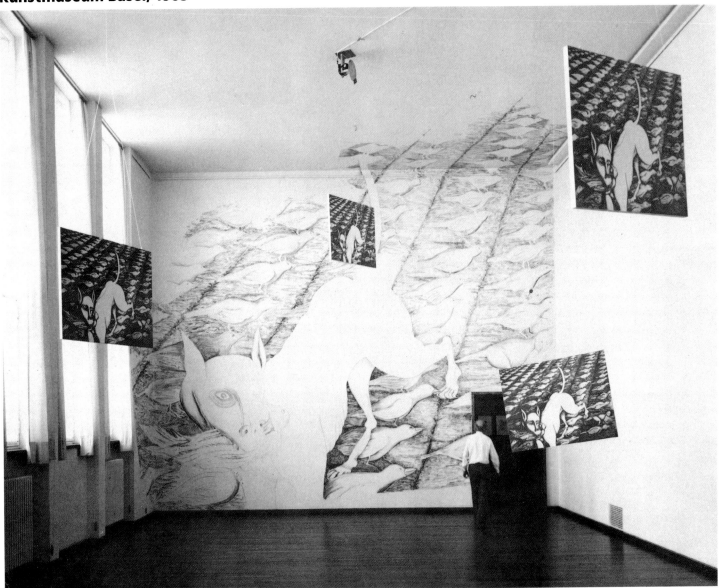

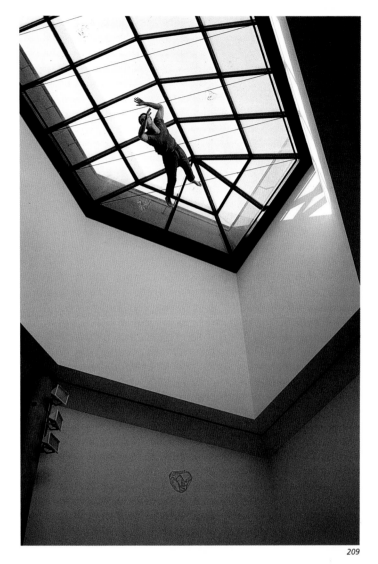

209

210

211

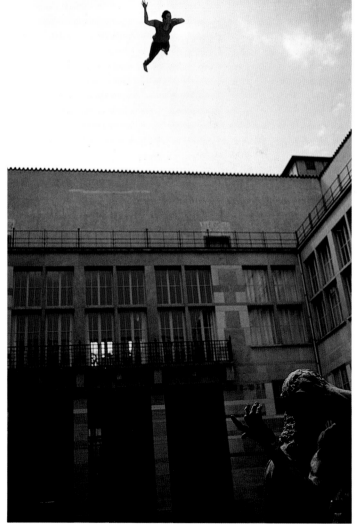

212

Paula Cooper Gallery, New York, 1983

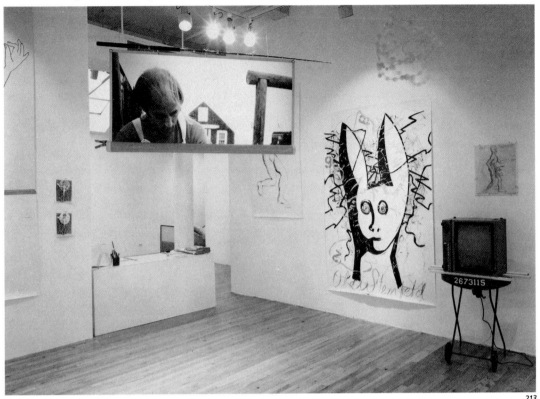

213

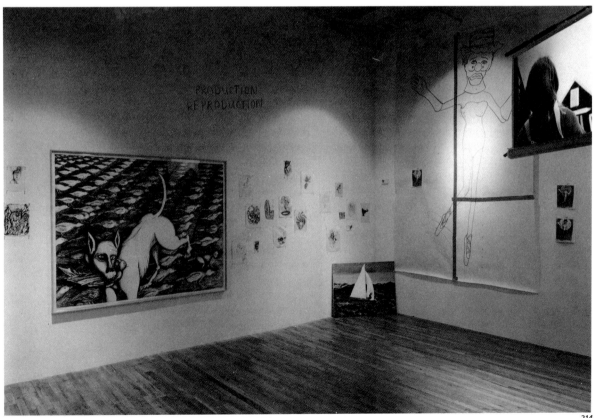

214

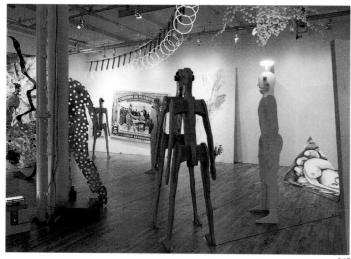

215

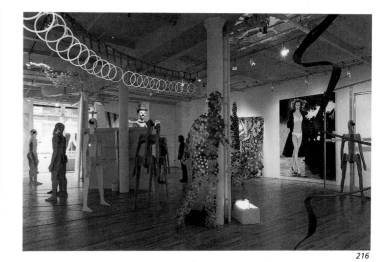

216

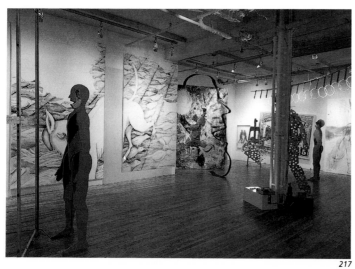

217

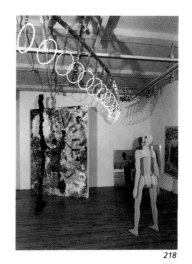

218

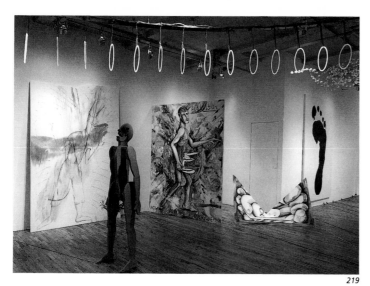

219

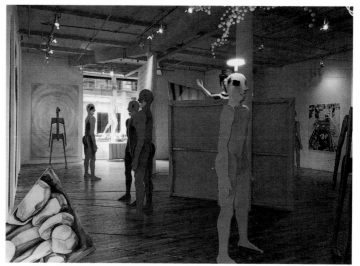

220

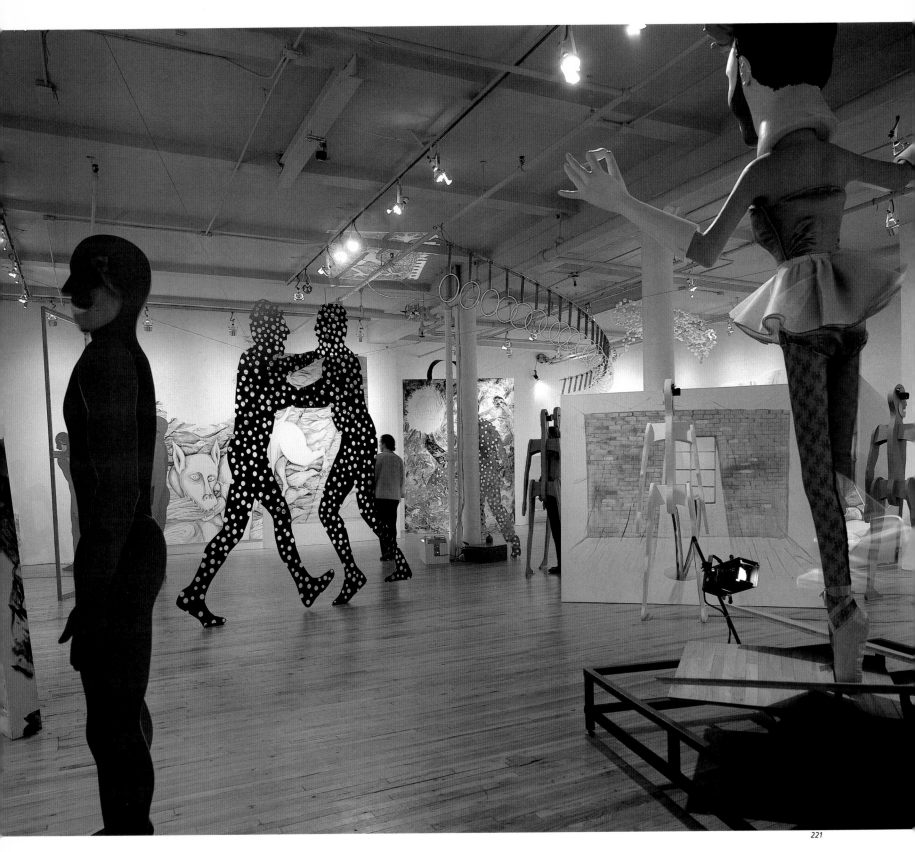

Paula Cooper Gallery, New York

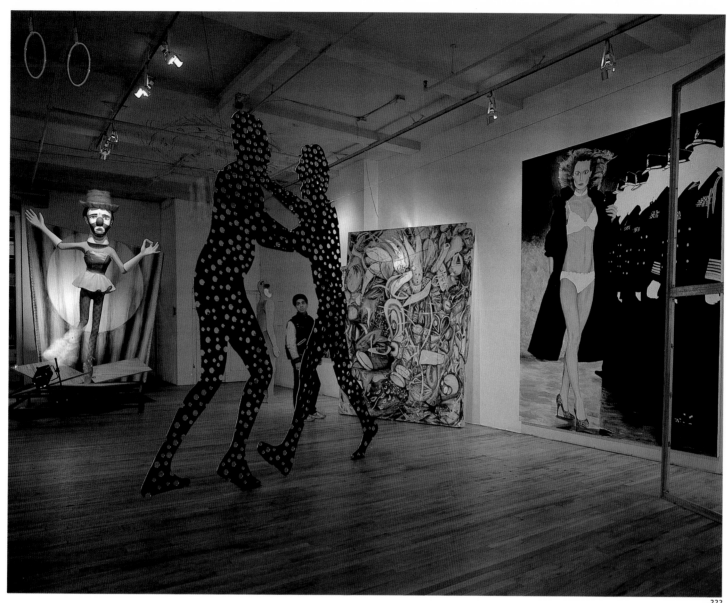

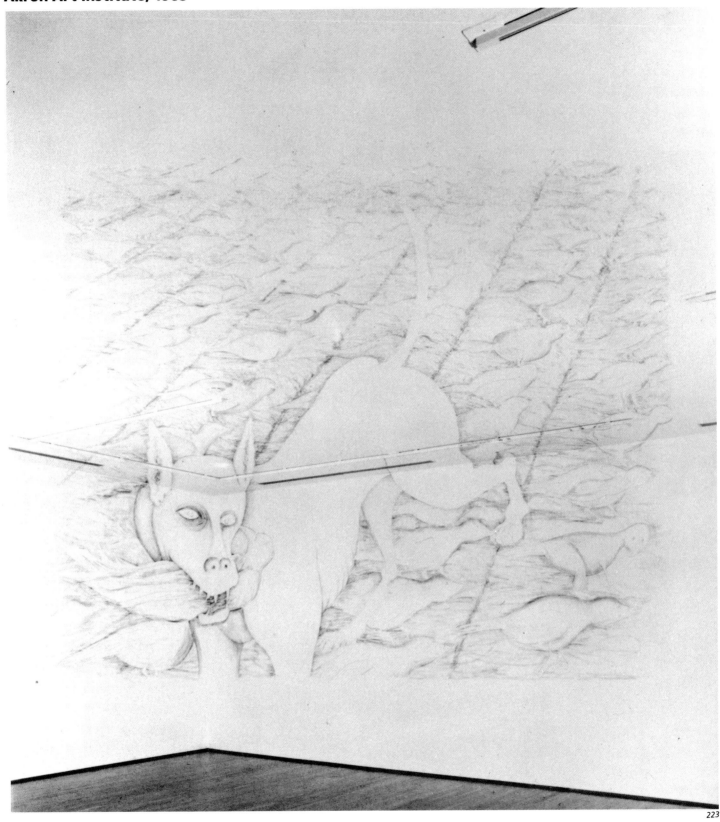

223

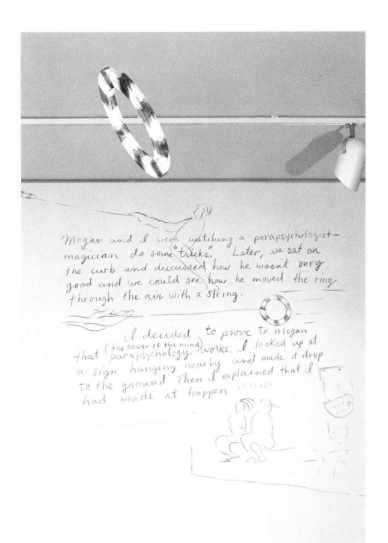

Megan and I were watching a parapsychologist-magician do some "tricks." Later, we sat on the curb and discussed how he wasn't very good and we could see how he moved the ring through the air with a string.

I decided to prove to Megan that (the power of the mind) parapsychology works. I looked up at a sign hanging nearby and made it drop to the ground. Then I explained that I had made it happen.

224

I dreamed I was walking down the stairs into the subway where a little black boy (light skin, 13 years old) was standing with an older woman and a younger woman. He asked me if I would be his older brother for this ride and that that way he would get on for a cheaper fare. I was about to tell him that he was black and I was white and that I didn't think we'd pass for brothers when I realized my color and hair were very much that of a black man — in fact we had similar features. The four of us talked for a while and I asked the little boy if he was a mulatto. He said he didn't know cause he was an orphan.

225

226

Institute of Contemporary Art, Boston, 1983

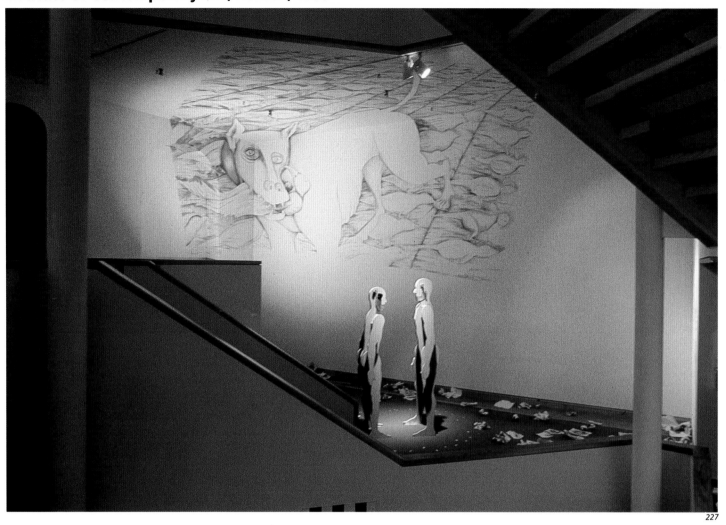

227

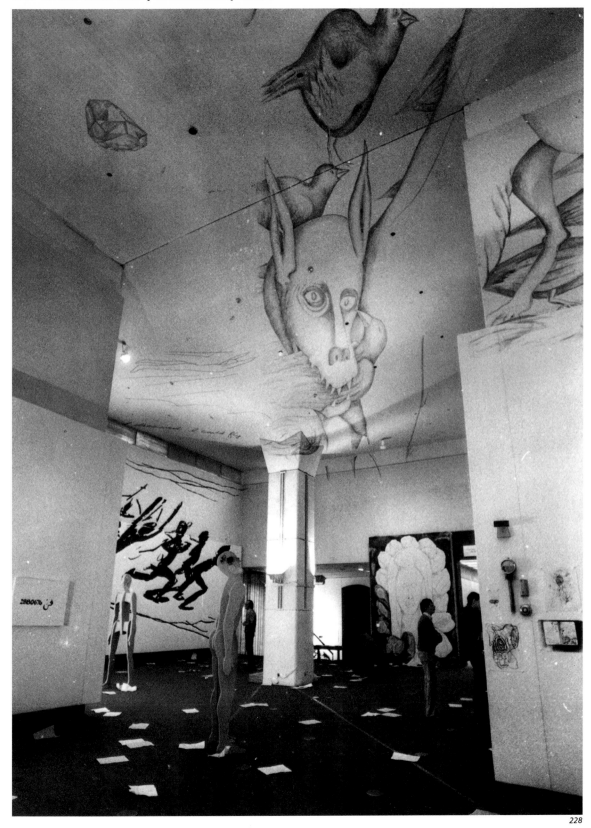

228

Exhibitions

1963

Group

Museum of Art, Carnegie Institute, Pittsburgh. "Fifty-third Annual Exhibition of Associated Artists of Pittsburgh." March 7–April 11.*

1964

Group

Museum of Art, Carnegie Institute, Pittsburgh. "Fifty-fourth Annual Exhibition of Associated Artists of Pittsburgh." March 6–April 19.*

1969

Group

Paula Cooper Gallery, New York. "No. 7." May 18–June 17.

Seattle Art Museum. "557,087." September 5–October 5. Traveled to Vancouver Art Gallery, British Columbia, as "955,000," January 13–February 8, 1970.*

1970

Group

Dwan Gallery, New York. "Language IV." June 2–25.

1973

One-man

Artists Space, New York. "Jon Borofsky." November 3–23.

1974

Group

Michael Wyman Gallery, Chicago. "Measure: Concept as Vision." March.

Paula Cooper Gallery, New York. "Drawing and Other Work." December 7, 1974–January 8, 1975.

1975

One-man

Paula Cooper Gallery, New York. "Jon Borofsky." March 8–April 2.

Group

Paula Cooper Gallery, New York. "Spring Group Show." June.

McLaughlin Library, University of Guelph. "Narrative in Contemporary Art." November 1–30.*

*A catalogue or brochure accompanied the exhibition

Fine Arts Building, New York. "Lives." November 29–December 20.*

Downtown Branch, Whitney Museum of American Art, New York. "Autogeography." December 11, 1975–January 7, 1976.*

Paula Cooper Gallery, New York. "Group Exhibition." December 13, 1975–January 14, 1976.

1976

One-man

Wadsworth Atheneum, Hartford. "Matrix 18: Jon Borofsky." April 6–May 3.*

Paula Cooper Gallery, New York. "Jon Borofsky." October 5–30.

Group

Paula Cooper Gallery, New York. "Changing Group Exhibition." February 14–March 4.

Fine Arts Building, New York. "Style and Process." May 15–25.*

M. L. D'Arc Gallery, New York. "Invited Group Show." May 19–June 16.

Paula Cooper Gallery, New York. "Group Exhibition." May 29–June 16.

International Pavilion, Thirty-seventh Venice Biennale, Italy. "International Events '72–76." July 18–October 10.*

Akademie der Künste, West Berlin. "New York—Downtown Manhattan: SoHo." September 5–October 15. Traveled to Louisiana Museum of Modern Art, Humlebaek, Denmark, November 1–December 30.*

Fine Arts Gallery, California State University, Los Angeles. "New Work/New York." October 4–28.*

1977

One-man

Art Gallery, University of California, Irvine. "Jon Borofsky." April 3–30.

Group

Upton Hall Gallery, State University College, Buffalo. "January." January 17–February 3.

Paula Cooper Gallery, New York. "Group Show." September 10–October 12.

Woods Gerry Gallery, Rhode Island School of Design, Providence. "Space Window." September 14–28.

New York State Museum, Albany. "New York: The State of Art." October 8–November 27.*

Joe and Emily Lowe Art Gallery, Syracuse University. "Critics' Choice." November 13–December 11. Traveled to Munson-Williams-Proctor Institute, Utica, January 8–29, 1978.

Holly Solomon Gallery, New York. "Surrogates/Self-Portraits." December 3, 1977–January 4, 1978.

1978

One-man

Protetch-McIntosh Gallery, Washington, D.C. "Jon Borofsky: Images." January 11–February 4.

Thomas Lewallen Gallery, Los Angeles. "Jon Borofsky." April 8–29.*

University Art Museum, University of California, Berkeley. "Matrix/Berkeley 10: Jon Borofsky/Megan Williams." June–August.*

Corps de Garde, Groningen. "Jon Borofsky: I Dreamed I Found a Red Ruby." August 12–September 30.

The Museum of Modern Art, New York. "Projects: Jonathan Borofsky." August 17–October 29.

Group

Holly Solomon Gallery, New York. "The New York Boat Show." January 7–26.

Paula Cooper Gallery, New York. "Changing Group Exhibition." January 28–April 1.

University Art Museum, University of California, Santa Barbara. "Contemporary Drawing/New York." February 22–March 26.*

Protetch-McIntosh Gallery, Washington, D.C. "The Minimal Image." March 7–April 5.

Independent Curators Incorporated, New York. "The Sense of the Self: From Self-Portrait to Autobiography." Organized for travel to Neuberger Museum, State University of New York, Purchase, September–November; New Gallery of Contemporary Art, Cleveland, January–February 1979; University of North Dakota, Grand Forks, February–March 1979; Alberta College of Art Gallery, Calgary, November–December 1979; Tangerman Fine Art Gallery, University of Cincinnati, February–March 1980; Allen Memorial Art Museum, Oberlin College, April–May 1980.*

Paula Cooper Gallery, New York. "Tenth Anniversary Group Exhibition." September 9–October 4.

Young Men's Hebrew Association, Philadelphia. "Group Show." n.d.

1979

One-man

Paula Cooper Gallery, New York. "Jon Borofsky." March 10–April 7.

Halle für Internationale Neue Kunst, Zürich. "Documentation 4: Jon Borofsky." August 14–September 21.*

Portland Center for the Visual Arts, Oregon. "Jon Borofsky: Wall Drawings." December 9, 1979–January 13, 1980.

Group

Whitney Museum of American Art, New York. "1979 Biennial Exhibition." February 6–April 8.*

Hampshire College Gallery, Amherst. "Images of the Self." February 17–March 14.*

De Cordova and Dana Museum and Park, Lincoln, Massachusetts. "Born in Boston." February 18–April 22.*

Ben Shahn Gallery, William Paterson College, Wayne, New Jersey. "Works on the Wall." March 23–April 6.*

The Renaissance Society at the University of Chicago. "Visionary Images." May 6–June 16.*

Paula Cooper Gallery, New York. "Jennifer Bartlett, Alan Shields, Lynda Benglis, Jon Borofsky." Summer.

Texas Gallery, Houston. "From Allan to Zucker." August 17–September 28.*

Paula Cooper Gallery, New York. "Group Show: Gallery and Invited Artists." September 8–October 10.

Neuberger Museum, State University of New York, Purchase. "Ten Artists/Artists Space." September 9–October 15.*

Philadelphia College of Art. Words and Images." September 14–October 12.*

Artists Space, New York. "Sixth Anniversary Exhibition." September 22–November 10.

1980

One-man
Paula Cooper Gallery, New York. "Jonathan Borofsky." October 18–November 15.

Hayden Gallery, Massachusetts Institute of Technology, Cambridge. "2699475—Jonathan Borofsky: An Installation." December 1–24.*

Group
Bell Gallery, Brown University, Providence. "Brown University Invitational." February 1–24.

Galerie Yvon Lambert, Paris. "Paula Cooper at Yvon Lambert." February 16–March 15.

Padiglione d'Arte Contemporanea, Milan. "Dammi il tempo di guardare: pitture d'oggi a New York." April–May.*

Paula Cooper Gallery, New York. "Works on Paper." May 24–June 14.

United States Pavilion, Thirty-ninth Venice Biennale, Italy. "Drawings: The Pluralist Decade." June 1–September 30. Traveled to the Institute of Contemporary Art, University of Pennsylvania, Philadelphia, October 4–November 9.*

International Pavilion, Thirty-ninth Venice Biennale, Italy. "Art in the Seventies: Open '80." June 1–September 30.*

Indianapolis Museum of Art. "Painting and Sculpture Today 1980." June 24–August 17.*

Art Gallery, California State University, Fullerton. "Visions and Figurations." November 7–December 11.*

E. R. Squibb Corporation, Princeton, New Jersey. "Aspects of Post-Modernism: Decorative and Narrative Art." December 6, 1980–January 10, 1981.*

1981

One-man
Contemporary Arts Museum, Houston. "Jonathan Borofsky: An Installation." March 7–April 5.*

Galerie Rudolf Zwirner, Cologne. "Jonathan Borofsky." May 29–July 9.

Kunsthalle Basel. "Jonathan Borofsky." July 12–September 13.

Institute of Contemporary Arts, London. "Jonathan Borofsky." October 9–November 15.*

Group
Marianne Deson Gallery, Chicago. "A Painting Show: Painting for the Eighties." January 16–February 11.

Whitney Museum of American Art, New York. "1981 Biennial Exhibition." January 20–April 19.*

Yale University Art Gallery, New Haven. "Twenty Artists: Yale School of Art 1950–1970." January 29–March 29.*

Sidney Janis Gallery, New York. "New Directions: Contemporary American Art from the Commodities Corporation Collection." February 12–March 7. Traveled to the Museum of Art, Fort Lauderdale, December 9, 1981–January 24, 1982; Oklahoma Museum of Art, Oklahoma City, February 8–March 28, 1982; Santa Barbara Museum of Art, April 17–May 30, 1982; Grand Rapids Art Museum, July 11–September 6, 1982; Madison Art Center, Wisconsin, October 3–November 28, 1982; Montgomery Museum of Fine Arts, Alabama, January 14–March 13, 1983.*

Freedman Gallery, Albright College, Reading, Pennsylvania. "Messages: Words and Images." March 20–April 24.*

Goddard-Riverside Community Center, New York. "Menagerie: Animal Imagery in Contemporary Art." April 30–May 19.*

The Aldrich Museum of Contemporary Art, Ridgefield, Connecticut. "New Dimensions in Drawing: 1950–1980." May 2–September 6.*

Museen der Stadt, Cologne. "Westkunst—Heute: Zeitgenössische Kunst seit 1939." May 30–August 16.*

Los Angeles County Museum of Art. "Art in Los Angeles—the Museum as Site: Sixteen Projects." July 21–October 4.*

Louisiana Museum of Modern Art, Humlebaek, Denmark. "Drawing Distinctions: American Drawings of the Seventies." August 15–September 20. Traveled to Kunsthalle Basel, October 4–November 15; Städtische Galerie im Lenbachhaus, Munich, February 17–April 11, 1982; Wilhelm-Hack-Museum, Ludwigshafen, September–October 1982.*

Akron Art Museum. "The Image in American Painting and Sculpture: 1950–1980." September 12–November 8.*

Musée d'Art Moderne de la Ville de Paris. "Baroques '81." October 1–November 15.*

Hayden Gallery, Massachusetts Institute of Technology, Cambridge. "Body Language: Figurative Aspects of Recent Art." October 2–December 24. Traveled to Fort Worth Art Museum, September 11–October 24, 1982; University of South Florida Art Gallery, Tampa, November 12–December 17, 1982; Contemporary Arts Center, Cincinnati, January 13–February 27, 1983.*

Nordiska Kompaniet, Stockholm. "US Art Now." October 28–November 7. Traveled to Göteborgs Konstmuseum, Göteborg, January 9–31, 1982.*

Proctor Art Center, Bard College, Annandale-on-Hudson. "Figures." November 18–December 15.

P.S. 1, Institute for Art and Urban Resources, Long Island City. "Figuratively Sculpting." December 1–13.

Artists Space, New York. "35 Artists Return to Artists Space: A Benefit Exhibition." December 4–24.*

Mattingly Baker Gallery, Dallas. "New York: The Eighties." December 5, 1981–January 15, 1982.

Barbara Toll Fine Arts, New York. "Large Format Drawings." December 8, 1981–January 2, 1982.

Paula Cooper Gallery, New York. "Print Exhibition." December 9, 1981–January 6, 1982.

Musée National d'Art Moderne, Centre Georges Pompidou, Paris. "Murs." December 17, 1981–February 8, 1982.*

1982

One-man
Museum Boymans–van Beuningen, Rotterdam. "Jon Borofsky: Werkers." February 20–April 5.

Museum van Hedendaagse Kunst, Ghent. "Jonathan Borofsky." April 17–May 15.*

Gemini G.E.L., Los Angeles. "Jonathan Borofsky: New Print and Sculpture Editions." September 10–30.

Paula Cooper Gallery, New York. "Jonathan Borofsky: New Prints from Gemini and SIMCA." September 14–October 9.

Erika and Otto Friedrich Gallery, Bern. "Portfolio 2740475." November 5–December 11.

Group
University Art Museum, University of California, Santa Barbara. "Figuration." January 6–February 7.*

Metro Pictures, New York. "Painting." January 9–30.

Centre d'Echanges Perrache, Lyons. "Energie New York." January 15–March 15.

Paula Cooper Gallery, New York. "Changing Group Exhibition." January 24–February 20.

Castelli Graphics, New York. "Black and White: A Print Survey." January 29–February 26.

Milwaukee Art Museum. "American Prints: 1960–1980." February 5–March 21.*

Contemporary Arts Center, Cincinnati. "Dynamix." March 11–April 17. Traveled to Sullivant Hall Gallery, Ohio State University, Columbus, September 6–October 17; Allen Memorial Art Museum, Oberlin College, November 1–21; Butler Institute of American Art, Youngstown, December 6, 1982–January 9, 1983; University of Kentucky Art Museum, Lexington, January 15–February 20, 1983; Joslyn Art Museum, Omaha, March 19–May 1, 1983; Doane Hall Art Gallery, Allegheny College, Meadville, May 5–27, 1983.*

Mura Aureliane, Rome. "Avanguardia Transavanguardia." April–July.*

Whitney Museum of American Art, New York. "Focus on the Figure: Twenty Years." April 15–June 13.*

Walker Art Center, Minneapolis. "Eight Artists: The Anxious Edge." April 25–June 13.*

Ronald Feldman Fine Arts, Inc., New York. "The Atomic Salon: Artists Against Nuclear War." June 9–July 7.

Alexander F. Milliken Gallery, New York. "Fast." June 11–July 15.*

Museum Fridericianum, Kassel. "Documenta 7." June 19–September 29.*

Indianapolis Museum of Art. "Painting and Sculpture Today 1982." July 6–August 15.*

The Museum of Modern Art, New York. "New Work on Paper 2." July 28–September 21.*

Delahunty Gallery, Dallas. "Prints by Borofsky, Chia, Clemente, Cucchi, Disler, Penck." September 11–October 27.

Westport Weston Arts Council Gallery, Town Hall, Connecticut. "Art of the '80s: 25 New American and European Artists." September 24–October 12.

Brainerd Art Gallery, State University College of Arts and Science, Potsdam. "20th Anniversary Exhibition of the Vogel Collection." October 1–December 1. Traveled to the Gallery of Art, University of Northern Iowa, Cedar Rapids, April 5–May 5, 1983.*

Sidney Janis Gallery, New York. "The Expressionist Image: American Art from Pollock to Today." October 9–30.

Martin-Gropius-Bau, West Berlin. "Zeitgeist." October 16, 1982–January 16, 1983.*

Kestner-Gesellschaft, Hannover. "New York Now." November 26, 1982–January 23, 1983. Traveled to Kunstverein Munich, February 2–March 6, 1983; Musée Cantonal des Beaux-Arts, Lausanne, March 30–May 15, 1983; Kunstverein für die Rheinlande und Westfalen, Düsseldorf, July 22–August 28, 1983.*

Milwaukee Art Museum. "New Figuration in America: John Porter Retzer and Florence Horn Retzer Exhibition." December 3, 1982–January 23, 1983.*

1983

One-man
Kunstmuseum Basel. "Jonathan Borofsky: Zeichnungen 1960–1983." June 4–July 31. Traveled to Städtisches Kunstmuseum Bonn, September 21–October 30; Kunstverein in Hamburg, January 14–February 26, 1984; Kunsthalle Bielefeld, April 1–May 13, 1984; Mannheimer Kunstverein, May 27–July 8, 1984; Moderna Museet, Stockholm, September 8–October 21, 1984.*

Akron Art Institute. "Jonathan Borofsky: Installation." September 11–November 6.

Gemini G.E.L., Los Angeles. "Jonathan Borofsky: New Print and Sculpture Editions." October 14–November 9.

Paula Cooper Gallery, New York. "Jonathan Borofsky." November 5–December 3. Traveled to the Lowe Art Museum, University of Miami, Coral Gables, as "Jonathan Borofsky: Dreams and Compulsions," January 18–February 26, 1984.

Group
Daniel Weinberg Gallery, Los Angeles. "Drawing Conclusions: A Survey of American Drawings 1958–83." January 29–February 26.

Muhlenberg College, Allentown. "Festival of the Arts." February 10–28.

The Museum of Modern Art, New York. "Recent Acquisitions from the Department of Drawings." February 10–April 12.

Whitney Museum of American Art, Fairfield County, Stamford. "Entering the Eighties: Selections from the Permanent Collection of the Whitney Museum of American Art." February 11–April 13.*

Baskerville and Watson, New York. "Borrowed Time." March 9–April 9.

Hirshhorn Museum and Sculpture Garden, Smithsonian Institution, Washington, D.C. "Directions 1983." March 10–May 15.*

Nigel Greenwood, Inc., London. "Eight Portfolios from Peter Blum Edition, New York." March 11–April 1.

Center Gallery, Bucknell University, Lewisburg. "Faces since the Fifties: A Generation of American Portraiture." March 11–April 17.*

Whitney Museum of American Art, New York. "1983 Biennial Exhibition." March 15–May 29.*

Kalamazoo Institute of Arts. "New Image/Pattern & Decoration: From the Morton G. Neumann Family Collection." March 18–May 1. Traveled to the Madison Art Center, Wisconsin, August 1–September 18; David Alfred Smart Gallery of the University of Chicago, October 5–December 4; Flint Institute of Arts, April 23–June 3, 1984; Arkansas Art Center, Little Rock, August 27–October 7, 1984; Memorial Art Gallery of the University of Rochester, October 26–November 25, 1984.*

Monique Knowlton Gallery, New York. "Intoxication." April 9–May 7.

International Running Center, New York. "Running '83: An Exhibition of Contemporary Art." April 29–May 30.

Robert Miller Gallery, New York. "Surreal." May 3–June 30.

The Renaissance Society, University of Chicago. "The Sixth Day: A Survey of Recent Developments in Figurative Sculpture." May 8–June 15.*

Kunstmuseum Luzern. "Back to the USA: Amerikanische Kunst der Siebziger und Achtziger." May 29–July 31. Traveled to Rheinisches Landesmuseum, Bonn, October 27, 1983–January 15, 1984; Württembergisches Kunstverein Stuttgart, April–June 1984.*

Whitney Museum of American Art, New York. "Minimalism to Expressionism: Painting and Sculpture since 1965 from the Permanent Collection." June 2–December 4.*

Tony Shafrazi Gallery, New York. "Painting Sculpture Totems and 3D." June 22–July 22.

Associated American Artists, Philadelphia. "New Work in Black and White." July 1–30.

Linda Farris Gallery, Seattle. "Self-Portraits." August 4–September 11. Traveled to Los Angeles Municipal Art Gallery, October 18–November 15.*

Kunsthaus, Zürich. "Bilder der Angst und der Bedrohung." August 12–October 23.*

Kijkhuis 83, The Hague. "World-wide Video Festival." September 6–11.

Walker Art Center, Minneapolis. "Recent Acquisitions for the Permanent Collection." September 11–October 16.

Tate Gallery, London. "New Art." September 14–October 23.

Sharpe Gallery, New York. "Self-Image." September 15–October 9.

The Art Museum of the Anteneum, Helsinki. "ARS 83 Helsinki." October 14–December 11.

The Brooklyn Museum, New York. "The American Artist as Printmaker: Twenty-third National Print Exhibition." October 28, 1983–January 22, 1984.*

Dowd Fine Arts Center Gallery, State University of New York, Cortland. "The Figurative Mode: Recent Drawings from New York City Galleries." November 5–30.

Staatliche Kunsthalle Baden-Baden, West Germany. "Kosmische Bilder in der Kunst des 20. Jahrhunderts." November 11, 1983–January 6, 1984. Traveled to Tel Aviv Museum, Israel, February 21–April 28, 1984.*

Institute of Contemporary Art, Boston. "Currents." November 22, 1983–January 14, 1984.

Paula Cooper Gallery, New York. "A Changing Group Exhibition." December 8, 1983–January 28, 1984.

Artists Space, New York. "Hundreds of Drawings." December 10, 1983–January 14, 1984.

Nordjyllands Kunstmuseum, Aalborg. "New York 1 Dag—Arbejder PA Papir, 18 amerikanske Kunstnere." December 26, 1983–February 19, 1984. Traveled to Randers Kunstmuseum, Denmark, March 2–April 1, 1984.*

1984

One-man
The Israel Museum, Jerusalem. "Jonathan Borofsky." April–August.*

Group
Archer M. Huntington Art Gallery, University of Texas, Austin. "New Directions for the Michener Collection—1984." January 12–March 5.*

Paula Cooper Gallery, New York. "Artists Call—Against U.S. Intervention in Central America." January 14–28.

Center Gallery, Bucknell University, Lewisburg. "Parasol and SIMCA: Two Presses/Two Processes." February 3–April 4. Traveled to Sordoni Art Gallery, Wilkes College, Wilkes-Barre, April 15–May 13.*

Charles Cowles Gallery, New York. "TOTEM." February 4–25.

Sidney Janis Gallery, New York. "Modern Expressionists: German, Italian, and American Painters." March 10–April 7.

La Jolla Museum of Contemporary Art (organized by the Whitney Museum of American Art). "American Art since 1970." March 10–April 22. Traveled to Museo Tamayo, Mexico City, May 17–July 29; North Carolina Museum of Art, Raleigh, September 29–November 25; Sheldon Memorial Art Gallery, University of Nebraska, Lincoln, January 12–March 3, 1985; and Center for the Fine Arts, Miami, March 30–May 26, 1985.*

Downtown Branch, Whitney Museum of American Art, New York. "Visions of Childhood; a Contemporary Iconography." March 28–May 11.*

The Museum of Modern Art, New York. "An International Survey of Recent Painting and Sculpture." May 17–August 28.

I dreamed I was walking down the stairs into the subway where a little black boy (light skin, 13 years old) was standing with an older woman and a younger woman. He asked me if I would be his older brother for this ride and that that way he would get on for a cheaper fare. I was about to tell him that he was black and I was white and that I didn't think we'd pass for brothers when I realized my color and hair were very much that of a black man — in fact we had similar features. The four of us talked for a while and I asked the little boy if he was a mulatto. He said he didn't know cause he was an orphan.

2445669

ESCAPE

I dreamed I was being chased by another man who had a gun. Actually we were both flying, (just our bodies), first outside and then around the inside of a large empty cubic space

I half yelled in my sleep and decided that next time I would really yell. Then Megan woke me by asking if I was okay.

2533766

I dreamed that a work by
Barry La Va and a work by
Carl André were being shown, side
by side, on the floor of a large
cafeteria space.

What was interesting was that some
of La Va's scattered ribbons had
drifted over onto André's gridded plates,
and some of André's plates could
be found in La Va's piece

2510767

Several weeks later, I dreamed that LeVa
had 8 pages of photos of his work in Art Forum Mag.
A series of ball bearing pieces were
on the floor — it was surprising to see how
structured they were layed out

2513645

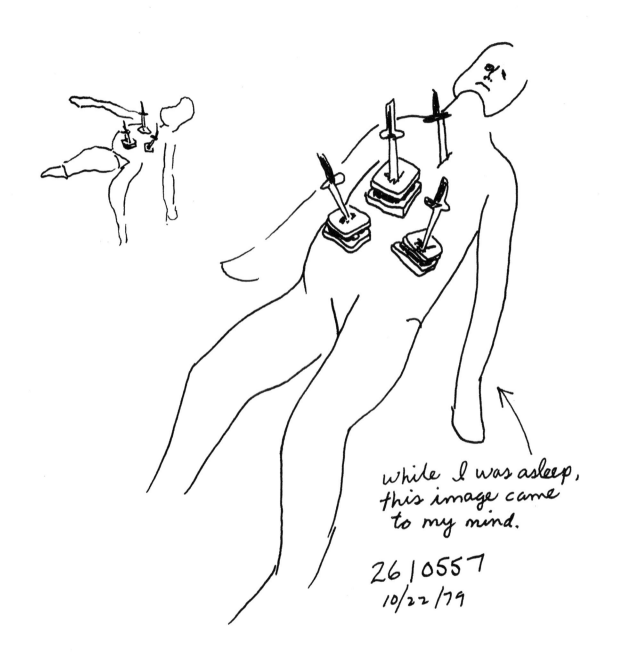

while I was asleep,
this image came
to my mind.

26 1 0557
10/22/79

Selected Bibliography

Articles, Reviews, and Monographic Catalogues

Allen, Jennifer. "From Obscurity to the Whitney." *The Daily News* (New York), February 20, 1981, p. M9.

Armstrong, Richard. "Jonathan Borofsky." *Artforum,* vol. 22, no. 6 (February 1984), pp. 75–76.

Beaucamp, Eduard. "Erleuchtung und Seelenflug." *Allgemein Zeitung* (Frankfurt), no. 1621, July 16, 1983, p. 19.

Berkeley, University Art Museum, University of California. *Matrix/Berkeley 10: Jon Borofsky/Megan Williams.* June–August 1978. Essay by Mark Rosenthal.

Borofsky, Jonathan. "Dreams." *The Paris Review,* vol. 23, no. 82 (Winter 1981), pp. 89–101.

————. "STRIKE: A Project by Jonathan Borofsky." *Artforum,* vol. 19, no. 6 (February 1981), pp. 50–55.

————. *2740475.* New York, 1982 (catalogue of lithographs).

Boston, Institute of Contemporary Art. *Male Aggression, Now Playing Everywhere.* November 22, 1983–January 14, 1984. Pamphlet by Elizabeth Sussman.

Bourdon, David. "Discerning the Shaman from the Showman." *The Village Voice,* July 4, 1977, p. 83.

Cambridge, Hayden Gallery, Massachusetts Institute of Technology. *2699475—Jonathan Borofsky: An Installation.* December 1–24, 1980. Interview by Kathy Halbreich.

Carlson, Prudence. "Jonathan Borofsky at Paula Cooper." *Art in America,* vol. 72, no. 3 (March 1984), pp. 157–58.

Christo, Cyril. "Paula Cooper: From Paris to Downtown New York." *Domus* (Milan), no. 631 (September 1982), pp. 84–85.

Curtis, Cathy, ed. "UAM Acquires Major Contemporary Sculpture." *University Art Museum Calendar* (Berkeley: University of California) April 1983, p. 1.

Deitch, Jeffrey. "Before the Reason of Images: The New Work of Jon Borofsky." *Arts Magazine,* vol. 51, no. 2 (October 1976), pp. 98–99.

Eisenman, Stephen F. "Jonathan Borofsky." *Arts Magazine,* vol. 57, no. 3 (November 1982), p. 57.

Flood, Richard. "Jonathan Borofsky, Paula Cooper Gallery," *Artforum,* vol. 19, no. 5 (January 1981), pp. 70–71.

Forgey, Benjamin. "From a Singular California Artist, Mysticism and Improbable Shapes." *The Washington Star,* January 15, 1978, p. G20.

Ghent, Museum van Hedendaagse Kunst. *Jonathan Borofsky.* April 17–May 15, 1982. Essay by Jan Hoet.

Glenn, Constance W. "Artist's Dialogue: A Conversation with Jonathan Borofsky." *Architectural Digest* (Los Angeles) (June 1983), pp. 44–52.

Groot, Paul. "The Running Man Jon Borofsky: Op weg naar een Boeddha-achtig figuur." *Museum Journaal* (Amsterdam), vol. 26, no. 1 (1981), pp. 8–15.

Hartford, Wadsworth Atheneum. *Matrix 18: Jon Borofsky.* April 6–May 3, 1976. Essay by Mark Rosenthal.

Hasli, Richard. "Keine Angst vor dem Fliegen: Jonathan Borofsky als Zeichner in Basel." *Neue Zurcher Zeitung* (Zürich), no. 130, June 7, 1983, p. 35.

Houston, Contemporary Arts Museum. *Jonathan Borofsky: An Environmental Installation.* March 7–April 5, 1981. Essay by Linda L. Cathcart.

Klein, Michael R. "Jon Borofsky's Doubt." *Arts Magazine,* vol. 54, no. 3 (November 1979), pp. 122–23.

————. "Jonathan Borofsky: Private & Public." *The Print Collector's Newsletter,* vol. 14, no. 2 (May–June 1983), pp. 51–54.

Koepplin, Dieter. "Flying Man." *Basler Zeitung, Basler Magazin* (Basel), no. 25, June 25, 1983, p. 9.

Kunsthalle Basel. *Jonathan Borofsky: Dreams, 1973–81.* July 12–September 13, 1981. Prefaces by Sandy Nairne and Jean-Christophe Ammann, essay by Joan Simon.

Kunstmuseum Basel. *Jonathan Borofsky: Zeichnungen 1960–1983.* June 4–July 31, 1983. Essays by Christian Geelhaar and Dieter Koepplin.

Larson, Kay. "Artists the Critics are Watching/New York/Jonathan Borofsky: Counting to a Billion." *ARTnews,* vol. 80, no. 5 (May 1981), pp. 75–76.

Leja, Michael. "Massachusetts—Hayden Gallery/M.I.T./Cambridge—Jonathan Borofsky: 2,699,475." *Art New England,* vol. 2 (February 1981), p. 7.

Lippard, Lucy R. "Jonathan Borofsky at 2,096,974." *Artforum,* vol. 13, no. 3 (November 1974), pp. 62–63.

Los Angeles, Thomas Lewallen Gallery. *Dreams.* April 8–29, 1978.

Morgan, Stuart. "Jonathan Borofsky at the ICA." *Artscribe,* no. 32 (December 1981), pp. 48–49.

Moufarrege, Nicolas A. "The Mutant International; V: Now Playing Everywhere." *Arts Magazine,* vol. 58, no. 5 (January 1984), pp. 134–37.

Perreault, John. "All Messed Up." *Soho News,* October 29, 1980, p. 61.

Plagens, Peter. "557,087." *Artforum,* vol. 8, no. 3 (November 1969), pp. 64–67.

Rein, Ingrid. "Kunst für den Geist." *Vogue* (Munich) (October 1983), pp. 250–51, 300, 302.

Rose, Barbara. "The Maximal Art of Jonathan Borofsky." *Vogue* (April 1984), pp. 344–45, 392.

Russell, John. "Art: Jonathan Borofsky Show." *New York Times,* November 18, 1983, p. C26.

————. "Art: Transformation of Jonathan Borofsky." *New York Times,* October 24, 1980, p. C23.

Simon, Joan. "An Interview with Jonathan Borofsky." *Art in America*, vol. 69, no. 9 (November 1981), pp. 156–67. Also appeared as "L'homme qui court." *Art Press* (Paris) (May 1982), pp. 21–23.

Smith, Philip. "Jon Borofsky." *Arts Magazine*, vol. 52, no. 7 (March 1978), p. 13.

Smith, Roberta. "Drawing Fire." *The Village Voice*, August 17, 1982, p. 74.

————. "Jonathan Borofsky Does It His Way." *The Village Voice*, November 29, 1983, p. 119.

Taylor, Robert. "Beguiling Surrealism at Hayden Gallery." *Boston Sunday Globe*, December 21, 1980, p. A17.

Temin, Christine. "Borofsky's Haunting Art from Dreams." *Boston Globe*, November 29, 1983, pp. 25, 27.

Thomas, Morgan. "Jon Borofsky's Dream Language." *Artweek*, vol. 8, no. 17, April 23, 1977, p. 4.

Wechsler, Max. "Basel: Jonathan Borofsky, Kunsthalle." *Artforum*, vol. 22, no. 4 (December 1983), p. 90.

Wingen, Ed. "De droombeelden van Jonathan Borofsky." *Kunst Beeld*, no. 6 (March 1982), pp. 10–12.

Wooster, Ann-Sargent. "Jonathan Borofsky." *ARTnews*, vol. 76, no. 1 (January 1977), pp. 121–22.

Zelevansky, Lynn. "Jonathan Borofsky's Dream Machine." *ARTnews*, vol. 83, no. 5 (May 1984), pp. 108–15.

General Articles, Reviews, and Exhibition Catalogues

Amherst, Hampshire College Gallery. *Arts Month 1979: Art as Auto Image*. February 17–March 14, 1979.

Bonito Oliva, Achille. "The International Trans-Avantgarde." *Flash Art* (Milan), no. 104 (October–November 1981), pp. 36–43.

————. *Transavantgarde International*. Milan, 1982.

Caroli, Flavio. *Magico primario: l'arte degli anni ottanta*. Milan, 1982. Also appeared as "Magico primario." *Interarte* (Bologna), vol. 23 (April 1982), pp. 5–27.

Cohen, Ronny H. "Energism: An Attitude." *Artforum*, vol. 19, no. 11 (September 1980), pp. 16–23.

Humlebaek, Denmark, Louisiana Museum of Modern Art. *Drawing Distinctions: American Drawings of the Seventies*. August 15–September 20, 1981.

Hunter, Sam. "Post-Modernist Painting." *Portfolio*, vol. 4, no. 1 (January–February 1982), pp. 46–53.

Kalamazoo Institute of Arts. *New Image/Pattern and Decoration: From the Morton G. Neumann Family Collection*. March 18–May 1, 1983.

Kontova, Helena. "From Performance to Painting." *Flash Art* (Milan), no. 106 (February–March 1982), pp. 16–21.

Kramer, Hilton. "An Audacious Inaugural Exhibition." *New York Times*, September 20, 1981, pp. D33–34.

Kunz, Martin. "The Development of Physical Action into a Psychic Intensity of the Picture." *Flash Art* (Milan), nos. 98–99 (Summer 1980), pp. 12–17.

La Jolla Museum of Contemporary Art. *American Art Since 1970*. March 10–April 22, 1984. Essay by Richard Marshall.

Larson, Kay. "Constructive Criticism." *The Village Voice*, October 29, 1980, p. 85.

————. "Stripped Affinities." *New York*, November 1, 1982, pp. 60–61.

Lawson, Thomas. "Painting in New York: An Illustrated Guide." *Flash Art* (Milan), nos. 92–93 (October–November 1979), pp. 4–11.

Lewisburg, Center Gallery, Bucknell University. *Parasol and Simca: Two Presses/Two Processes*. February 3–April 4, 1984.

Lippard, Lucy R. "Groups." *Studio International*, vol. 179, no. 920 (March 1970), pp. 93–99.

————, ed. *Six Years: The Dematerialization of the Art Object from 1966 to 1972*. New York, 1973.

Milwaukee Art Museum. *New Figuration in America: John Porter Retzer and Florence Horn Retzer Exhibition*. December 3, 1982–January 23, 1983.

Minneapolis, Walker Art Center. *Eight Artists: The Anxious Edge*. April 25–June 13, 1982.

New York, Artists Space. *Pictures*. September 24–October 29, 1977.

Paris, Musée National d'Art Moderne, Centre Georges Pompidou. *Murs*. December 17, 1981–February 8, 1982.

Rose, Barbara. "In Berlin: 'The Spirit of the Times'—Zeitgeist." *Vogue* (February 1983), pp. 296–301.

Rosenthal, Mark. "From Primary Structures to Primary Imagery." *Arts Magazine*, vol. 53, no. 2 (October 1978), pp. 106–7.

————. "The Ascendance of Subject Matter and a 1960s Sensibility." *Arts Magazine*, vol. 56, no. 10 (June 1982), pp. 92–94.

Saatchi, Doris, "Zeitgeist: Worst at Its Best." *Artscribe*, no. 38 (December 1982), pp. 12–15.

Seattle Art Museum, Contemporary Art Council. *557,087: An Exhibition*. September 5–October 5, 1969.

Simon, Joan. "Report from Berlin: 'Zeitgeist': The Times & The Place." *Art in America*, vol. 71, no. 3 (March 1983), pp. 33–37.

Smith, Roberta. "Review: Artists Space." *Artforum*, vol. 12, no. 5 (January 1974), pp. 75–76.

Stevens, Mark. "The Dizzy Decade." *Newsweek*, vol. 93, no. 13 (March 26, 1979), pp. 88–94.

Tomkins, Calvin. "Boom." *The New Yorker*, December 22, 1980, pp. 78–80.

Volmer, Suzanne. "Drawings and Prints: As the Twain Meet." *Arts Magazine*, vol. 57, no. 6 (February 1983), pp. 84–85.

West Berlin, Martin-Gropius-Bau. *Zeitgeist: Internationale Kunstausstellung, Berlin 1982*. October 16, 1982–January 16, 1983.

Zürich, Halle für Internationale Neue Kunst. *Documentation 4: Jon Borofsky*. August 14–September 21, 1979.

Zürich, Kunsthaus. *Bilder der Angst und der Bedrohung*. August 12–October 23, 1983.

Index of Illustrations

Photographic credits

E. Irving Blomstrann: pls. 79-81;
Joan Broderick: pp. 6, 8, 23, 27,
86, 99, 194-97, pl. 11;
Geoffrey Clements: figs. 1-3,
13-17, 19, 20, 22, 26, 27, 32, 33,
37, 39, 41, 49-51, 55, 56, 72, pls. 2,
7, 13, 15-17, 25-29, 32, 36, 38, 40,
41, 44, 46-48, 51, 53, 64, 66, 68,
70-75, 82-84, 123-25, 127, 134,
151-53, 155, 162, 164, 207, 213-20;
Dorit Cypis: pl. 102;
eeva-inkeri: p. 10, figs. 8, 9, 23,
25, 28, pls. 1, 5, 8-10, 14, 18-20, 23,
30, 31, 33, 39, 45, 49, 54, 55,
57-63, 154, 196, 222;
Herb Engelsberg: fig. 57, pls.
156-60;
Jacques Faujour: pls. 188-90;
Tjeerd Frederikse: figs. 66, 67, pls.
191-93;
Frequin: pl. 22;
Rick Gardner: pls. 165-68;
Giacomelli: pl. 69;
Hans Gissinger: pl. 56;
Francine Keery: pls. 50, 52;
Salvatore Licitra: pl. 197;
Locations: pls. 114-16;
Richard Marshall: figs. 58, 59, 64,
pls. 122, 172, 175;
Charles Mayer: pl. 227;
Moeschlin & Disch: pl. 179;
Eric Pollitzer: fig. 38, pl. 6;
Stephen White: pl. 186;
Megan Williams: fig. 10;
M. Wortz: fig. 44, pl. 91.

Design: Laurence Channing
Assistant: Mark La Riviere

Library of Congress Cataloging in Publication Data

Rosenthal, Mark.
 Jonathan Borofsky.
 Catalogue of an exhibition held at the Philadelphia Museum
of Art, Oct. 7–Dec. 2, 1984; Whitney Museum of American Art,
New York, Dec. 20, 1984–March 10, 1985; University Art Mu-
seum, Berkeley, Apr. 17–June 16, 1985; Walker Art Center, Min-
neapolis, Sept. 13–Nov. 3, 1985; The Corcoran Gallery of Art,
Wash., D.C., Dec. 14, 1985–Feb. 9, 1986.
 Bibliography: p.
 Includes index.
 1. Borofsky, Jonathan, 1942– —Exhibitions.
I. Marshall, Richard. II. Philadelphia Museum of Art.
III. Whitney Museum of American Art. IV. Title.
N6537.B64A4 1984 700'.92'4 84-9615
ISBN 0-8109-0740-2 (Abrams)
ISBN 0-87633-059-6 (pbk.)

The following works were among those included in the traveling
exhibition "Jonathan Borofsky": p. 10; fig. 5; pls. 1, 2, 3, 4 (shown in
Philadelphia and New York only), 5, 6, 7, 8, 9, 10, 12, 13, 18, 20, 21, 23, 24,
25, 30, 31, 34, 35, 36, 37, 38, 39, 42, 44, 45, 46, 47 (shown in Philadelphia
and New York only), 48, 49, 51, 54 (Collection of Harvey and Judy
Gushner, Philadelphia), 55 (Philadelphia Museum of Art), 57, 60, 61, 63,
152 (*Cambodian Mother at 2,668,302*, 1980, Allen Memorial Art Museum,
Oberlin College), 171 (*Self-Portrait at 2,717,997*, 1981, The Museum of
Modern Art; shown in Philadelphia and New York only), 216 (*Molecule
Man with Briefcase at 2,845,323*, 1982–83, Collection of Wil J.
Hergenrader, Memphis).